THE WORLD OF MARY ELLEN BEST

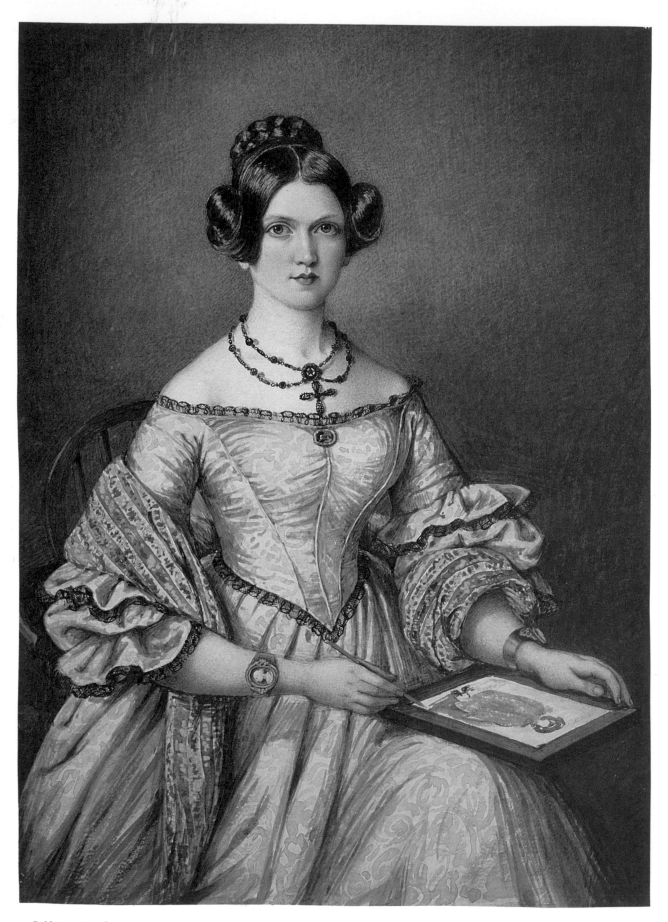

1 *Self-portrait, 1839*

THE WORLD OF Mary Ellen Best

by CAROLINE DAVIDSON

with a foreword by Howard Rutkowski

CHATTO & WINDUS · THE HOGARTH PRESS LONDON

Published by Chatto & Windus Ltd
40 William IV Street, London WC2 4DF

Davidson, Caroline
 The world of Mary Ellen Best
 1. Best, Mary Ellen 2. Painters – England – Biography
 I. Title II. Best, Mary Ellen
 759.2 ND497.B/

ISBN 0–7011–2905–0

Copyright © Caroline Davidson 1985

Phototypeset by
Wyvern Typesetting Ltd, Bristol

Origination by
Waterden Reproductions Ltd, London

Printed in Great Britain by
The Roundwood Press
Kineton, Warwick

By the same author

One Family, Two Empires:
The Spanish Hapsburgs, The Hapsburgs in Europe

A Woman's Work is Never Done:
A History of Housework in the British Isles 1650–1950

Science and Technology at Unilever

The Ham House Kitchen

edited

Science in Contemporary China

The Country Housewife and Lady's Director

FRONTISPIECE

1 *Self-portrait, 1839*

Ellen painted this self-portrait for her sister Rosamond at the end of 1839, just before her marriage to Johann Anton Phillip Sarg.

Unlike some of her quick sketches, it is a very finely wrought work. She has taken great care to capture the sheen of her silk dress, the detail in the ironwork necklace she had recently bought in Berlin, and the softness of her cashmere shawl. She has also been completely honest in showing that her left eye was higher than her right.

Ellen usually presented herself as an artist in her self-portraits: in this one, she is holding a paint brush and a portrait of her niece, Ann Robinson, is balanced on her knee.

Ellen painted a similar self-portrait for Johann in December 1839, in which she wears the same dress and bracelets, but holds his portrait.

Contents

for Clive, again

ACKNOWLEDGEMENTS

I thank all the descendants of Mary Ellen Best in England, the United States, Australia and Guatemala for their great help and kindness to me. Without their heart-warming co-operation in showing me their collections of Mary Ellen Best's water-colours and unpublished family papers, it would not have been possible to discover so much about her life and work or to write this book. Those whose paintings are reproduced are acknowledged separately on p. 158.

I owe particular gratitude to Richard and Sally Howard-Vyse for their tremendous generosity in lending Rosamond Robinson's *Family Chronicle*. They were very helpful in identifying pictures, as were Jeremy Lawrance, Philippa Moyle, Francis Taylor, Rosamond Selsey, George Garwood, Joan Lawrance, Hugh Lawrance (in England), Rose Harms, Mary Sarg Murphy, Jeanne Dominick, Juan José Sarg, Francis Sarg (in America), Timothy Turpin (in Australia), Clara Luz Sarg and Francisco Sarg Castañeda (in Guatemala).

I am extremely grateful to Eva Hanebutt-Benz of the Museum für Kunsthandwerk in Frankfurt for spending so much time investigating Mary Ellen Best's life in Germany and for making so many fascinating discoveries which have been a major contribution to this book. The same applies to Marianne Howarth of Lanchester Polytechnic, Coventry for her invaluable research in England, Germany and the United States.

I would also like to thank Howard Rutkowski of Sotheby's for writing the foreword. He is responsible for the 'discovery' of Mary Ellen Best and has been very kind in passing on useful information.

I am greatly indebted to David Alexander and Peter Brears for much valuable information about Yorkshire, to Joop Witteveen for assistance in interpreting Mary Ellen Best's watercolours of Dutch kitchens, and to Fernand Baudin for his detective work in Malines.

Many other people have helped with this book, including Marcus Bell, Léo Van Buyten, Francesca and Richard Calvo-coressi, Wendy Cooper, Jane Davidson, Anne Digby, Herbert Dubrow, Ruth Dubrow, Trevor Fawcett, David and Honor Godfrey-McCabe, St John Gore, Ian Graham, Hero Granger-Taylor, Richard Green, Gerhard Hirschfeld, Henri Installé, Heinz-Joachim Jaensch, Randal Keynes, Thomas Laqueur, Graham Mackrill, T. S. A. Macquiban, Margaret Mallory, Philip Mansel, Sandra Mansfield, Ione Martin, Iona Opie, Donald Peck, Marlinde Reinold, Albert Russell, Eda Sagarra, Lore Sauerwein, Marten Van Sinderen, Richard Stokes, Gil Swift, George Tee, William Vaughan, Giles Worsley, Martin Wittek, and Andrew Wyld. I am grateful to all of them.

Hugo Brunner, Ron Costley and Robert Ducas also deserve special thanks: they have far exceeded the normal contributions of editor, book designer and literary agent.

6

Foreword

Caroline Davidson's assiduousness in piecing together the story of Mary Ellen Best has been more than amply rewarded and I am delighted to have this opportunity to introduce it.

The discovery of Mary Ellen Best happened almost by chance. A client writing to Sotheby's about some watercolours done by an ancestor was told that they would not be saleable. A few days later, in a passing conversation, a colleague gave me a description of these items and asked if they would be of interest. I called the owner, Mrs Mary Sarg Murphy, and after a brief discussion, it was decided that she would send the group of forty-seven watercolours by her great-grandmother to me.

In addition to the watercolours, there was a family album together with photographs, letters and other documents that suggested there was more to these charming views of early nineteenth-century life than immediately met the eye. Indeed, the watercolours themselves were a diary, a chronicle of the life of a young woman of the previous century. Promoted as such, these watercolours proved a tremendous success, not only in the salesroom, but in the public's mind as well.

The second group of watercolours appeared in a similar, but unrelated way. Another caller informed me that he had an album of watercolours painted by a family member in 1840. Only the date inspired hope and, expecting a sheaf of amateur doodlings, I was quite unprepared to see a dedication by Mary Ellen Sarg. Unlike the first album, which had been partly broken up earlier in this century for framing, these watercolours were in almost original state and focused on Mary Ellen's first trip to the Continent. My excitement was mixed with incredulity when I was told by the owner, Mr Ronald Graney, a great-grandnephew of the artist, that he was completely unaware of the group Sotheby's had sold the previous year.

Undoubtedly, the great appeal of the art of Mary Ellen Best lies in her renderings of interiors. The precision of line and great attention to detail of these rooms, whether they are the country houses of her youth, the museums of Europe or even an hotel room, make them accessible to the imagination. For Mary Ellen they were her version of the family photograph album; for us they are a window on a world and its trappings long since gone. The profusion of colour and variety of style in these rooms awake the modern viewer to a sense of design and decoration that is oftimes at odds with his preconceptions of period décor.

Her many views of picture galleries, both public and private, prove that her interest in art went beyond the production of her own genteel watercolours. Her views of the then newly-completed Städel Institute are remarkable in their minute rendering of each picture. In addition to the Old Masters, she showed great interest in the art of her contemporaries, as witnessed by a view of an exhibition of 'Modern' pictures. In fact, several of the watercolours produced in Germany suggest an influence of the German Romantic painters whose work she no doubt saw.

She is unfortunately less successful when she travels out of doors. Her limited knowledge of perspective requires her to cling to an architectural element in order to carry off a design. The crowded streets of an old German town are perfect grist to her mill, but trees do not possess the hard edge of brick, wood and stone and the ambiguity of a natural landscape lies beyond her talents. In many of these outdoor views one gets the sense that she is experimenting – cognisant of the problem and attempting to discover a solution.

On the surface, the narrative of Mary Ellen Best's life would suit a contemporary novel, with companion illustrations. Indeed, Thackeray's *Vanity Fair* includes a chapter describing a Rhine tour not unlike those undertaken by the subject of this book. However, given our present understanding of the role of women in the first half of the nineteenth century, Mary Ellen's independence seems quite remarkable. The dispersal of her descendants and of her watercolours to all parts of the globe is a testament to this independence and to her *Wanderlust*. One hopes that the publication of this book will bring many more of Mary Ellen's watercolours to light.

HOWARD RUTKOWSKI
New York, February 1985

2 *'Ellen's cutting out', 1816 or 1817*

Ellen made this black and white paper cut-out of a bird
feeding its young at the age of seven or eight. She was then
living in Nice, with her parents, and liked to send little
presents to her sister Rosamond who remained in England.
Her father wrote in a letter of 'little Ellen' amusing herself all
day by cutting out and painting.

Rosamond often referred to Ellen's work in her letters to
Nice. In August 1816 she wrote from her uncle Francis Best's
rectory at South Dalton that: 'I have found one of dear little
Ellen's Drawings, which contained these words, – When the
carriage comes on I will . . . Tell her we think & talk of her
Night and Day.'

In making this cut-out, Ellen was undoubtedly inspired by
her father's miniature watercolours of birds. Like Turner, Dr
Best was very interested in bird-watching and took great care
to record his observations with delicacy and accuracy.

Introduction

For anyone interested in the way Europeans lived in the early nineteenth century, Mary Ellen Best is the most fascinating and informative of artists. Her watercolours provide a unique and charming insight into innumerable aspects of English provincial life in the 1830s, including the fashion for travelling round Holland and up the Rhine into Germany. They also give a rare view of Germany and Belgium in the 1840s, just before the age of photography.

Mary Ellen Best was not interested in the usual repertoire of the early nineteenth-century artist: 'picturesque' landscapes and views; great moments from history and literature; religious scenes; and portraits of important men and their families. Instead, she recorded what she saw around her.

In England she painted the interiors of the Yorkshire houses and cottages she knew well, the streets and markets where she went walking and did her shopping, the churches where she worshipped, as well as portraits of her family, friends and acquaintances. On her continental tours of the 1830s, she painted humble people in local costume, the places she visited, and the frequently bizarre sights which intrigued her. In 1840 she married a German and settled permanently on the Continent. She then concentrated on painting the progress of her three children through the successive stages of babyhood and childhood and the appearance of the cities and houses where her family lived.

Although many artists have painted scenes from everyday life, few have depicted them with such accuracy and faithful attention to detail as Mary Ellen Best. Nor have many been as thorough and systematic in recording their daily lives as she was. Indeed Mary Ellen Best stands out among her contemporaries in having deliberately set out to 'paint' her autobiography. In between satisfying her friends and patrons with commissioned portraits, still-lives and interiors, she was hard at work for herself. She amassed an extensive portrait collection capturing the character of the people she knew best, as well as some of her strange acquaintances. (Ellen was drawn to servant girls, orphans, actresses, street singers, infant prodigies and the like.) She also painted watercolours chronicling the main events and experiences in her life.

Later on, in middle age, when she felt that she had her life in perspective, she selected the most significant of these pictures, put them into logical order, and pasted them into large albums, each of which had a specific theme. One contained early works, depicting her life in York in the early 1830s and her holiday in Wales in 1832. Another was devoted to her first continental tour and stay in Frankfurt on the Main in 1834–35. A third concentrated on her life in Yorkshire between 1832 and 1839. A fourth covered her visit to the Continent, in 1838, a fifth the main events in her life between 1839 and 1841, and so on. Each album was duly equipped with picture captions and an explanatory index and dedicated to a member of her family.

Because so many of Mary Ellen Best's watercolours survive (more than 370 have come to light out of an estimated 1,500) and because her life is exceptionally well documented, she is a particularly fascinating example of a woman painter who worked in the first half of the nineteenth century. Very few women admitted to being artists at this time. According to the census of 1841, when Britain had a population of 18.5 million, there were only 299 women artists in the country, compared to 4,038 men.

There were fundamental differences between the careers of men and women artists. The male artist had a public persona: he was a professional, intent on exhibiting and selling his work and making a name for himself. If he was successful, he probably lived in London, the centre of the art world, and had a studio. Although he might paint in watercolours, he preferred working in oils, usually on a large scale, handling the grand, academic themes popular among his patrons.

The woman artist, on the other, usually worked in private, painting watercolours, which did not require a studio or the outlay of much money. She specialised in portraits, flowers and landscapes and made painstaking copies of accepted masterpieces. She rarely exhibited or publicised her work, made little or no effort to sell it and, if she lived in the provinces, remained there rather than moving to London.

Mary Ellen Best's career exemplified some of these female characteristics but also departed from the norm. Unlike most women of the time, she called herself an artist and strove for recognition. Far from staying at home, she loved travel and new experiences. But most important of all, she had no inhibitions about rejecting the conventional subject matter of early nineteenth-century art and painting a vivid record of her life.

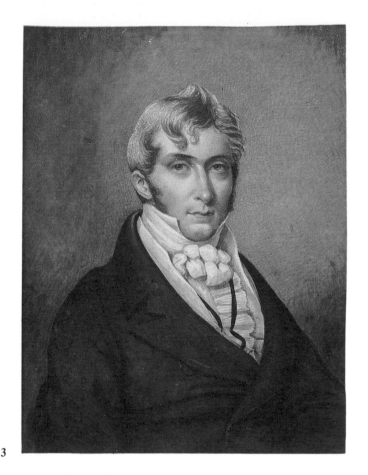

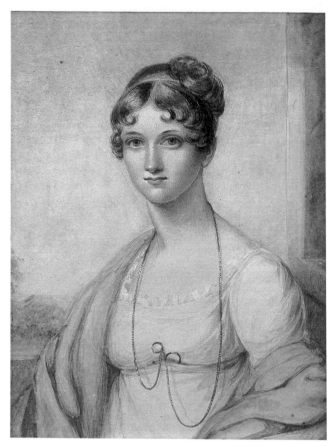

3

4

3 & 4 *Copies of portraits of Dr Charles Best and his wife,*
Mary Norcliffe

Ellen painted several copies of these portraits, both for herself
and as presents for her relatives. Their small size made them
the equivalent of modern photographs.

She was not imagining her parents in their youth, but
reproducing a pair of existing portraits which were probably
painted at the time of their marriage in 1807.

1 – A Scandalous Childhood

Mary Ellen Best was born in York in October 1809.[1] Her parents, Charles and Mary Best, lived on Little Blake Street, near the ancient city's famous cathedral, and had been married for just over two years.[2] She was their second child.

3, 4

Both of Ellen's parents were educated, cultured people from well-to-do Yorkshire families. Charles Best was the third son of Francis Best, rector of the East Riding parish of South Dalton between 1757 and 1802.[3] While his eldest brother went into the Church and succeeded his father at South Dalton, Charles Best became a doctor. He took his MD at Edinburgh University, which was then the best place in Britain to pursue medical studies, and published a thesis on vaccination in 1801.[4] This choice of subject shows that Dr Best was up to date in his medical interests: Edward Jenner had only published his findings about vaccination against smallpox in 1798.

Dr Best seems not only to have held progressive medical views, but also to have had a social conscience. In March 1802, at the age of twenty-three, he joined the Carey Street Dispensary in London as an unpaid assistant physician. The dispensary was a pioneering institution which provided free medical care to the poor, headed by Dr Robert Willan, who had conducted outstanding research on skin disease.

Dr Best, however, did not remain at Carey Street Dispensary for long: he resigned in June, explaining that he was 'obliged to leave London'.[5] He had to return home to Yorkshire because his father was seriously ill. Five months after his father's death in August 1802, Dr Best took another unpaid post, as an assistant physician at the York Dispensary. This was a flourishing charity, with a staff of six physicians, five surgeons and one apothecary. According to Oswald Allen, one of its directors, Dr Best was 'a pleasing and an accomplished man, both as a gentleman and a Physician, and universally respected'. He described him as being 'a very assiduous and regular attendant upon the Institution'.[6]

In 1804, Dr Best took a paid job as assistant to Dr Alexander Hunter, Physician to the York Lunatic Asylum. It had been founded in 1774 to care for fifty-four patients and, like the dispensary, was considered a model of its kind.

A Parliamentary Committee on Criminal and Pauper Lunatics commended it for its 'excellent management' in 1807.[7] Unfortunately, Dr Best's health soon began to fail. In 1808, he informed the governors of the asylum that he was suffering from 'an infection of the lungs' (i.e. tuberculosis) and requested leave of absence for a sea voyage and winter holiday in a better climate. The governors agreed to let him go and Dr Best spent the winter in Lisbon as 'Physician Extraordinary to the Forces'.[8] (Britain had gone to the aid of her ally, Portugal, after the French invasion.) When Dr Hunter died in the spring 1809, Dr Best was elected Physician to the asylum, defeating five other candidates. He returned to York to take up this post and also resumed work at the dispensary.

Mary Ellen's mother, née Mary Norcliffe Dalton, was the third daughter of a prominent Yorkshire landowner, Lieutenant-Colonel Thomas Norcliffe Dalton, and his wife Ann. They lived in a pleasant country house at Langton, a village seventeen miles from York. They gave their daughter an excellent education: she was well read, had a strong interest in natural history, could pen a good letter and speak French. She was an attractive person and they lost no time in marrying her off, at the age of seventeen, to Dr Best.

5

The house in Little Blake Street where Ellen and her elder sister, Rosamond, spent their early childhood no longer exists. It stood in what is now Duncombe Place, well within the ancient city walls. It was probably an eighteenth-century terraced house on three or four floors, of the type which is still very common in the city centre.

The Bests employed at least two servants and enjoyed a comfortable standard of living. Dr Best may not have had substantial private means, but he did earn a good income. He was able to supplement his salary from the York Lunatic Asylum, which was set at 300 guineas a year in 1814, by admitting his own private patients and charging them fees.[10] He also had a stake in a profitable private madhouse at Acomb in York which had belonged to his predecessor at the asylum. Under Dr Hunter's will, Dr Best was to divide the profits from it with Hunter's family for eleven years.[11]

The Bests led a genteel life. The city was the centre of social, legal and ecclesiastical life in Yorkshire, but it had hardly been touched by the Industrial Revolution, which was transforming the character of other towns like Bradford and Leeds. Indeed there were only two factories in York, one producing white and red lead and the other glass. The population was still small: 18,217 in 1811 rising to 28,842 in 1841.[12] The city's amenities included its cathedral and twenty-four parish churches, its theatre and assembly rooms, its medical institutions and a recently established subscription library. However, several of the cultural innovations that enlivened Ellen's youth were yet to come: the

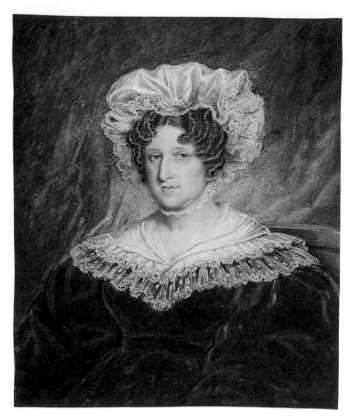

5

5 Portrait of Mrs Thomas Norcliffe, August 1830

This unconventional portrait, with its mysterious fiery background, is of Ellen's maternal grandmother, Ann Norcliffe (1762–1835) of Langton Hall. She was a cultured, energetic woman with a mind of her own and plenty of money. Her father, Thomas Wilson of Leeds, had left her his fortune and her husband, Lieutenant-Colonel Thomas Norcliffe Dalton, who changed his surname to Norcliffe in 1820, left her in control of his estate when he died that year.

Ann Norcliffe was very fond of Rosamond and Ellen and exerted an important influence on their upbringing. She often had them to stay at Langton Hall, a gracious country house seventeen miles from York. She gave them lots of presents and made generous provision for them in her will.

Festival Concert Room, which could accommodate an audience of 2,000, opened in 1824, the York Institute of Popular Science and Literature in 1827, and the Yorkshire Philosophical Society's Museum and Gardens in 1830.[13]

The first major event in Ellen's life was the York Lunatic Asylum scandal which broke out in 1813, with her father at the centre of it. The asylum suddenly came under attack from two writers. Samuel Tuke published a book promoting the Retreat, a Quaker asylum, in which he criticised the management of the rival York Lunatic Asylum. At the same time, a magistrate named Godfrey Higgins published articles in the *York Herald* claiming that patients at York Lunatic Asylum were being seriously mistreated.[14]

As might be expected, these allegations aroused considerable public concern. When four patients who had been chained to a wall died in a fire in December 1813 this concern grew even stronger. But the governors, who were used to leaving the Physician in sole charge of the asylum, took no action. Many of them were Dr Best's personal friends and some were his relations.[15] They had no reason to doubt his competence.

Dr Best, by contrast, did take these attacks on the asylum seriously. He suspected that other men were after his job and he therefore did his best to defend himself. He argued, with some justification, that the governors were in charge of the asylum and that he was only responsible for the patients' medical treatment; it was unfair to blame him for their living conditions.

He also claimed that he had never treated the inmates in an inhumane way and that living conditions were not really bad. In an attempt to prove it, he even asked former patients to write in his defence. 'Dear Sir,' his standard letter read, 'As we are accused, at the Asylum of harsh treatment & cruelty to the patients, neglecting to afford them a sufficient supply of food & attention to cleanliness, I shall be much obliged to you if you will candidly state what you yourself *experienced & observed* upon these several points, during your residence at the Lunatic Asylum.'[16] Some of their replies, which date from December 1813, make interesting reading. A Thomas Bell from North Barton near Hull, for example, absolved Dr Best from all charges and added that 'I can only say that we were all treated with the greatest *humanity* . . .'.[17] But a Mr J. W. Nicoll from Fulford said that standards of cleanliness were poor, although Dr Best's medical treatment was adequate.[18]

The strain of defending himself led to a further deterioration in Dr Best's health. But he resisted the temptation of spending another winter in Lisbon (a friend provided him with a flattering letter of introduction to Sir Charles Stuart, the British envoy there) and remained in England to try to clear his name.[19]

Unfortunately, conditions at the asylum did not improve in 1813. Nor did the bad publicity die down: the *York Herald* was full of stories about the asylum. In the spring of 1814 forty philanthropic gentlemen each paid £20 to qualify as new governors and instituted their own enquiry. Their investigations revealed that Tuke's and Higgins' allegations were well founded. The patients at the asylum were indeed being ill treated: their accommodation was overcrowded, filthy and damp; their clothing was inadequate; and their food wretched. The inmates were often whipped and the women patients raped.

In March Thomas Thompson, a Member of Parliament, visited the asylum and learned that three patients had just murdered another inmate. He found the cells and day room in a state of indescribable filth.[20]

Anne Digby, who has written a fascinating analysis of this scandalous affair, explains that it would be wrong to hold Dr Best entirely responsible. The asylum was suffering from severe financial problems as a result of the inflationary Napoleonic Wars and had been forced to accept more patients and lower its standards to remain solvent. The number of patients had increased from 54 to 199 between 1777 and 1813, with no corresponding increase in the seven keepers employed to clean and feed them. The quality of medical care the patients received had also deteriorated. For while Dr Hunter had enjoyed the advantage of an assistant physician, the governors did not appoint anybody to help Dr Best.

If all this had happened a hundred years earlier, few people would have minded. But by the early nineteenth century a much more humanitarian 'modern' attitude to insanity was coming into fashion: lunatics were not to be treated like animals but as human beings and every effort was to be made to cure them.

To make things worse, Dr Best's opponents began to accuse him of financial irregularities at the asylum. Although a small majority of governors eventually voted him not guilty, this was the last straw.[21] By May 1815, when Dr Best was in London trying to present evidence to a Parliamentary Committee on Madhouses, his letters home bore every sign of a man undergoing a physical and mental breakdown.[22]

Ellen, now six years old, was of an age to understand the substance of what was going on, if not the details. All semblance of normal family life soon came to an end. In 1815, her father resigned his post at the asylum, on the grounds of ill health, and went abroad to Nice in the South of France.[23] He was accompanied by Mrs Best, Ellen and their faithful servant, Elizabeth Alderson, who was the daughter of a local farmer. Rosamond was left behind in Yorkshire in the care of relations. Ellen, who adored her elder sister, missed her enormously and sent her paintings and cut-outs as presents, such as the one reproduced on page 8.

Some idea of the Bests' time in Nice is conveyed in a letter Mrs Best sent her mother in June 1816. By this point they had rented a house and settled down: Ellen even had a pet dormouse in a cage. Although they spoke French and had a small circle of English friends, life was not much fun. Money problems preyed on their minds and Ellen had been seriously ill: 'We have been very near losing our poor little Ellen in a liver disorder, accompanied with jaundice. We had to sit up with her every night for a week, with very slight hopes of her getting over it.' There was no improvement in Dr Best's health: in addition to the tuberculosis, he had also been suffering 'a great deal from several attacks of acute rheumatism'.[24] The following January, Dr Best had a 'fatal attack of his illness' and, realising he was at death's door, made his will.[25] He died on 30 July 1817. Ellen was not yet nine.

Mrs Best found that she and her daughters had been well provided for. Dr Best left £1,000 to each girl, which they were to inherit at the age of twenty-one. Meanwhile, the income from this capital (around £100 a year) was to pay for their upbringing and education. Mrs Best inherited all his personal property and another £300.[26]

In a letter to her brother-in-law, Mrs Best commented that 'It was a frequent cause of surprise & satisfaction to him that in his ruined state of health & fortune he should have been enabled to bequeath his children a sum, w^{ch} will secure them a trifling independence in future'. She explained that the money had arisen from various sources: 'principally from Mr F. Wilson's gift of £500, his own very successful practice at Nice, & the agreement he had entered into with Dr Beckwith, which has proved very advantageous, aided by an entire seclusion from company & a system of the most severe & careful economy.'[27]

Mrs Best dealt with the funeral arrangements, which proved to be very complicated, as her husband had not wanted to be interred in the English burial grounds at Nice and an alternative site had to be found. (In the end he was buried by the lighthouse of Villefranche, about three miles from Nice, on a promontory jutting into the Mediterranean.)[28] She then moved to a smaller, cheaper house in Nice, only returning to England with Ellen and Elizabeth Alderson in July 1818.[29] They had been abroad for three years.

It seems likely that Mrs Best and her daughters lived at Langton Hall for a while, before moving into a succession of lodgings in York. It was from Langton that Mrs Best composed a marathon eleven-page letter to Lord Lansdowne defending her husband in July 1819. She had read a

report in *The Courier* of a speech he had made in Parliament about the Lunatic Regulations Bill and felt compelled to set the record straight about the York Lunatic Asylum scandal. She was certain that her husband's 'valuable life was prematurely shortened by the long, harassing and most unmerited persecution he underwent on the subject of that institution'. And she could not resist pointing out that conditions at the asylum had not improved since his departure: a murder had recently taken place, the apothecary had been dismissed for improper familiarity with female patients, and the place was dirtier than ever.[30]

An important effect of Dr Best's death was to plunge Ellen and her sister into an almost exclusively feminine environment. Mrs Best did not remarry. She brought her daughters up with the help of Elizabeth Alderson and her closest relations. These included her unmarried sisters, Isabella and Charlotte, who also lived in York (at no. 9 Petergate) and her mother, Ann Norcliffe, who was not far away at Langton.

Male figures were few and far between on both sides of the family. On her mother's side, Ellen had a grandfather, who died in 1820, and she also had an uncle, Norcliffe Norcliffe, but he did not spend much time in Yorkshire. On her father's side, there was only her uncle, the Reverend Francis Best, and he lived some distance away at South Dalton.

Dr Best's bequests did guarantee his daughters an income, the 'trifling independence' which Mrs Best mentioned in her letter. This gave them three great advantages: they could afford a good education; they would not have to earn their living (an important consideration since occupations for young women from genteel backgrounds were scarce in the early nineteenth century); and they would not be forced to marry for financial reasons. In 1820 their financial prospects improved further when Mrs Best inherited £6,250 from her father.[31] She and her daughters were now comfortably off.

Like many other girls of their social class, Ellen and Rosamond were sent away to boarding school in their early teens. They had learned the three Rs, needlework and painting at home. Now they were to broaden their horizons, by living in a different environment and making friends with other girls of their age, who would later invite them home and introduce them to suitable young men.

The two schools Rosamond and Ellen attended could not have been more different from the harsh school for clergymen's daughters near Leeds which the unfortunate Brontë sisters were sent to at about the same time. Their first school was in Doncaster and was run by a splendid woman called Ann Haugh (1766–1849). She had started her career as a governess, before marrying George Haugh, a drawing master who specialised in portraits and landscapes. They did not have any children and perhaps because of this she opened a school for twelve young ladies at Hall Cross Hill in 1797. It proved such a success that within three years her husband built a residence which was specially 'fitted for the accommodation of a ladies' school'. Mrs Haugh, who had *idées de grandeur*, laid out the school gardens on the pattern of the Duke of Marlborough's seat in Berkshire, White Knights.[32]

A lively impression of the school is provided in the letters of Caroline Forth, a girl from York who was sent there in 1816. 'Mrs Haugh has improved the garden so much, that I scarcely knew it when I returned, having thrown it all into a pleasure ground,' she wrote to her mother in May 1819. Later that month she reported that Mrs Haugh had bought her two new bonnets and in October she described Mrs Haugh's birthday party: 'We had a concert in the morning, and a ball at night, and I assure you we spent a very delightful day, and did not go to bed till between two and three the next morning'.[33]

By the time Rosamond and Ellen went to Mrs Haugh's school, in the early 1820s, it had acquired a literary reputation. Mrs Haugh's friend and former teaching colleague had become one of the most popular and prolific women novelists in England. Barbara Hoole, as this now obscure writer was called, embarked on her career out of dire necessity: she was a widow and the firm in which her money had been invested went bankrupt. Although she married again, she was compelled to continue writing as her husband did not earn enough money to support them. By 1824 she had published twenty-four novels, one of which was dedicated to Mrs Haugh.[34]

As a sideline Barbara Hoole also churned out morally uplifting tales for young people and geography text books. The latter, which were based on her teaching experience at Mrs Haugh's school, were imaginative and enlightened works. She believed that learning should be fun and that children absorbed facts easily if they were also entertained in the process. In *The Panorama of Europe; or, a new game of geography*, first published in 1813 and into its fourth edition by 1824, she made children assume the persona of different countries, as if they were acting out a drama. In *The young Northern Traveller: being a Series of Letters from Frederic to Charles, during a Tour through the North of Europe* (1825) and in *Alfred Campbell, or Travels of a young Pilgrim in Egypt and the Holy Land* (1826) her heroes were real children. Books such as these stimulated Ellen's desire to travel and see the world. It is significant that a painting she did of a room in her next school shows three enormous maps hanging on the walls.[35]

Mrs Haugh, following her friend's example, also tried her

hand at educational writing. *A Few slight Sketches of History, etc. intended as Hints to Future Study* (1826) encapsulated the history of the world in forty-four pithy pages. Thus the fifth century 'saw the miserable dissolution of the western empire by the barbarians' and the fourteenth century 'was celebrated by the ever-memorable inventions of the mariner's compass, gun-powder, and (best of all) the art of printing'. As for the present, all her students had to know was that 'The west of Europe is at peace; but in the east, Greece continues to wage an unequal war with her oppressors the Turks; and Persia has broken the bonds of peace with her encroaching neighbours the Russians'.[36]

The teaching of drawing and painting was a strong point at Mrs Haugh's school. In her letter of October 1819 Caroline Forth told her mother that she had begun to learn flower painting 'which I think I shall like very much'.[37] At this time it was normal for girls from middle and upper-class backgrounds to have lessons in drawing and painting. As James Roberts, portrait painter to the Duke of Clarence, put it in 1809: 'Painting has long been considered as a graceful accomplishment for the dignified and opulent, and also an useful acquirement for those who compose the middle ranks of society. Most, if not all the elegancies of polished life, have the art of Design for their basis.'

This thinking was so generally accepted that people expressed surprise if a young lady could not count drawing and painting among her accomplishments. Thus in Jane Austen's novel *Pride and Prejudice* (1813), Lady Catherine de Bourgh asks Elizabeth Bennet whether she and her sisters can draw. Elizabeth replies, 'No, not at all' and Lady de Bourgh comments, 'That is very strange. But I suppose you had no opportunity. Your mother should have taken you to town every spring for the benefit of masters'.[38]

Drawing masters were to be found in almost every provincial town, teaching at local schools and visiting their pupils' homes. Most of them were professional artists who needed to supplement their incomes by teaching. The artist and engraver Henry Cave had an extensive teaching practice in York in the early 1800s. He taught at the best known girls' schools – the Manor School and Peasholm-green House – as well as many other lesser academies. He gave lessons in drawing, still-life, flower and landscape painting, and the making of needlework pictures. (He would sketch out the designs for his pupils to fill in with needlework; and if the designs included people he would paint in the faces and hands.)[39]

Although one cannot be sure, it is likely that Mrs Best engaged Henry Cave to teach Rosamond and Ellen before they went to boarding-school. Ellen's love of painting had been evident since her time in Nice; according to family tradition she even made paint brushes out of her own hair.

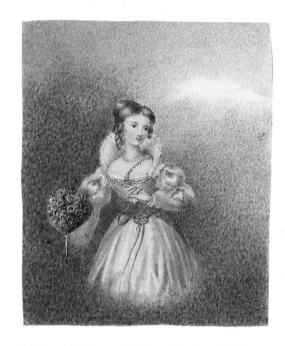

6

6 *Young girl in pseudo Elizabethan dress holding a peacock fan*

Another present for Rosamond. Ellen wrapped this watercolour (reproduced actual size) in a homemade envelope and inscribed it as follows:

'To Miss Barramond Best. Being the fulfillment of an ancient promise to draw her something. Let this oh Barramond! stop your mouth. I wish I cd stop the mouth of all who make me similar requests!'

The picture, which Ellen painted in her early teens, reflects her interest in the theatre and fancy dress. The dedication, with its dramatic rhetoric and obscure pun on Rosamond's name, shows that she was already overwhelmed with requests for pictures. In the 1820s and '30s there was a craze for compiling albums and scrap books and their owners were always eager to include sketches by their friends and relations.

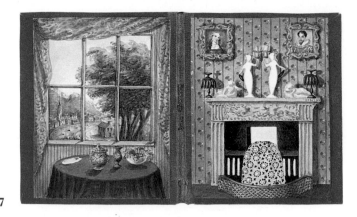

7

7 *Pink folder with two painted cut-outs of interiors*

Another juvenile work. It shows that Ellen mastered perspective at an early age and that she was already interested in interior decoration. The decorative firescreen is an unusual feature.

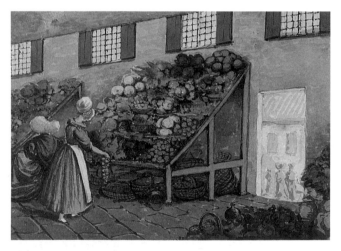

8

8 *The vegetable stall, 1825*

Ellen painted this when she was sixteen.

There was every reason to encourage her: Dr Best had been an enthusiastic watercolourist and the Norcliffes were keen patrons of the arts. Nor was there any financial problem to overcome. Mrs Best was not in the unhappy position of Mrs Jane Pontey who in 1825 decided that her grand-daughter, a pupil at the Manor School in York where Henry Cave was master, was 'not to learn drawing, at least at present' for 'there has been far too much money spent on that matter'.[40]

Indeed Mrs Best may have employed several drawing masters to instruct her daughters. Many parents thought it was a good idea for their children to learn from more than one teacher. The Reverend Patrick Brontë was one of these. He had Thomas Plummer of Keighley coming to the vicarage at Haworth from about 1829 to 1834 and then engaged the Leeds portrait painter William Robinson for a year or so, paying him 2 guineas a visit.[41] Several artists were working in York in the 1820s. William Edward Shinton taught drawing in St Saviourgate, as did Miss De Guandastague in Petergate. Robert Bank painted miniatures in Harker's yard, Micklegate. A landscape painter called John Brown was to be found in Walmgate and an animal painter, David Dalby, outside Micklegate Bar.[42]

By attending Mrs Haugh's school, Rosamond and Ellen had the benefit of lessons from a particularly well qualified and dedicated art master. George Haugh (1755–1827) was a successful painter, exhibiting regularly at the Royal Academy and the British Institution. Other artists thought highly of him. Richard Dagley, for example, included one of Mr Haugh's landscapes (of 'Rocks at Hartlepool') as a model for students to copy in his *Compendium of the Theory and Practice of Drawing and Painting* (1822). Francis Nicholson, who was preoccupied with the tendency of watercolour pigments to fade when exposed to light, thought that Mr Haugh's special formula for 'permanent' Indian Red was second to none.

Although George Haugh lived in a small provincial town, he was well connected and knew what was going on in London. One of his closest friends was Barbara Hoole's second husband, the landscape painter and book illustrator Thomas Christopher Hofland. Since the Hoflands lived in London during the 1810s and '20s (in Newman Street, the address of many other artists) the Haughs were kept up to date with all the latest trends in the metropolis.[43] Mr Haugh also knew the other artists working in Doncaster during the 1820s and invited them to the school to give lessons. These included two portrait painters, William Adamson and Thomas Webb, and the animal painter John Frederick Herring.[44]

As Ellen's principal drawing master, Mr Haugh could not have been better. He taught his pupils how to draw an accurate outline with a lead pencil, shade their pictures,

apply washes of Indian ink to tint them and, when these lessons had been mastered, the more difficult art of 'drawing in watercolours'. Mr Haugh also had an ample supply of good drawings and prints for his more serious students to copy. He had a lifetime's experience in mixing and applying paint and was well versed in the rules of perspective. Above all, he had a great love of sketching from nature and thought nothing of spending a whole day out of doors doing just that.

Under Mr Haugh's tuition, Ellen steadily increased her proficiency in drawing and watercolour painting. By the time she was twelve she could paint a creditable portrait and, by the age of fourteen, her market scenes displayed a real flair for composition.

Although there is no record of how Ellen got on with Mr Haugh, she and Rosamond clearly liked Mrs Haugh, for they remained friends with her for many years after his death in 1827. Rosamond was delighted when Mrs Haugh sent her children a New Year's present in 1835 'of a case containing fifty engravings from Old Masters, illustrations of the Gospel History, with a book of references'.[45]

In 1824 the two sisters were sent further afield, to Miss Shepherd's school in Bromley, then a small market town ten miles south-east of London. This was a similar establishment to Mrs Haugh's, but for slightly older girls. (According to the 1841 census, Miss Shepherd had eighteen pupils, fifteen of whom were aged fifteen.)[46] The school had just opened, but it soon gained an excellent reputation and Miss Shepherd was to become a highly respected figure in the neighbourhood.[47] She was more intellectual and serious-minded than Mrs Haugh. After the death of her father, a well known clergyman, she completed a very successful treatise he had written on the Book of Common Prayer.[48]

Ellen, who was fifteen when she went to Miss Shepherd's school on Bromley Common, found herself in the hands of a genuine pioneer in girls' education. Fanny Shepherd was a disciple of the Swiss educational reformer Johann Heinrich Pestalozzi whom she had visited at Yverdon in Switzerland in 1818.[49] Pestalozzi believed that children should be allowed to develop at their own pace, following the dictates of 'nature', and that education should aim to make them as independent and self-sufficient as possible. In his famous novel, *Leonard and Gertrude*, which Fanny Shepherd's sister Eliza translated into English, he argued that mothers played an extremely important role in children's education and that a secure, well-ordered homelife was the foundation of happiness.[50] Of course such ideas now seem commonplace, but in the early nineteenth century they were quite out of the ordinary.

Ellen and Rosamond continued to have art lessons at Miss Shepherd's school, although it is not possible to say

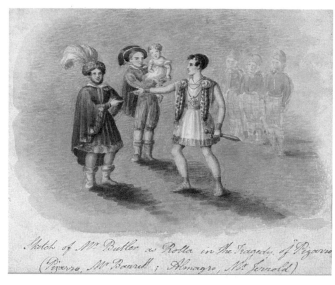

9 *'Sketch of Mr Butler as Rolla in the Tragedy of Pizarro (Pizarro, Mr Barnell; Almagro, Mr Jerrold)', 1825*

The actors were famous and the play was *Pizarro; A Tragedy in Five Acts*, which Richard Sheridan had adapted in 1799 from Auguste von Kotzebue's German. Ellen probably saw the play in London, while attending Miss Shepherd's school at Bromley.

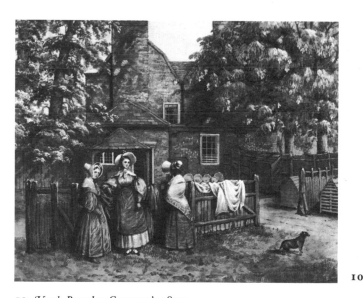

10 *'Yard, Bromley Common', 1837*

This is the back of Miss Fanny Shepherd's school at Bromley Common in Kent which Rosamond and Ellen attended in the 1820s. Miss Shepherd remained in close touch with both sisters during the next thirty years.

Ellen gave Miss Shepherd several portraits of her god-daughter Rosamond Robinson and painted the portraits of her fourteen pupils while staying at Bromley Common between April and July 1837. Judging from the leaves on the trees and the girls' costumes, it was during this visit that Ellen painted the yard.

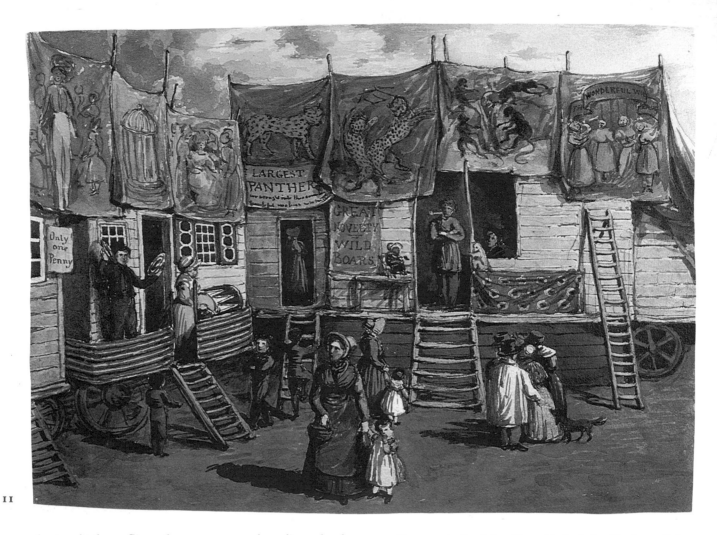

who taught them. Since there were many boarding schools in Bromley and the town was close to London, they probably had several drawing masters. They may even have had lessons from Amelia Long, Lady Farnborough (1772–1837) who lived locally at Bromley Hill Place. She was a talented, widely travelled painter, well known for her topographical watercolours and picturesque scenes of her home and estate.[51] Her husband, Charles, was a connoisseur and collector who acted as artistic adviser to George III and George IV. As Miss Shepherd was on social terms with many aristocratic and titled families, she may have known the Longs and introduced her students to them.

Rosamond and Ellen were profoundly influenced by Miss Shepherd. After leaving school in the late 1820s, they both proved independent, well organised and family minded. Their former teacher became a lifelong friend. After her mother's death, Ellen chose to stay with her for three months, and later, when she was living on the Continent, she made a point of visiting Miss Shepherd on her trips back to England.[52] Rosamond was similarly devoted to her. She often had Miss Shepherd to stay in York and sent three of her daughters to be educated at Bromley Common.[53]

11 *'Caravans in Peasholme Green, York, during Martinmas Fair, [November] 1833'*

George Wombwell's travelling menagerie made regular visits to York in the early nineteenth century, providing the city's inhabitants with a rare opportunity to see exotic animals such as elephants, hippos, lions, tigers, leopards, camels, bears, zebras, wolves, antelopes and monkeys. The caravans in Ellen's picture were used to transport the animals. They were parked in an open square to create an enclosure for the show and decked out with paintings of animals fighting each other and being hunted and captured. A brass band played rousing music when the animals were brought out and a 'spieler' recited blood-curdling stories to the crowd.

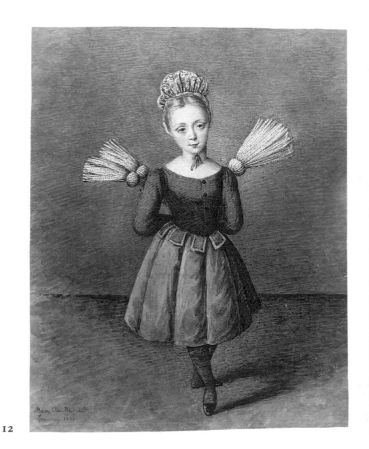

12

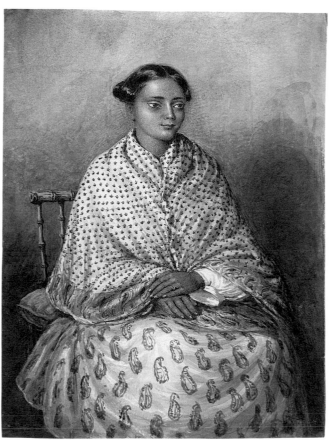

13

12 *'Miss Emmeline Margaretta James of Cooke's Royal Circus, as the Bavarian Broom Girl, York, January 1833'*

Miss Emmeline was an infant equestrian prodigy. Ellen was charmed by the seven-year-old girl and also painted her standing on horseback 'in the character of Diana'. Thomas Taplin Cooke erected permanent buildings for his circus at Newcastle-on-Tyne, Sunderland and Hull in the early 1830s, but not in York. In 1836 he took 120 of his 'artistes' on a tour of the United States.

13 *'Isabella Paula, a Portuguese Hindoo, York, May 1834'*

Human freaks were a popular attraction at fairs and circuses. Visitors loved to oggle at giants, midgets, 'fat women', 'thin men' and anyone with unusual skin or hair colouring. At York's Martinmas Fair of 1833, Ellen painted a portrait of James Heritage, an eleven-year-old albino from Frome in Somersetshire.

2 – The Ambitious Young Artist

When Rosamond and Ellen left Miss Shepherd's school in 1828, they returned to a quiet but very pleasant life in York. They accompanied their mother on her busy round of social calls, visited their aunts at Petergate, went on daily walks round York, borrowed books from Barclay's Reading Rooms, made new clothes to improve their wardrobes, joined their friends for boating parties on the River Ouse, trekked over to 'Alderson's Farm' in West Huntington for **26, 27** copious teas, and looked forward to their grandmother's **28, 29** carriage arriving to carry them off to stay at Langton Hall.[1]

They also spent a great deal of time with their friends, the Wakes, who lived in an elegant house in Blake Street. Dr Baldwin Wake, the paterfamilias, was a kindly man who had succeeded their father as Physician of the York Lunatic Asylum. He and his wife Sarah had several children, some of whom were around Rosamond and Ellen's age: James Hare, who became a clergyman, Charles Hare, who went into the army, and Baldwin Arden, who joined the navy.

Both sisters were keen antiquarians and regarded the fire which partially destroyed the Minster in 1829 as a major tragedy. Rosamond sent Charles Hare Wake, who was a homesick cadet in India, a present of 'a box made of the wood of poor York Minster's'. (Although he promptly lost it, he did not think it had been stolen, as he had yet to meet a 'darkie antiquarian'.)[2] Rosamond and Ellen followed the heated debate which raged in York about the best way of **14** restoring the cathedral, for which some £60,000 was raised all over Britain. They also supported the movement to record and preserve other antiquities in York, such as the crumbling Bar Walls.[3]

The Bests' family solicitor and friend, John Brook, was one of the main leaders of this movement, along with other acquaintances such as the Reverend Charles Wellbeloved and the geologist, Professor John Phillips. With their encouragement, Rosamond embarked on a job which nobody had done before: drawing views of York's twenty-four ancient parish churches and compiling short descriptions of each. Her work was so good, and so timely, that it **16** was published commercially as a book in 1831.[4]

17 Rosamond might have gone on to compile more books of this nature had she not married a red-haired solicitor called

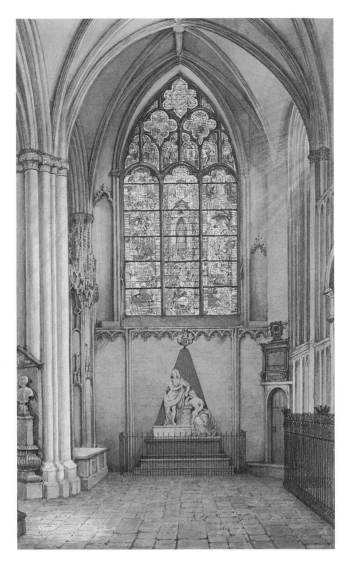

14

14 *'Monuments, York Minster'* c. *1836*

Innumerable nineteenth-century artists were inspired by York's main attraction, its Gothic Minster, and Ellen was no exception. This view of the south aisle of the Lady Chapel (the chapel itself is out of sight to the left of the picture) was among her eight watercolours at the 1836 York art exhibition.

Its appearance has changed considerably since then. The monument partially visible on the extreme left of the picture was moved to the South Choir Aisle around 1844: it is by Michael Rysbrack (1738) and is a memorial to the brothers Henry and Edward Finch who were respectively Dean and Canon of York.

In 1923 the South Aisle was dedicated to All Saints and became the chapel of the Duke of Wellington's Regiment. To make way for the altar, the handsome monument to Thomas and Alice Watson-Wentworth under the window (made by Giovanni Battista Guelfi c. 1731 to a design by William Kent) was moved to the North Aisle Choir. New furnishings were added and the stone flags covered with carpets and pews. A sanctuary lamp was hung before the altar in 1928 and new iron grilles introduced in 1930 and 1949.

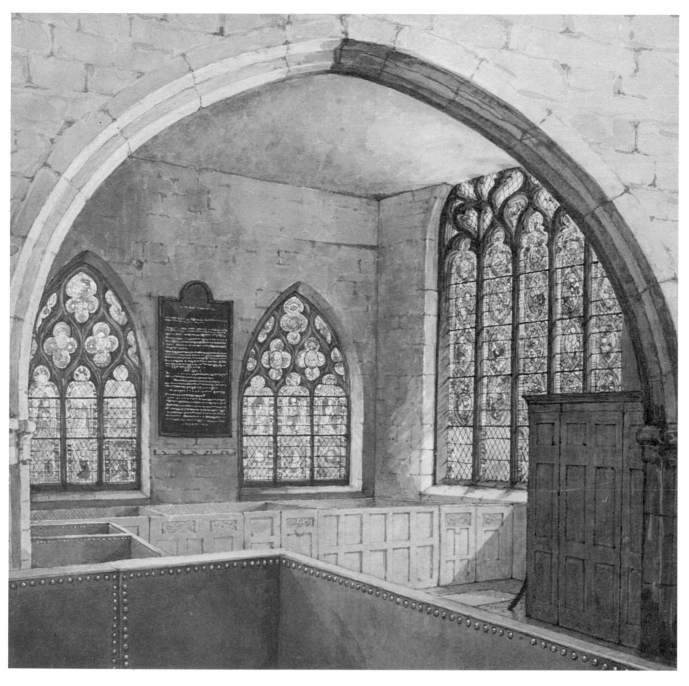

15 *'St Denis Church, [Walmgate] York', 1830s*

The interior of this twelfth-century church has changed for the worse since Ellen painted it. Admittedly the false ceiling behind the arch has been taken down, liberating the early stained glass window to the right and exposing the beams of the roof. But the pulpit and leather-lined pews have gone, along with the painted noticeboard between the smaller windows. The Norman arch has been turned into a Victorian Gothic one and the stonework above it covered over with plaster.

16 *Pen lithograph of the exterior from Rosamond Best's 'Views of the parish churches in York', 1831*

18 Henry Robinson in May 1830 and borne him thirteen children in the space of twenty years. Their offspring thrived and she had little time to spare for antiquarian projects. She did, however, continue to be fascinated by heraldry and genealogy. She also embarked on writing *A Family Chronicle of Twenty Years in the Life of Mr and Mrs Henry Robinson 1831–1851*, a faithful record of their daily existence and of important happenings in the lives of relations and friends.

Ellen and her mother continued to live together in a succession of lodgings: in November 1831 they moved from Pulleyn's Lodgings in Blake Street to Brookbank's Lodgings at no. 48 Coney Street and in October 1835 they moved again to Ellison's Lodgings on Lord Mayor's Walk. Rosamond, who started off her married life at no. 12 St Saviourgate before moving to a larger house at no. 44 Clifton in October 1832, came to visit them almost every day. By 1833 she often had three of her 'little darlings' in tow: Hugh, Ann and Charles.

Mrs Best and Ellen became extremely fond of the Robinson children and often gave them presents, which Rosamond duly recorded in the *Family Chronicle*. Hugh, being the first born, was particularly favoured. 'I completed the weaning of my little boy, who was just as well pleased to take biscuit powder boiled in cow's milk out of a silver horn with parchment tied over the end. This my Mother gave me for his use' ran a typical entry in August 1831.[5] A few months later she reported that 'Ellen gave my Baby his first pair of shoes, which were of copper coloured leather, and he was so pleased with them that he could not keep his feet out of his mouth'.[6]

Whenever Mrs Best and Ellen went away on holiday, they came back laden with more presents for the Robinson children. In November 1832, when they returned from a tour of North Wales, Rosamond noted that 'My mother brought Hugh a brown beaver hat, 3 braided jean frocks and one pelisse of the same material, a china mug with his name gilt on it, some very nice toys, and a little Welsh terrier, named Corra. She gave Annie a dove or fawn-coloured beaver bonnet & feathers, a green gingham frock, a white frock waist, & a pr of merino shoes'. Ellen, who was just as generous but had less money at her disposal, 'brought a lilac gingham frock for Hugh, and a packet of East India Soujee* for Annie'.[7]

When Rosamond wanted a rest from the children, she often left them with her mother and sister. They seem to have been very happy to baby-sit, entertaining the children in their lodgings, taking them out for walks and going further afield in the gig. They also took charge of the

* Soujee is a kind of flour obtained by grinding Indian wheat, which was used for making puddings.

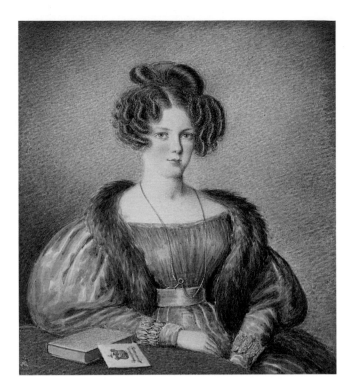

17

18

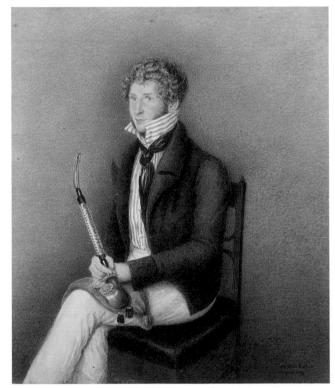

⟶ p. 32

17 *Portrait of Rosamond Best, February 1830*

Ellen painted this portrait of her sister Rosamond (1808–1881) just before her marriage to Henry Robinson, as a present for their mother. Rosamond is fashionably dressed in a silk dress with long sleeves (note the bracelets which go over them), a fur tippet and a top knot of false hair.

The portrait alludes to Rosamond's interest in heraldry and genealogy. She devoted many hours to compiling heraldic manuscripts and painting meticulous watercolours of coats of arms. The book represented here was probably an ambitious project she had just completed: *A Roll of Arms of Peers and Knights in the Reign of Edward the Second from a contemporary manuscript by Nicholas Harris Nicolas, Esq. blazoned by Rosamond Best, 1829*. The coat of arms leaning against it is a typical example of her heraldic painting.

18 *Portrait of Henry Robinson, August 1829*

This shows Henry Robinson (1800–1858) shortly before his marriage to Rosamond in May 1830. He established himself as a solicitor in York in 1826 and won Rosamond's heart during boating parties on the River Ouse. Henry was a fervent antiquarian and, during the fire which damaged York Minster in 1829, he and his friends carried the brass eagle out of the choir, saving it from destruction.

Although Ellen painted the portrait for herself, she ended up selling it to Rosamond who added her own label to the back: 'Henry Robinson Esq. (7th son of Rear-Admiral Hugh Robinson) In the costume of the York Boat Club, 1827 and one of the crew of Hero.' The exotic pipe Henry is holding was probably a gift from their friend Charles Hare Wake, then an army cadet in India. In November 1828 he wrote to Rosamond: 'I hope all the boating parties went on well during the summer and that all the Heroes are flourishing.'

19 *'A farm kitchen at Clifton', York, May 1834*

One can see at a glance that this kitchen-parlour was used for several functions and that domestic arrangements were rough and ready. Things were dumped wherever convenient and jobs done with whatever equipment happened to be at hand, however incongruous. (The elderly woman is washing linen in a dough bin balanced on a Chippendale chair!)

This farm kitchen shows more signs of prosperity than its cottage counterpart: a black painted dresser, mirror, strip of curtain, rug, two tea tables, and lots of cheap blue transfer pottery.

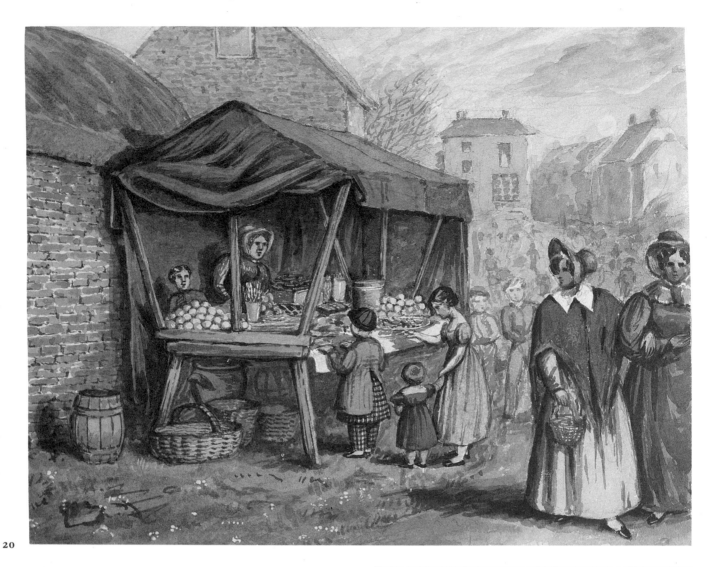

20

20 & 21 *Clifton Feast, York, May Day, 1833*

Clifton Feast was a fair held each year on the first or second of
May, just outside the Robinsons' house at no. 44 Clifton.
There were stalls selling oranges and toys and many small
shows of freaks and performing animals. Rosamond and her
son Hugh can be seen in plate 21.

Rosamond always held a 'juvenile party' to celebrate Clifton
Feast, which was one of the most exciting local events of the
year. In 1833 she 'entertained a juvenile party of
fifteen to tea and supper'. Hugh enjoyed himself greatly 'and
whenever the servant Jane answered the bell during tea, he
called out "more cake, more cake"'. The guests consumed
large quantities of cheesecake, which was the standard York-
shire food served at festivities, and played Blind Man's Buff.

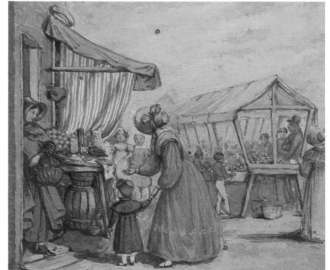

21

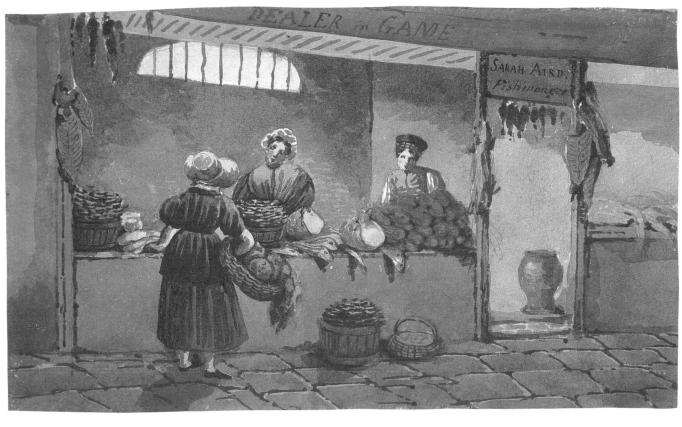

22 *'Fish stall in St John's Market, Liverpool', 1832*

St John's Market was designed by John Foster to accommodate five long spacious avenues of food shops, stalls and stands. When it opened in 1822, it was the first market in England to be lit by gas. 'On entering the interior,' commented a contemporary, 'the spectator is amazed at the immense size of the structure, its loftiness, lightness, and airiness. It is one large, well formed, and lightly painted hall; compared with which, the celebrated Fleet Market is a miserable shed, and Westminster Hall a moderate-sized room.'

The market was demolished in 1964 to make way for a shopping precinct.

23 *'Hat stall in the gallery of Carmarthen Market', 1832*

The shape of these country women's hats dates back to the eighteenth century. Straw hats were worn in summer, the undersides of the brims being lined with brightly coloured material. The black beaver hats, which were far more expensive, were for winter wear.

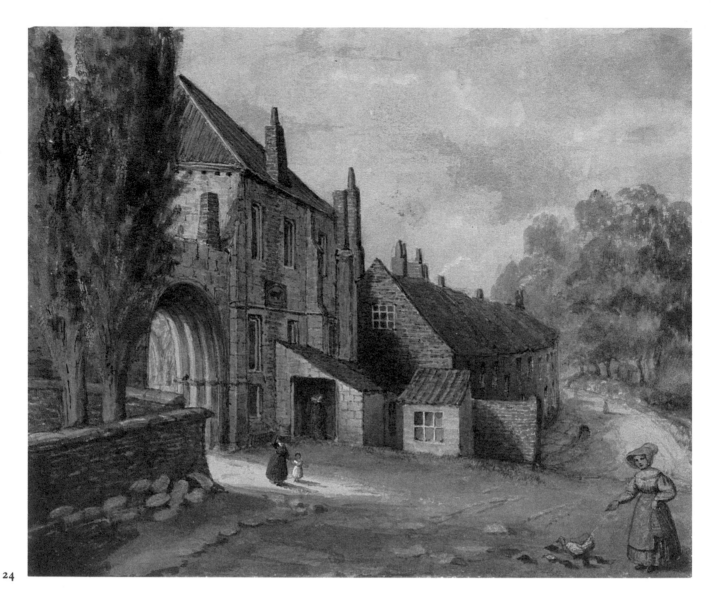

24

24 *View in Marygate, York, 1830*

This is an example of a watercolour Ellen worked up from two pencil drawings in her sketchbook.

It shows how rural and unsanitary York was at this time. An open sewer runs down the middle of the earth road (it would have drained into the River Ouse, which is shielded by the trees in the background) and a woman can be seen feeding her chickens. Another woman is carrying a bucket of water on her head. One can understand why Asiatic Cholera made its first appearance in the city in June 1832.

The arch leading into the Museum Gardens still exists, and so does the late fifteenth-century Abbey Gatehouse to its right (though it has lost its red pitched roof). But the ramshackle lean-to structures, terraced cottages and trees have all disappeared.

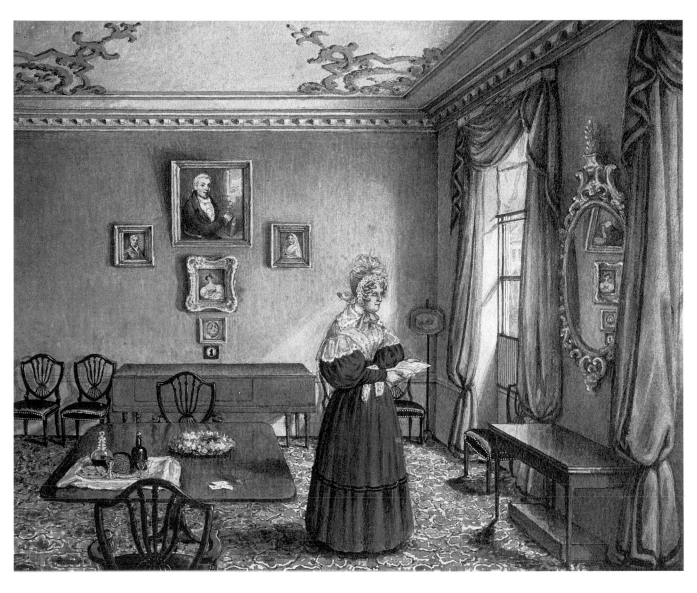

25 *'Mrs Duffin's dining room York', early 1830s*

Ellen often went with her sister, mother and grandmother to see their old friend Sarah-Jane Duffin at 58 Micklegate. In this watercolour she looks as if she is expecting one of their calls: there are some visiting cards on the table and a tray is laid with refreshments. Presumably she will entertain them by reading out the letter in her hand.

Mrs Duffin's husband was an influential character in York. He had been appointed Director of the York Dispensary in 1818 and was a member of the Yorkshire Philosophical Society. After her marriage in 1840, Ellen painted a posthumous portrait of him which she inscribed as follows:

'William Duffin Esq. Formerly surgeon of eminence at Madras. Died at York 1838, aged 93. In remembrance of one of my earliest and truest friends, a faithful servant of God whom I hope to meet in heaven. Mary Ellen Sarg.'

The décor of the dining room is somewhat old-fashioned for the 1830s, although the square piano and gilt frame above it are up to date. The slatted green silk shade at the bottom of the window, to prevent people looking in from the street, is an unusual detail: such minor, ephemeral furnishings do not usually survive.

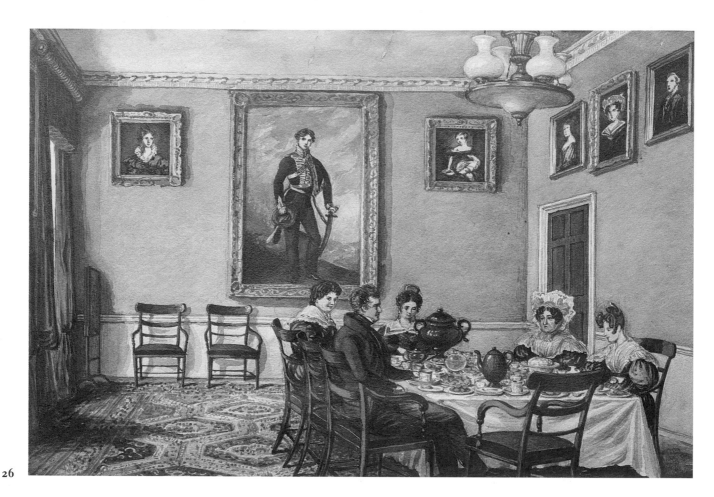

26

26 *'Dining room at Langton, family at breakfast'*, c. *1832–1834*

The woman wearing the cap is Ellen's grandmother, Ann
Norcliffe, owner of Langton Hall, and the man opposite is her
son and heir, Norcliffe Norcliffe. The two women at the end
of the table are Ann Norcliffe's two unmarried daughters,
Charlotte and Isabella, who lived in her house at no. 9
Petergate, York when they were not visiting friends and
relations or travelling on the Continent. The woman in the
green dress is the wife of Norcliffe Norcliffe's first cousin,
Charles Dalton.

It is interesting to see the tea urn and coffee pot among the
copious breakfast spread, the height at which the family
portraits were hung, the oil lamp hanging from the ceiling and
the arrangement of chairs against the walls. The large picture
on the far wall, depicting Norcliffe Norcliffe in the uniform of
the 18th Hussars, now hangs in the National Army Museum in
London.

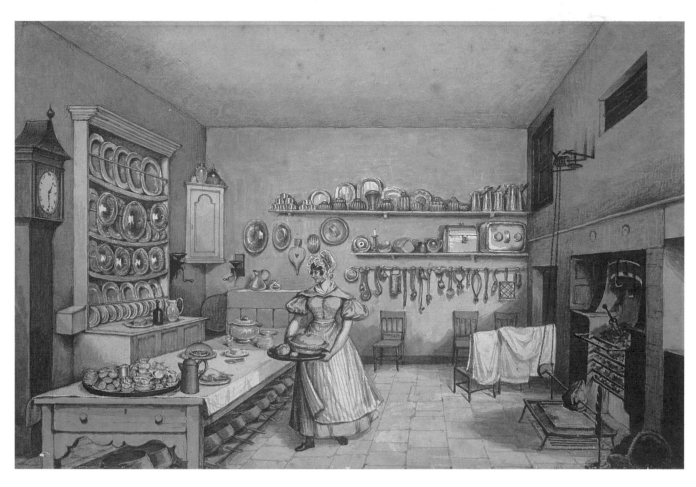

27 *'Kitchen at Langton', 1830s*

It is half past one. A smoke jack in the chimney is turning the
spit in front of the open range, and the cook in her short-
sleeved work dress is assembling the food to be served at
dinner. In the 1830s this meal was usually served in the early
afternoon.

The pie she is carrying was baked in the oven to the left of
the roasting range. The cloths drying on the chair backs are
not for drying dishes (washing-up took place in the scullery
next door) but to cover rising dough, puddings and pies, etc.
Soup and vegetables were cooked on the boiling range to the
right, part of which can be seen in the corner of the picture.

The kitchen is well equipped with implements and utensils
of copper, brass, pewter and tin. The dresser shelves are
bowed under the weight of pewter dishes, and copper sauce-
pans in graduated sizes are stored on the ledge under the
kitchen table. Note the coffee grinders fixed to the wall on
each side of the corner cupboard and the bain-marie lying on
its side on the far right.

The kitchen table is still in use at Langton Hall, which is
now a boys' preparatory school.

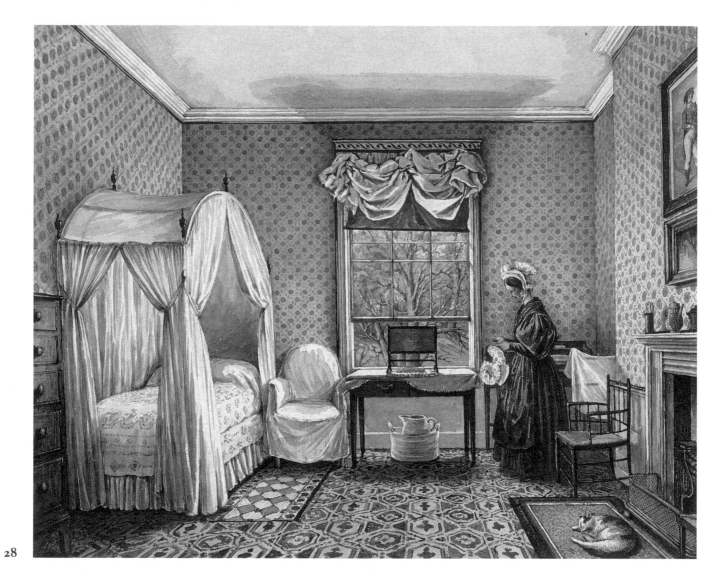

28

28 'Bedroom at Langton Hall', c. 1835

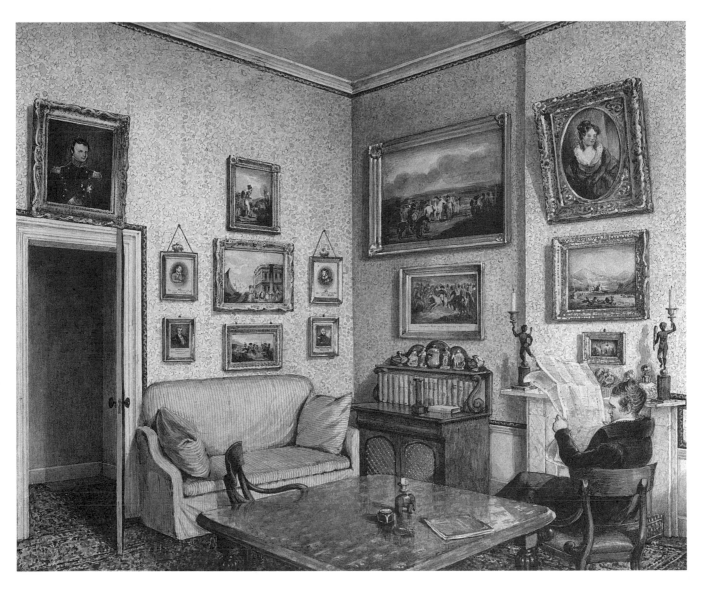

29 *'Colonel Norcliffe's study at Langton', 1837–39*

The man reading the newspaper is Ellen's uncle, Norcliffe Norcliffe (1791–1862). Like his father Thomas Norcliffe, he went into the army. He joined the 4th Regiment of Light Dragoons as a lieutenant in 1808 and fought the French in the Peninsular Wars. He was severely wounded in Wellington's victory at Salamanca. Although Norcliffe Norcliffe retired from full-time service as a major in 1823, he continued as a reserve officer in the 18th Hussars, being promoted to lieutenant-colonel in 1837 and major-general in 1855. His interest in the Napoleonic Wars is revealed by the prints and paintings on the walls.

Norcliffe Norcliffe inherited Langton Hall on the death of his mother Ann Norcliffe in 1835, but he never spent much time there. He preferred living in London and travelling round the Continent and North America. Henry Robinson was given the job of collecting his rents.

He was very fond of Ellen: he commissioned portraits from her, was a witness at her wedding, and visited her on the Continent in the 1840s and '50s.

At Norcliffe Norcliffe's death in 1862, Langton Hall passed to Rosamond who then changed her surname to Norcliffe. (His wife had died in 1828 and his only child, Thomas, in 1849.)

Robinson children when Henry and Rosamond wanted a holiday. In September 1831 Hugh remained in York while his parents went to take the waters in Harrogate. On her return, Rosamond was delighted to find that 'Ellen had commenced a portrait of him to surprise us which proved an admirable likeness'. Ellen's decision to draw her nephew in his christening cap and frock, with the same coral and bells round his waist that Dr Best had worn as a baby, shows that she shared her sister's feelings about the importance of the Church and family tradition.[8]

Ellen, however, was far from being a meek maiden aunt. If she did not like something (or someone) she made no secret of her views. When Rosamond's consumptive brother-in-law, Thomas Robinson, met Ellen in the Museum Gardens on 1 June 1831, he was so astonished by her forthright manner of speaking that he recorded their entire conversation in his diary. The dialogue went like this:

Ellen: 'Who cut your hair?'
Thomas: 'Aye, it was cut close by my own orders.'
Ellen: 'Oh! It is quite frightful.'
Thomas: 'It will soon grow again . . . By this time next week, you would scarcely find out it had been cut.'
Ellen: 'I hope so because it is frightful.'
Thomas: 'How do the boating parties go on?'
Ellen: 'I ought to apply to you for information.'
Thomas: 'I have not been out of the house for two months.'
Ellen: 'Indeed! I never heard of it. I thought that you were about as usual: but still, I was surprised that I never saw you.'[9]

Thomas Robinson kept a diary between 1831 and his death in 1838 which contains many references to 'the artist Ellen Best'. When he called on his friends, he often found that she was engaged on a new portrait, or heard that she had secured a good price for a painting. On one occasion he had to borrow a Union Jack: she wanted to include this prop in her portrait of Baldwin Wake, who was leaving York to start his career in the navy. Because Thomas was plagued with heavy debts he could not afford to commission anything himself, but this did not stop him from trying to persuade Ellen to paint him a picture of 'ducrow', a game they often played together, and to contribute drawings to his sister's album.[10]

It is clear from this diary and Rosamond's *Family Chronicle* that Ellen set herself up as a semi-professional artist in York as soon as she left Miss Shepherd's school. Like most women of her generation, she chose to paint in watercolour. It was a very practical medium. The equipment required – paper, drawing board, palette, ready-made colours and brushes – were inexpensive, light and easily transportable.

Watercolour painting could be practised more or less anywhere, under any conditions. It was quick and did not create much mess. It also had all the appeal of an exciting and fashionable medium. There was a strong sense, in the early nineteenth century, that watercolour offered more challenges and opportunities for innovation than oil. This was reflected in the emergence, from 1805, of independent societies of watercolour painters exhibiting their work and the fashion for framing watercolours in elaborate gilt frames, in overt rivalry with oils.

Although Ellen embarked on her career as a painter on leaving school, she still had much to learn. Like most art lovers of her era, she wanted to know all about the different national schools of painting, the names, dates and subject matter of each country's major painters, as well as those of their principal pupils and followers.[11] A hint of her zeal in absorbing this type of factual information is given in Rosamond's observation that Ellen had taught Hugh 'to know by name every artist in her book of "Arts and Artists", Carlo Dolci, Hogarth etc.' by the time he was two.[12]

She also wanted to improve her technique. But here there were limits to what she could learn from books. Although there were countless drawing and painting manuals on the market, very few of them were any good. Most were directed at beginners and almost all assumed that their readers were only interested in painting picturesque landscapes and flowers.

Practice was the only answer. Two of her surviving sketch books, dating from 1829 to 1830, show that she went out nearly every day to 'draw from nature'. If the weather was good she sketched out of doors; if it was bad, she concentrated on the interior of a cottage or church. In summer, when the days were long, she often left York and ventured into the surrounding countryside, walking to one of the many villages nearby. Sometimes she went to stay with friends and accompanied them on local sketching trips. When Ellen went to Easby to stay with her close friend Rose Stovin, who had married an army officer called Thomas Taylor Worsley in 1825, they visited the nearby abbey and sketched the picturesque ruins.

Ellen also went on expeditions to visit country houses in Yorkshire with important art collections.[13] Most of them were open to the public on appointed days or to visitors who presented the housekeeper with suitable letters of introduction.[14] In this way she was able to improve her knowledge of the history of art, study the work of great painters whose techniques she admired, and copy Old Masters.

The grandest of all the Yorkshire houses was Castle Howard. The fabulous works of art in the state rooms, museum and antique gallery and the beauty of its majestic

30a &

31

30a

32

30b

30a & b *Two pen and wash drawings from Ellen's Yorkshire sketchbook of September 1829 to October 1830*

30a Manor House, York (13 April 1830)
30b Vault and Reservoir, Manor Shore, York (14 April 1830)

The sketchbook was bought from the well known art dealer and supplier of artists' materials, R. Ackermann Junior of 191 Regent Street, London. It contains sixteen pen and wash drawings and seven pencil sketches and is of great interest because it shows what subject matter attracted Ellen at this time: churches, vicarages, houses, cottages, street scenes and waterscapes. Some of the pencil sketches contain notes about colours and can be matched with surviving watercolours.

32 *'Family Scene, York', 26 July 1833*

Rosamond and Henry Robinson are in the garden of their house at no. 44 Clifton with four children. Rosamond described the occasion as follows:

'Tom Norcliffe and little Albinia Dalton dined with us, and amused themselves by climbing and blowing soap-bubbles in the garden. Our darlings watched them eagerly, and Ellen took a sketch of the family party, as we sat out of doors.'

At this date the Robinsons only had two 'darlings': Hugh, born in May 1831, who has his arms in the air, and Ann, born in June 1832, sitting in the high chair. Thomas and Albinia were Rosamond and Ellen's young cousins.

The sketch is a good example of what Ellen could produce quickly, to please a relation or friend.

31

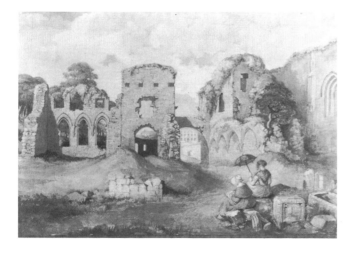

31 *'Part of the ruins of Easby Abbey, Yorkshire', 1830s*

Easby Abbey, a mile east of Richmond, is one of the most 'picturesque' tourist sites in Yorkshire. Artists in the late eighteenth and early nineteenth centuries invariably included it in their tours of Yorkshire.

In this picture Ellen can be seen in her sun bonnet, sketching the twelfth-century monastic ruins and the view of Easby Hall to be glimpsed through the archway. The woman holding the parasol is her great friend, Rose, the wife of Thomas Taylor Worsley. The two women often went to stay with each other.

This is the only known example of Ellen sketching ruins, the classic subject matter of romantic painting.

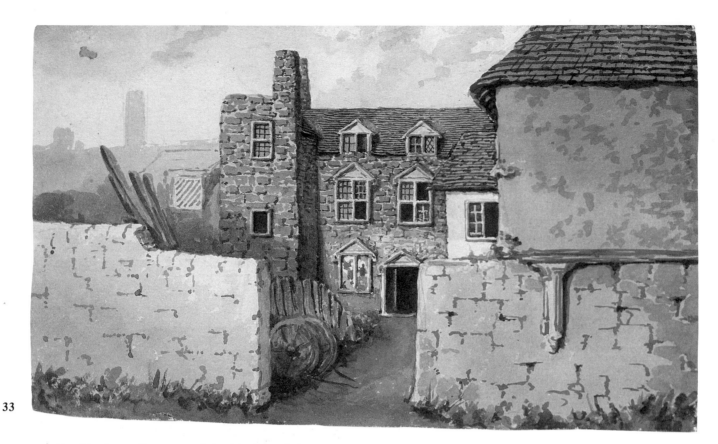

33

33 *'An old palace at Beaumaris inhabited by the Bulkeley family',*
1832

'Hen Blas', the Welsh name of this house, means 'old palace'
in English. It was built by the Bulkeley family in the fifteenth
century, but by the mid nineteenth century a dozen different
families, some of them paupers, were living there. The build-
ing became so delapidated that it was pulled down in 1869.

park attracted large numbers of visitors each year. (Accommodation and refreshments were available at Castle Howard Inn, which was conveniently situated at the south entrance of the park.)[15] Ellen spent several days exploring the castle in July 1832 and was so impressed with the pictures in the green damask room that she painted a record of them. On another occasion she went to see Studley Park near Ripon and painted the banqueting room at Fountains Hall next door.

Ellen had many other opportunities to study works of art in lesser houses where her friends lived, such as Howsham Hall, the seat of Colonel George Cholmley. There was also plenty to see in her grandmother's house, Langton Hall, where the hallway was dominated by a statue of Venus by Canova which Norcliffe Norcliffe had brought back from Italy.[16]

Mrs Best enjoyed going on expeditions and was delighted to chaperone Ellen further afield when her health permitted. In August 1832 mother and daughter set off on a three-month tour of North Wales, travelling via Liverpool and pausing in Conway (where Ellen sketched an interior of the Elizabethan house Plas Mawr), Beaumaris (where she painted the castle, the market and an old palace), Caernarvon and Carmarthen. North Wales was a well known holiday area in the early nineteenth century: artists and tourists were invariably inspired by the wild scenery and picturesque castles to be seen in the region.

Nearly two years later, on 29 July 1834, Ellen and Mrs Best departed for the Continent. They did not go to Italy, the usual mecca for aspiring artists, or even to France, which had become a popular alternative after Napoleon's exile to Elba. Instead they travelled rapidly through Holland, pausing only in Rotterdam and Nijmegen, and steamed up the Rhine into Germany, staying a few days at every place of interest until they got to Mainz. This scenic and comfortable way of seeing Germany had been favoured by continental travellers since the early 1820s and was beginning to become popular with English tourists.[17]

In September Ellen and her mother left the Rhine and travelled up the River Main to the large, bustling city of Frankfurt, where they settled for the winter. It was 'unquestionably a fine city' according to Seth William Stevenson who visited it in 1825, with 'a great appearance of business and activity in the streets ... being a sort of rendez-vous for the rich merchants of every nation under the sun'. Some of the central parts of the city were 'old enough to interest the antiquary', but most of the principal houses had been built within the last thirty years and exhibited 'a mélange of French and Italian magnificence, German solidity, and English comfort'.[18] Unlike most German cities, it was an independent 'free town' with a

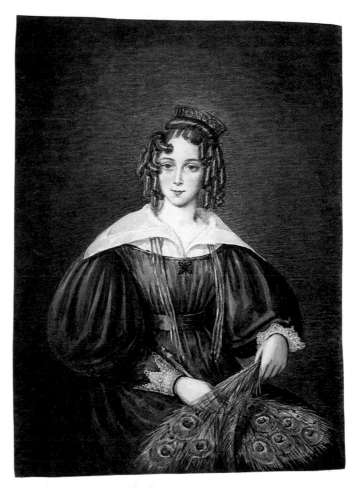

34

34 *'Miss Mary Kirby of Castle Howard Inn, Yorkshire, Castle Howard, July 1832'*

Mary was probably the daughter of Seth and Anne Kirby who ran the Castle Howard Inn from 1812 to 1836. She is fashionably dressed and is holding a fan made out of feathers dropped by the Earl of Carlisle's peacocks.

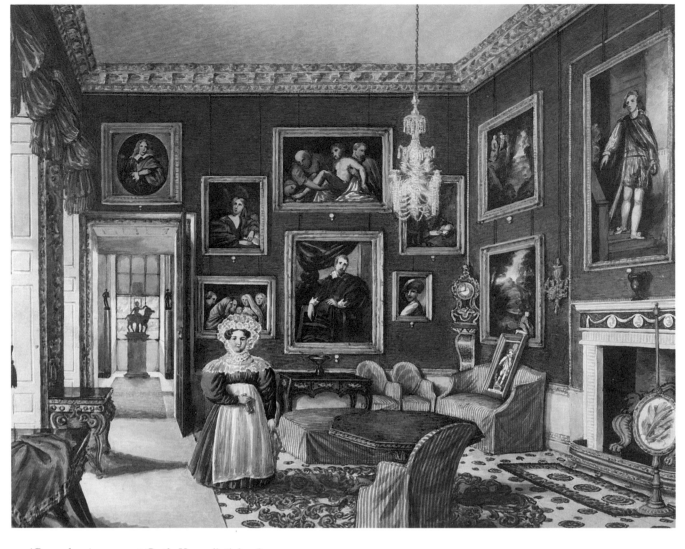

35 'Green drawing room at Castle Howard', July 1832

Although there were no public art galleries in Yorkshire in the 1830s, there were several important private art collections in country houses and the owners usually allowed visitors with suitable credentials to see them. Thus Ellen was able to study the superb paintings and sculptures at Castle Howard, even though she did not know the 6th Earl of Carlisle. The woman standing in the middle of her picture with the chatelaine dangling from her waist was the housekeeper, who showed visitors round.

Ellen and her mother stayed at Castle Howard Inn for several days in July 1832. Rosamond's son, Hugh, joined them for a day and was taken to see the golden pheasants in the park.

This watercolour provides a detailed record of the pictures in the Green drawing room (now known as the Orleans room) which Simon Howard has identified as follows (from right to left, and from top to bottom):

1. (Over fireplace) The 5th Earl of Carlisle, wearing his robes of the Order of the Thistle, by Sir Joshua Reynolds. Still in the house, but in another room.

2. The Temptation, by Paulo Fiammingo (formerly ascribed to Tintoretto). Burnt during the fire of 1940.

3. The Sacrifice of Isaac, by Paulo Fiammingo (formerly ascribed to Tintoretto). Still in this room.

4. (Behind the chandelier) Bassano's Mother, by Bassano. Still in this room.

5. Annibale Caracci, self-portrait. Still in this room.

6. The Entombment of Christ, by Ludovico Caracci. Sold at Christie's, 18 February 1944, lot 19.

7. Frans Snyders, by Sir Anthony Van Dyck. Sold to Colnaghi in 1909.

8. St John the Evangelist, by Domenichino, sold at Christie's, 18 February 1944, lot 28.

9. The Circumcision, by Giovanni Bellini, presented to the National Gallery in 1895.

10. (Above the door) Lord Philip Herbert, later the 5th Earl of Pembroke, by Sir Anthony Van Dyck. Sold to Colnaghi in 1909.

In the window of the next room is a stone statue of a youthful Bacchus on a goat, with two bronzes on either side. All the tables shown in Ellen's watercolour are still in the house.

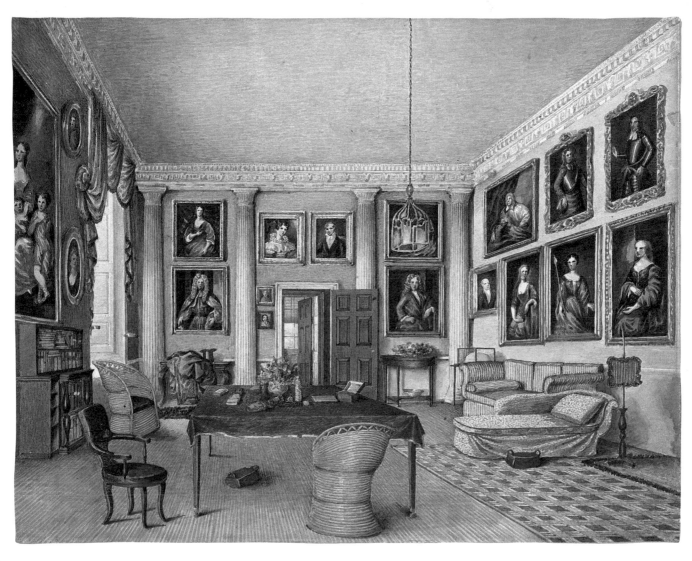

36

36 *'Saloon at Howsham', 1830s*

Howsham Hall is a Jacobean country house near Langton Hall. It is now a boys' preparatory school, but in the 1830s it belonged to Ellen's friends, Colonel George Cholmley (1781–1857) and his wife Hannah, who often had her to stay.

After entering the front door, visitors turn right into this imposing reception room. In the 1830s, the Cholmleys used the saloon to display their family portraits and to receive visitors (note the cloak and top hat to the left of the door). When interviewing estate workers and servants, Colonel Cholmley probably sat behind the table in the comfortable basketwork chair. Such chairs used to be quite common, but very few now survive. It is likely that the plasterwork and paintwork in the room date from the 1770s, when the house was redecorated.

Ellen also painted the drawing room at Howsham, on the floor above. It had red walls, white paintwork, a finer plaster-work ceiling, curtains which reached the ground, and a more expensive wall-to-wall carpet. This room was used for formal entertaining and displaying the Cholmleys' most important oil paintings.

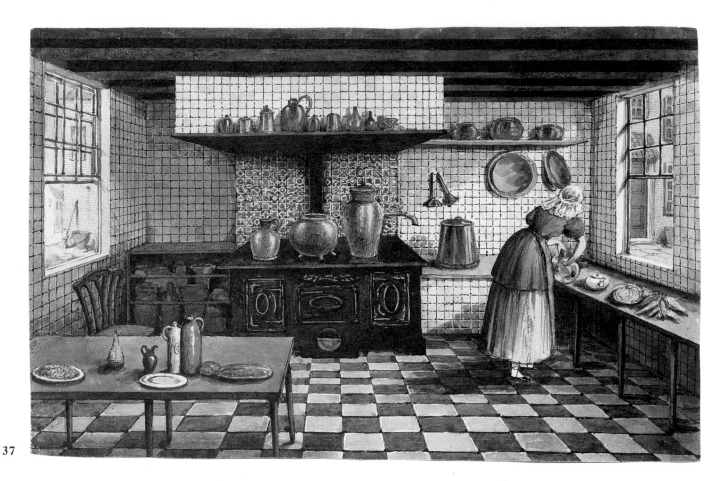

37 *'Kitchen of the Hotel St Lucas, in the Hoogstraat, Rotterdam', August 1834*

This was the first hotel Ellen and her mother stayed at during their fourteen-month tour of the Continent; it was one of the best in Rotterdam.

In depicting its kitchen, Ellen could hardly have chosen a better way of recording her first impressions of the Dutch. For the interior exemplifies the order, cleanliness and neatness which so impressed English travellers in the Netherlands. It is clear from a glance that the kitchen is absolutely spotless. There is no soot from an open kitchen fire: the very up to date peat-burning range funnels it up a pipe into the chimney. The walls and floors are lined with hygienic tiles. The windows are clean, the metal utensils gleam, and all the work surfaces appear freshly scrubbed. Unlike English kitchens, there is no clutter and every object appears to lie in its appointed place. The maid has her hair tucked away and is diligently scouring a pot. And just in case one has not got the point, a bucket and broom can be seen out of the window on the left!

There are certain items which would not have been found in an English kitchen, such as the *vuurpot* or brazier sitting in the middle of the range and the large rainwater container on the right. There is also a *doofpot* below the funnels hanging to the right of the range; pieces of peat were kept aglow in this, for use in fire lighting. The earthenware gin bottles on the table held drinking water and other beverages like beer.

38 *'Kitchen of the Weeshuis or Orphan House, in Goudsche-Wagen-Straat, Rotterdam', August 1834*

This orphanage for burghers' children had been run by the Dutch Reformed Church since the sixteenth century. It still exists, although it is in a new building.

Ellen was very interested in charitable institutions and often went to visit them. She was clearly impressed by the large, clean and airy kitchen of this orphanage, with its tiled walls and raised gallery for the superintendent. The machine in front of the fireplace was probably used for mixing boiled potatoes with other common vegetables such as turnips and swedes. Alternatively, it could be a primitive machine for washing clothes.

Ellen also painted the portrait of an orphan called Alida van der Meulen and, in 1838, she returned to paint the 'hospital room'.

When William Chambers toured the Continent in 1838, he too was impressed by the charitable institutions in Rotterdam and Amsterdam. He concluded that 'in no country are the poor so well taken care of as in Holland'.

39 *'Hospital room in the orphan house at Rotterdam, July 1838'*

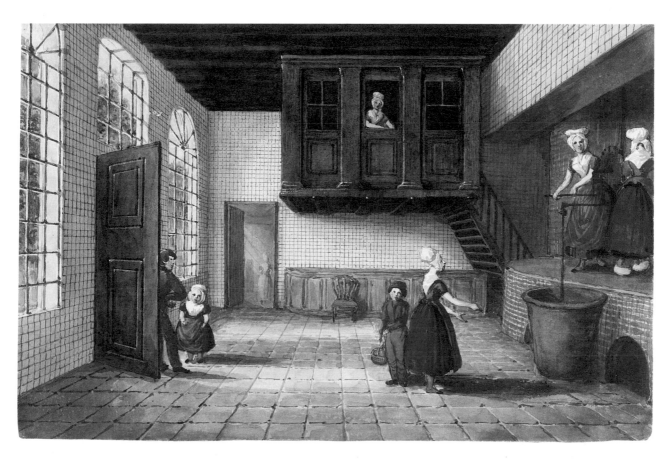

38

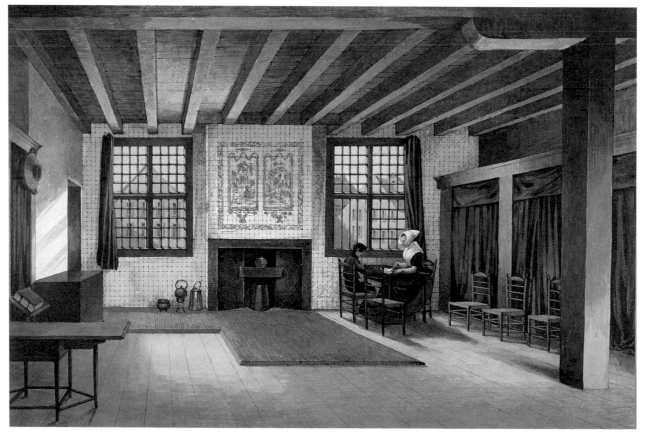

39

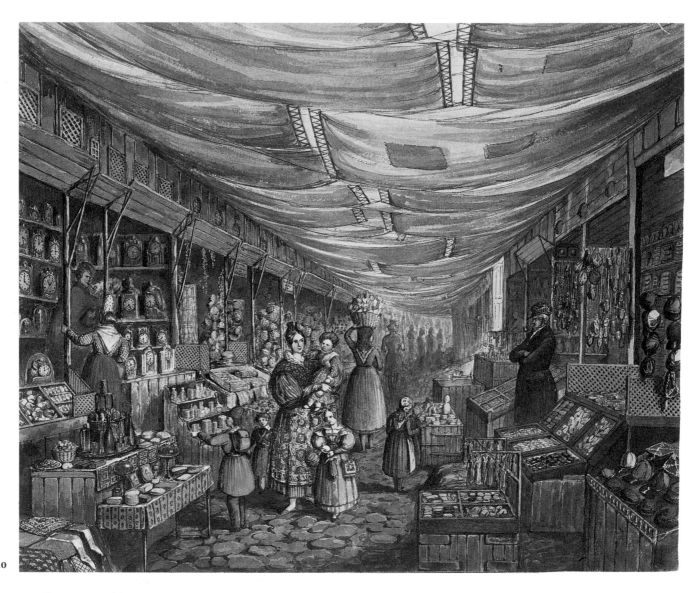

40

40 *'Scene in Frankfurt Fair, April 1835. Part of the line of stalls extending along the River Mayn'*

Ellen and her mother did a lot of shopping at Frankfurt's spring and Christmas fairs. In January 1835 Rosamond was pleased to receive 'a box from my mother, in which, besides presents to myself and others, she sent Ann a little mock turquoise ring, bought at Frankfurt Fair, and Hugh a French tumbler and a pink bishop and trousers . . . Ellen sent Ann a lackered bread-tray, and Hugh a box of ingenious little models of kitchen furniture, stewpans, frying pans, cleavers, paste wheel, lemon slicer, etc . . .'

Ellen had her nephews and niece in mind when painting this picture, since she included two of the stalls where she and her mother had bought presents for them. The stall in the left hand corner supplied five different patterns of Swiss prints to make them frocks, and the stall on the right was the source of some splendid caps. Charles received 'a jockey cap made of lilac jean, a garden cap of toile cirée, and a blue cloth Polish Lancers' cap trimmed with silver lace' and Hugh 'a green cloth

Lancers' cap with silver lace, a light horse hair foraging cap [and] a garden cap of toile cirée'.

Ellen was not alone in seeing the fair as a child's paradise. The Frankfurt artist Carl Theodor Reiffenstein regarded them as the high spots of his childhood in the 1820s and '30s. He was enchanted by the bareback riders, tight-rope walkers and barrel organ players who put on special performances for children.

democratic form of self-government. The majority of the city's 50,000 inhabitants were Lutheran, but there were also sizeable communities of Calvinists, Roman Catholics and Jews.[19]

41

Although Frankfurt was famous for the excellence of its hotels, Ellen and her mother decided to take lodgings.[20] They spotted an advertisement in the French-language *Journal de Francfort* of 5 October which, to their surprise, was in English. It read as follows: 'A convenient second floor, consisting of several furnished rooms, kitchen and servants room, is to be let. Rossmarkt, F 107.'[21] The Rossmarkt was a large open place with a magnificent bronze fountain in the middle, lined with good houses, and well located in the picturesque old part of town.[22] The furnished rooms at no. 107, which Ellen and her mother duly rented, were next door to no. 106, the home of Johann Conrad Eckhard, a well-to-do wine merchant with three daughters of about Ellen's age: Susanna, Margarethe Elisabeth, and Dorothea Johanna.[23] Ellen soon made friends with them, particularly Margarethe Elisabeth, or 'Lilly' as she was known, whose English was exceptionally good.[24] Little did Ellen realise that Lilly Eckhard would be bridesmaid at her wedding five years later!

44

After a short while, Mrs Best and Ellen moved to new lodgings at no. 9 Neue Mainzer Strasse.[25] This handsome mansion, in the elegant new part of Frankfurt, housed the Bavarian Embassy and by December 1834 Ellen was on portrait-painting terms with the ambassador, Maximilian, Count of Marogna, his wife Louise, and their two children.[26] Although Ellen and her mother had initially only planned to spend the winter in Frankfurt, they enjoyed the city so much that they decided to stay on. They only left Frankfurt in August 1835 because Ann Norcliffe was on her death bed and they had been summoned back to England.

Ellen was an enthusiastic sightseer throughout her fourteen months on the Continent and took every opportunity to visit art galleries and museums. During her stop in Cologne she painted an interior of the public picture gallery there.

48

In Frankfurt she paid frequent visits to the newly opened Städel Institute and acquired an intimate knowledge of its magnificent collection of Old Master paintings. She made copies of her favourites, such as Vincenzo Catena's picture of St Jerome reading in his study (then attributed to Domenico Santa Croce) and a portrait of a baby girl sitting in her feeding chair which Cornelius de Vos had painted in 1627. She also painted interiors of the four rooms which housed 'the old German school', 'the Italian school', 'the old Flemish masters' and 'the drawings in watercolours', showing their contents in great detail.

46
47

Like all visitors to Frankfurt in the 1830s, she saw Moritz

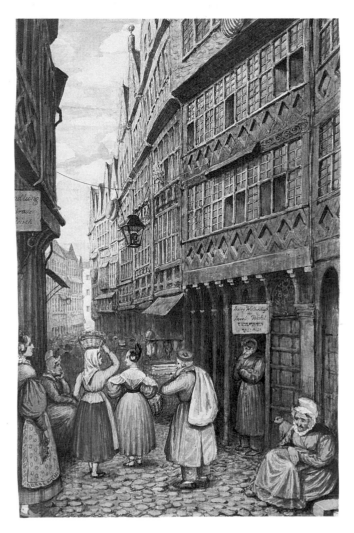

41

41 *'View in the Judengasse (Jew's Street), Frankfurt', July 1835*

Frankfurt's Jewish ghetto was established in 1462 following several imperial decrees and a papal edict of Pius II. It was situated in the heart of the old town, north-east of the cathedral, and consisted of a single street, Judengasse. This was enclosed by high walls along the sides (no Jew was allowed to look out over the Christian part of the city) and the town council controlled the gates at each end.

The ghetto's area remained fixed, whatever the size of its population, and the Jews were forbidden to build upwards (no house could be more than four storeys and one gable high), so living conditions were extremely over-crowded and insanitary. The ghetto burned down twice in the eighteenth century.

Although the ghetto was formally abolished in 1811, allowing Jews to live elsewhere in the city, Judengasse was still the centre of Jewish life when Ellen painted it in 1835. Very few families were sufficiently wealthy or well assimilated in Gentile society to move out. The street was therefore as crowded and busy as ever and retained its poverty-stricken atmosphere.

Ellen could not resist caricaturing some of the Jewish faces. But Jacob Wohl, who can be seen standing with his arms crossed in the entrance of his restaurant, really did exist: his address is listed as 'Judeng. A 56' in the Frankfurt directory for 1837–38.

von Bethman's famous statue gallery which included 'a beautiful statuary group, by Dannecke, of Ariadne sitting on a tyger'.[27] And if she visited the Englischer Hof, she would have seen its 'Picture Room', in which Seth William Stevenson discovered 'several excellent works of the Old Masters, and also some highly creditable productions of the modern German pencil'.[28]

Although Ellen spent a great deal of her time in Frankfurt studying Old Masters, she also developed a taste for contemporary German art. There had been many interesting developments in German painting during the previous three decades which were not generally known in England. This was partly because of the language barrier (very few English people could speak German) but mainly because it was difficult to make sense of them: Düsseldorf, Hamburg, Dresden, Munich and Frankfurt all had their own schools of painting.

Ellen was fortunate in making the acquaintance of several people in Frankfurt who were in an excellent position to educate her about these developments. She and her mother had arrived in the city with letters of introduction which had borne fruit. They soon had a number of contacts who were well connected and willing to give them an *entrée* into Frankfurt society.

One of these was the honorary British consul, Christian Friedrich Koch, who was famous for his hospitality to English people. His brother Peter worked for the Bethmann Bank and his son Robert was vice-consul. When Ellen arrived in Frankfurt, Robert had just married a particularly intelligent and lively woman, Clothilde Koch-Gontard, who spoke good English and did a great deal of entertaining. British visitors were invariably invited to her dinner parties and salons, where they were liable to meet artists like Theodor Reiffenstein and Schmidt von der Launitz and her musical friends, who included Felix Mendelssohn, Clara Schumann and Jenny Lind.[29]

Another key contact was the immensely snobbish English doctor, Sir Alexander Mackenzie Downie, who by 1842 was describing himself as 'Physician in ordinary to His Royal Highness the Duke of Cambridge, to Her Royal Highness the late Landgravine of Hesse Homburg, and to Her Majesty's Legation at Frankfort', although he made most of his money by acting as a consulting physician at the nearby spa of Wiesbaden.[30]

One introduction led to another and Ellen soon made friends with two women painters like herself. The most senior was the watercolourist Luise Friederike Auguste van Panhuys (1763–1844) whom Goethe's mother considered to be the most highly educated woman in Frankfurt. When Ellen met her, Madame de Panhuys presided over her brother's house, Drei Könige in Eschenheimer Gasse,

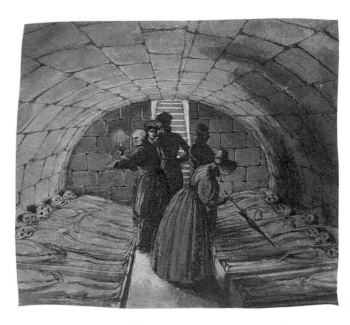

42

42 *'Vault under the Chapel of Kreuzberg near Bonn, containing the bodies of twenty five monks. Visited by us in company with Messrs Lewis & Value, in August 1834'*

This type of macabre tourist attraction was created by unusual atmospheric conditions that effectively 'mummified' dead bodies. When a monk died, he was put into a coffin for the funeral. Afterwards his body was removed (so that the coffin could be re-used) and laid out in the vault in its winding sheet. There, the steady circulation of dry air turned it into a 'mummy'. Ellen was not faint-hearted or squeamish about such sights: she is the woman poking a monk with the tip of her umbrella.

The bodies of the monks, who were buried between 1640 and 1799, remain perfectly preserved in the crypt, just as Ellen painted them, and can be seen by appointment.

43

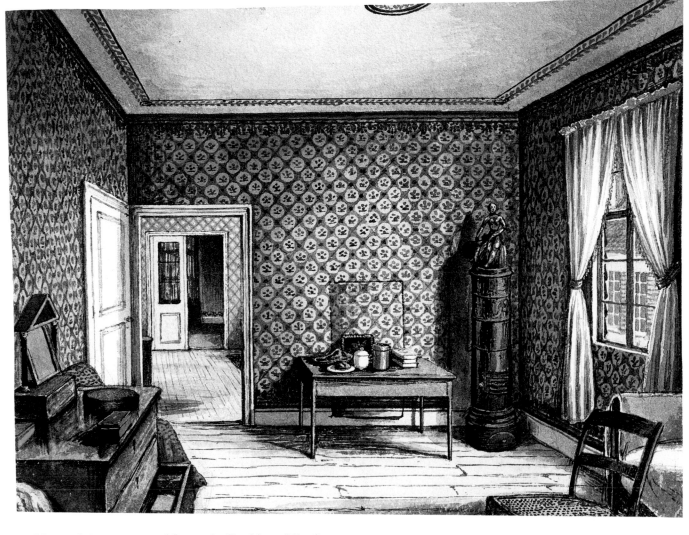

44 *'My own bedroom at no. 106 Rossmarkt, Frankfurt a/M', 1834*

The narrow bed, stove and bare floor boards make this a
typical German bedroom of the time.

45 *'Portrait of Frederike Cramer, a native of Hesse Cassel, for a
short time in our service, at Frankfurt a/M', November 1834*

Frederike Cramer was the Bests' servant while they were
lodging in the Rossmarkt. Ellen painted two portraits of her.

43 *'Attempt at a sunset effect [at the Insel Bridge], near Untermain-
Thor, Frankfurt', 1834 or 1835*

This rickety little bridge was built in 1828 to connect the old
town's raised promenade along the River Main to a small
pleasure island which was planted with trees and lawns.
Although the island was a stone's throw from the old town,
Ellen has emphasised its romantic, rural atmosphere. The
picture is one of her experimental attempts to capture special
lighting effects and shows the influence of German Romantic
painting. It is one of the few landscapes she painted.

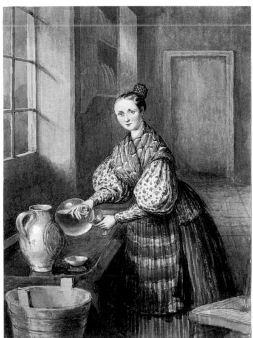

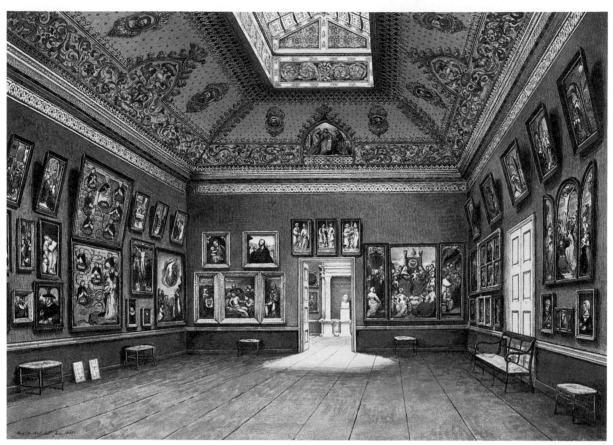

46

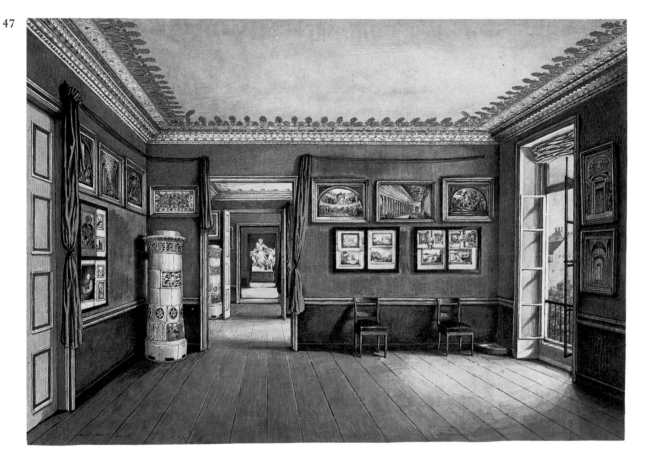

47

44

46 'Interior of the Saloon of the Old German School, Stadels Institute', June 1835

The Städel Institute consisted of a public art gallery and an art school. It was established in 1816 through the bequest of Johann Friedrich Städel, a wealthy Frankfurt merchant and banker, but the gallery was not opened to the public until March 1833. It contained the finest art collection in Frankfurt and soon became one of the city's most important tourist attractions.

The catalogue of 1835 lists 333 works in the museum's collection, divided into seven categories which encapsulate the prevailing hierarchy of artistic values. A large collection of classical sculpture and plaster casts was followed by rooms devoted to the Flemish School, Old German Masters, the Italian School, the German and French School, Cartoons and Frescoes by Recent Masters, and New Acquisitions.

Great care was taken with the decoration of the Städel Institute, each room having a different painted ceiling and colour scheme. The most important galleries also had stained glass sky lights, such as the one depicted here. There is plenty of seating for visitors, and information panels are propped up against the skirting, providing a key to the sixty-five paintings which were hung on the walls. A bust of Städel, whose pictures formed the nucleus of the museum's collection, can be glimpsed in the far room which housed the Italian School of paintings.

47 'Interior of one of the decorated apartments in Stadels Institute, Frankfurt, containing chiefly the drawings in watercolours', June 1835

This watercolour shows off the museum's bold, co-ordinated colour scheme: watercolours and prints were displayed against brown walls, whereas blue was chosen for the oil paintings next door, and red to dramatise the plaster cast of the Laocoön in the background. Note that the watercolours are protected from sunlight by window blinds and curtains.

The Städel Institute's location at no. 53 Neue Mainzer Strasse was very convenient when the Bests were lodging at no. 9. Ellen also painted interiors of the two rooms which housed the Italian and Flemish Old Masters.

which contained an art collection and was a well known intellectual centre. She had studied landscape painting in England before her marriage to a Dutchman who was appointed governor-general of the South American colony of Surinam in 1811. Being an adventurous woman, she accompanied him there and painted everything she saw around their home. When her husband was poisoned by the natives in 1816, she was forced to go into hiding in the jungle. Fortunately, she managed to get on board a ship returning to Germany and made her way back to Frankfurt, where she continued to paint into old age.[31] The second artist was Susanna Maria Rebecca Elisabeth von Adlerflycht (1775–1846), who painted flowers and fruit, landscapes, portraits and genre scenes.[32]

Through meeting the Kochs, Madame de Panhuys and Madame d'Adlerflycht, Ellen was able to talk to people who knew about German art and could speak English or French. (Her knowledge of German was still rudimentary.)[33] She also had opportunities to see examples of contemporary German painting, both in private houses and in public places. In May 1835 she was able to compare the various schools of contemporary German painting when the Frankfurt Art Society exhibited 119 paintings by eighty-six different artists in the ballroom of the Goldnes Ross Hotel.[34]

Ellen was especially attracted and influenced by the extraordinary lighting effects developed by certain German Romantic painters such as Caspar David Friedrich and Carl Gustav Carus. Their twilight, moon light and dawn scenes appealed to her sense of mystery, as well as to her delight in novelty.[35] She also loved the Biedermeier fashion of painting serene portraits of people in their domestic environment: the underlying ethos coincided with her own deep love of family life.[36]

It is interesting to compare Ellen's art training with that of male Yorkshire artists working at the same time. The most famous of these was the history painter William Etty.[37] Born in 1787, the son of a York miller and gingerbread baker, he went to London in 1805, as soon as he had finished an apprenticeship in the printing trade. He spent two years studying on his own, drawing from nature and the antique, copying prints and paintings, and visiting museums, before he was proficient enough to be admitted into the Royal Academy's Schools of Design at Somerset House.

These schools had opened in 1769 to train painters and sculptors. Once admitted, artists were expected to spend up to ten years drawing, painting and modelling in the 'Antique School' and the 'School of Drawing from the Life'. They also attended the 'Painting School' to learn how to copy Old Masters and paint portraits. This regime was punctuated

with regular lectures on anatomy, architecture, painting, perspective and geometry. Although the standard of instruction was often poor, aspiring artists had the benefit of advice from professional painters and contact with other students.[38]

In his reminiscences, Etty says that he pursued his studies very energetically: 'I lit the lamp at both ends of the day. I studied the skeleton, the origin and insertion of muscles. I sketched from Albinus. I drew in the morning. I painted in the evening; and after the Royal Academy, went and drew from the prints of the Antique statues of the Capitolini, the Clementina, Florentine and other Galleries; finishing the extremities in black lead pencil with great care. This I did at the London Institution in Moorfields. I returned home; kept in my fire all night to the great dismay of my landlord, that I might get up early next morning before daylight, to draw.'[39] On top of this, Etty also had a year's apprenticeship with the most fashionable portrait painter of the day, Sir Thomas Lawrence. He rounded off his education by visiting museums and art galleries in France and Italy.

Branwell Brontë tried to follow this well worn path to success. He left the vicarage at Haworth for London in 1835, aged eighteen, armed with letters of introduction to prominent Yorkshire artists. His aim was, of course, to gain admission to the Academy Schools. But his nerve failed and he returned home. For three years he continued to take lessons from his old teacher, William Robinson, in his studio at Leeds, before setting himself up as a portrait painter in Bradford.[40]

George Knowles, an aspiring artist-cum-architect from Shipley, did not study in London, but headed straight for Paris. In his diary of 1837, he describes how he celebrated his twenty-third birthday by going, as usual, to the Louvre. He was copying paintings there, spending about eight days on each one. Encouraged by the sale of his copy of a portrait by Raphael for 5 guineas, he copied a landscape by Salvator Rosa and a beggar boy by Murillo. When he was not at work in the Louvre, he visited the sights of Paris, looked at other picture collections, read art books in the Bibliothèque Royale, sketched the live models at his drawing academy and the servants in his lodgings, and went on sketching rambles with his friends. He pursued a similar regime when he visited Belgium in 1838 and Switzerland and Italy in 1840. Wherever he went, he entered into an easy camaraderie with other male artists, most of them English, who accompanied him on sight-seeing expeditions and criticised his work.[41]

As a woman, Ellen could not have pursued these courses of instruction, even if she had wished to do so. There was no point in going to London because only men were admitted to the Academy Schools. Henry Sass' art school in

48 '*An interior in the House of Wallrof, the public picture gallery of Cologne*', August 1834

Cologne was the first German city visited by Ellen. Like many early nineteenth-century painters, she spent as much time as she could in art galleries and often copied the paintings she admired.

This interior shows how pictures were detached from the walls and put on special stands to accommodate students wishing to copy them.

49 '*Exhibition of the works of Modern Artists in the Ball-room of the Goldnes Ross Hotel, Frankfurt*', May 1835

Ellen's interest in contemporary German painting is clear from this watercolour. She is standing in the middle of the room studying the catalogue.

The exhibition was organised by the Frankfurt Art Society and opened on 16 May. It contained 119 paintings by eighty-six artists, most of them German. The Munich and Düsseldorf schools were particularly well represented. Landscapes, religious themes and portraits of people and animals predominated, but there were also a few historical subjects, genre scenes and still-life paintings. A review in Frankfurt's cultural newspaper, *Didaskalia*, tactfully singled out 'The Presentation in the Temple' by Philip Veit, director of the Städel Institute, for special praise. It extolled the importance of art and exhorted the citizens of Frankfurt to continue funding exhibitions of this kind.

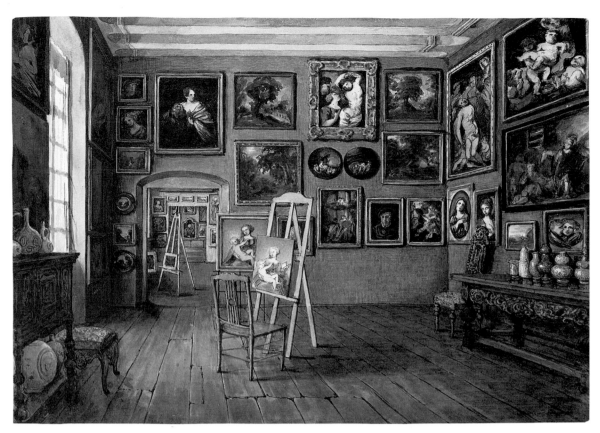

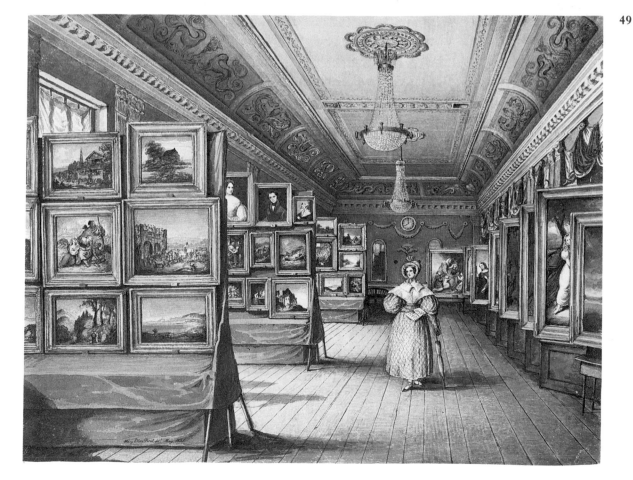

Bloomsbury, the first to take women students, was only established in 1835.[42] Furthermore, social convention made it impossible for her to train in an artist's studio like William Etty and Branwell Brontë: unmarried young women of her class could not be left in the company of men without a chaperone. For the same reason, she could never have enjoyed the variety and freedom of association which characterised George Knowles' life on the Continent.

The limitations of Ellen's training and its comparative loneliness help to explain why she stuck to watercolours and never progressed to oils. They also explain why she stood outside the mainstream of early nineteenth-century painting and specialised in two genres of painting which were particularly well suited to her circumstances: portraits and still-lives.

Before the age of photography there was an enormous market for portraits. Men and women of all social classes had a strong desire to record their own personal appearance, as well as that of their friends and relations. Their appetite for portraits was particularly strong when they left home, got married or had children. If it faltered during their thirties, it invariably revived in middle age: then as now, the average person would want a 'likeness' of a child who was going into the world, of a grandchild, or of a relative who was seriously ill and in danger of dying.

In the early nineteenth century the market for portraits fell into two main sectors: substantial oil paintings, which were expensive, and small watercolours, which were easily affordable. While the former were hung on the wall to provide a lasting record of the sitter's appearance, the latter were more ephemeral, even impressionistic works. They might be framed and hung round the fireplace, but they could equally well be pasted into albums or scrap books and put away in a drawer.

Despite her lack of formal training in anatomy, Ellen aimed to satisfy this second market for small watercolour portraits. Her 'List of Portraits' painted between 1828 and 1849 shows that her market was dominated by the female sex. Women were more family minded than men and generally had less money to spend: they could not afford oils. Sixty-six per cent of the portraits Ellen painted between 1828 and her marriage in 1840 were commissioned by women. Nearly 60 per cent of her sitters were female.

Ellen's 'List of Portraits' also shows that she painted about forty portraits a year before 1840. She gave away or bartered half her portraits, sold a third of them for cash, and kept the rest herself. If one excludes those portraits which Ellen painted for herself, it turns out that she gave away 60 per cent of her work and sold 40 per cent.

Most of the people who commissioned portraits from Ellen before her marriage lived in or around York. Many of

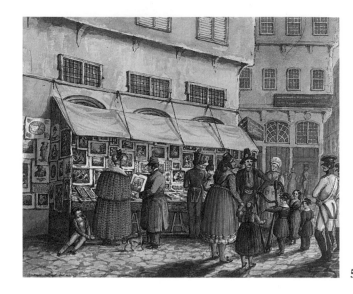

50

50 'A print-stall in Frankfurt Fair at the corner of the Sandgasse', April 1835

Before the age of photographic reproductions, people had to buy prints if they wanted a record of paintings. Ellen had quite a large collection and is seen here inspecting a prospective purchase. Azor, the dog she acquired in Frankfurt is at her side.

According to Carl Theodor Reiffenstein, who painted the scene in 1852, the stall disappeared in 1863 when the ground floor of the building behind it was converted into a shop.

51 'The great room in the Forsthaus, a place of public entertainment in Frankfurt Forest, with our own party drinking coffee', August 1835

The Oberforsthaus was a fashionable inn in Goldstein Forest, within easy reach of Frankfurt. Some guests stayed for the shooting, but the majority went there to enjoy the fresh air, to drink coffee and to be seen.

The chandeliers are under wraps to protect them against flies.

52 'Interior of the room we occupied in the New Bath Hotel on the Boompjes, Rotterdam, looking on the River Maese, September 1835'

Mrs Best is sitting by a table strewn with Ellen's paraphernalia and her daughter, or possibly a maid, is reflected in the mirror, standing beside the bed. The décor of the hotel room is lavish compared to its equivalent in Germany.

Despite the bright colours, the mood of the picture is autumnal and foreboding. This is hardly surprising since the Bests' continental tour was ending sadly: they had been summoned home because Ann Norcliffe was dying.

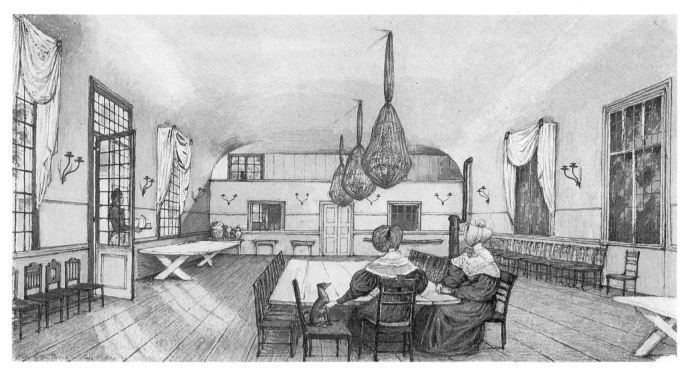

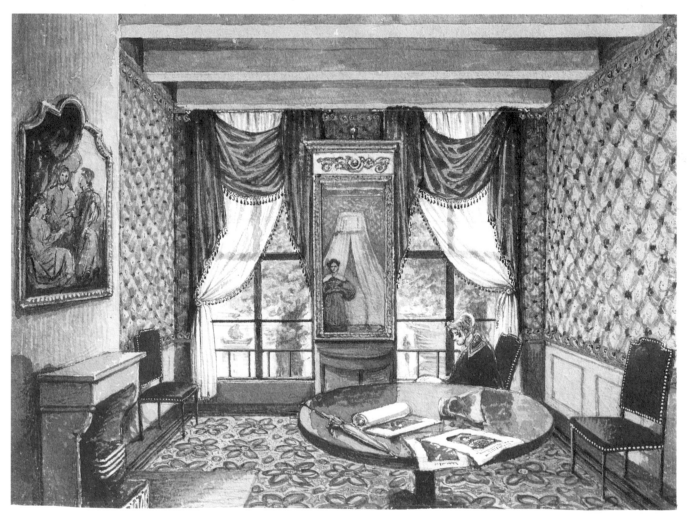

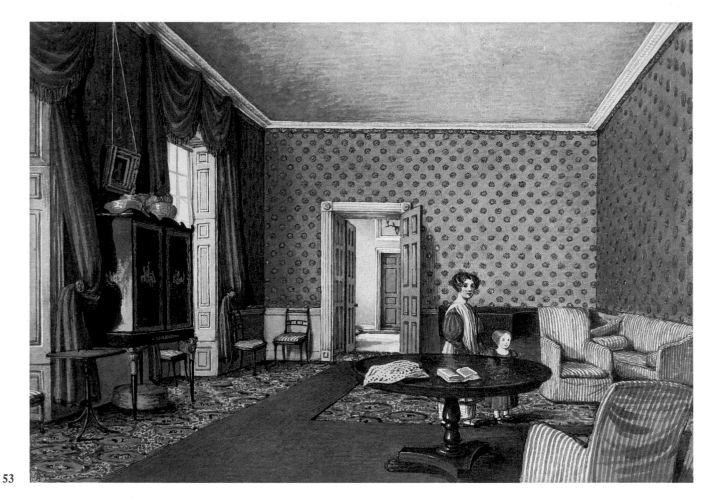

53

53 *'Drawing room at Naburn, the seat of George Palmes Esq.',*
c. *1834*

George Palmes (1776–1851) was a substantial landowner who
lived at Naburn Hall, just south of York, with his wife and
children. Ellen was very friendly with the family and often
called on them in the 1830s. On her return trips to England in
1845 and 1851 she went to stay with them.

The absence of paintings on the walls, the freshness of the
chair covers, and the drugget protecting the carpet suggest that
the drawing room had recently been redecorated.

them were relations. Ellen's mother had commissioned sixteen by 1834 and her uncle, Norcliffe Norcliffe, was so pleased with one of his son Thomas that he had it made into a lithograph. Rosamond wanted portraits of all her children: indeed she sometimes summoned her sister to sketch a baby on the day of its birth. Ellen's cousin Albinia Dalton was only slightly less demanding after her marriage to the Reverend George Kelly Holdsworth.

Old family friends like the Duffins and Wakes of York, the Palmes of Naburn, the Cholmleys of Howsham Hall, and the Mainwarings of Middleton Hall provided another important group of patrons. Once one member of a family had commissioned a portrait from Ellen, the others would follow suit. In some cases Ellen would be commissioned to paint an entire family, spreading the work over several months. She painted seven of the Palmes, for example, between March and June 1834. Ellen's own friends and acquaintances also provided a steady stream of commissions. Her portrait list is full of references to school friends, clergymen, lawyers, and young men starting careers in the army and navy.

Ellen was not snobbish about who sat for her portraits or who commissioned them. She was quite prepared to paint servants and was often asked to do so. John Alderson, the yeoman farmer who owned 'Alderson's Farm' at West Huntington, commissioned a portrait of Elizabeth Alderson in October 1828. Mrs Ann Burnett, a servant at Langton Hall who eventually became housekeeper, commissioned a portrait of her husband in September 1832. A servant in Frankfurt, Frederike Cramer, commissioned a portrait of herself in November 1834. And, during Ellen's holiday in England in June 1845, Norcliffe Norcliffe asked for a portrait of Mr Hide, the gamekeeper at Langton Hall.

Ellen also liked to paint people in the world of entertainment. In June 1832 she painted the famous actress Mrs Elizabeth Yates.[43] Then, in January 1834, the guitarist Giulio Regondi had a couple of sittings: Ellen and Mrs Best had met him at a concert he gave in York.[44] A few months later it was the turn of Isabella Paula, 'a Portuguese Hindoo'. Another popular entertainer was a young woman street singer from Innsbruck called Franz [sic] Rossenbaum whom Ellen met in Cologne in August 1834.

Ellen established her reputation as a still-life painter in May 1830 when the *Yorkshire Gazette* announced that the London Society for the Encouragement of Arts, Manufactures and Commerce (now known as the Royal Society of Arts) had awarded 'Miss M. E. Best of this city' their large silver medal 'for a drawing of still-life'.[45]

The Society tried to promote good art and design in Britain by organising competitions in the different 'polite arts' each year and giving prizes to the best entries in each category. Ellen's award was 'for the best original composition, painted in oil or water-colours, for three or more subjects as are usually called still-life, by persons under the age of twenty-one'.[46]

After the judges had decided that Ellen's still-life deserved their top prize, they invited her to come to London to do a painting in front of them, to prove that the watercolour she had submitted was indeed her own work, and to attend the prize-giving ceremony. Ellen replied that she would like to come, provided her mother's health would allow her to do so. Unfortunately, Mrs Best's health did not improve, so the judges asked Dr George Goldie (who had succeeded Dr Best at the York Dispensary) to act as their surrogate.[47] Although the Society's competitions were national, they did not usually attract entries from places as far away as York. Only three of the twenty-two women who won awards in 1830 lived outside London.

At first Ellen confined her still-lives to fairly simple compositions of objects arranged on table tops or on shelves. But she soon became more ambitious and began to paint the interiors of cottages, houses, churches and workplaces. She treated them in exactly the same spirit as her smaller, more conventional still-lives, taking great care to choose an interesting composition and to record the physical appearance of every object in minute detail. Watercolours of this type enjoyed a brief vogue in Europe between about 1820 and 1840. The genre was dominated by women and many British examples are reproduced in John Cornforth's book, *English Interiors 1790–1848*.[48] Unlike most of her contemporaries, however, Ellen did not just paint the interiors of grand houses: she was fascinated by the living arrangements of all social classes and the insides of other kinds of building.

Sometimes Ellen added people to her interiors, combining the two genres of portraiture and still-life painting in one. These pictures, however, do not really qualify as group portraits or as 'conversation pieces' (informal portraits of people in their normal surroundings, busy with a social or domestic activity).[49] The people in Ellen's watercolours are incidental, doll-like creatures: their characters are not revealed by their expressions and body language, but by their clothes and surroundings.

Most of the people with titles or independent means who drew and painted in the early nineteenth century were not interested in selling their work. Ellen, however, was not one of these 'amateurs'. After she reached her majority in 1830, she welcomed any supplement to the £50 she received each year from her father's legacy. She also found that selling pictures boosted her morale: if people were prepared to pay money for her work they clearly thought it was good. One can just imagine her jubilation when the Reverend

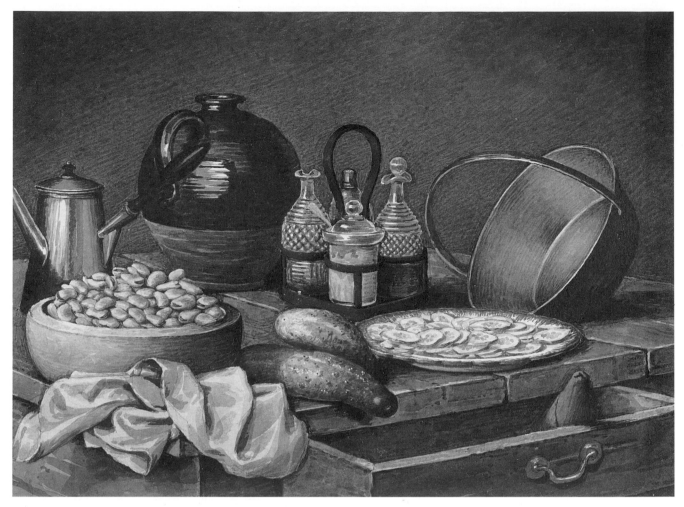

54

55

54 *Still-life with broad beans, cucumbers and cruet, 1830s*

There are two unusual features in this kitchen table-top still-life: the large cruet for oil, vinegar and mustard and the unopened sugar cone wrapped in blue paper peeping out of the drawer.

56 *Still-life with bread and oranges, 1830s*

This still-life is Ellen's simplest composition and one of her most successful: the harmony and luminosity of the colours are reminiscent of the seventeenth-century Spanish painter Francisco de Zurburán.

55 *Still-life, 1829*

In 1830 Ellen won a silver medal for this painting in a national competition organised by the Society for the Encouragement of Arts, Manufactures and Commerce.

57 *Still-life with Chinese box, 1830s*

The Chinese tea box with its metal foil lining is of particular interest because such ephemeral containers rarely survive.

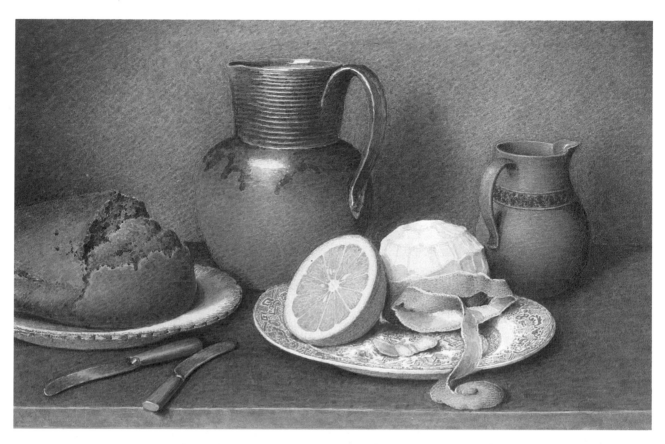

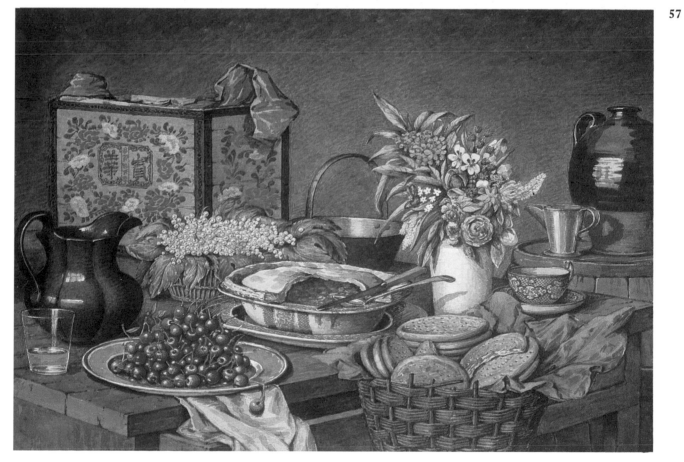

Frederick Kendall of Riccall offered 12 guineas for two of her watercolours in May 1831. Thomas Robinson was so impressed that he made a special note of it in his diary!

If Ellen had been a man, or belonged to a lower social class, she could have advertised her work by displaying it in the window of her lodgings, inserting notices in the local newspapers and putting her name and address into directories. But none of these options was available to her.

On the other hand, Ellen's social connections brought her work. She had a large number of potential patrons within her immediate circle of friends and acquaintances in York and its environs. These people were always running into each other, so Ellen's willingness and ability to carry out commissions was passed on by word of mouth. Furthermore, many of the men in this circle were members of the Yorkshire Philosophical Society, founded in 1823 to promote 'the diffusion of scientific knowledge generally, and more particularly the elucidation of the Geology, Natural History, and Antiquities of Yorkshire'.[50] It rapidly became an important focus of cultural life in Yorkshire, its membership increasing from 238 to 397 between 1826 and 1839.

Ellen's family was intimately involved with the society from the start. When the society decided to create a museum, Ann Norcliffe helped to build up its mineral collection by donating a large ammonite from the calc-grit, Langton Wold, and Norcliffe Norcliffe gave a piece of oxidulated iron from Sweden. Mrs Best contributed a *Testudo graeca* to the reptile section in 1827 and a lachrymatory found at the Mount near York to the antiquities department in 1828. In 1832 she gave an alligator's egg and an emperor moth to the zoology section, various Roman remains and coins to the antiquities section and copies of Rousseau's *Botany* and Fawke's *Modern Chronology* to the library. Two years later she handed over twelve books from her husband's library, most of them medical texts. Rosamond's husband Henry was a member of the society from 1825 and became curator of the library in 1835.[51]

Although the Yorkshire Philosophical Society did not admit women members, Ellen and Rosamond were frequent visitors to its museum and gardens. (In 1830 the society decided to allow women to use these amenities because it needed extra revenue.) Since the gardens were delightful and conveniently situated in the centre of York, Ellen and Rosamond went walking there almost every day. Inevitably they met other members of the society and made new friends and acquaintances. In this way, Ellen's circle of patrons was continually reinforced and enlarged.

Ellen also used other methods to gain commissions. One of these was to ensure that she always had one or two paintings being framed by Mr Benjamin Evers at the 'Repository of the Arts' at no. 43 Stonegate.[52] People passing by in the street could see Ellen's pictures and pop in to enquire who had done them. Mr Evers was a carver, gilder and picture cleaner who liked to catch the public's eye: in 1829 he exhibited a portrait of Jonathon Martin, the man who had set York Minster on fire, which had been painted in York prison by Edward Linley.[53]

Mr Evers had regular contact with well known art dealers such as Messrs Ackermann of London and Messrs Agnew and Zanetti of Manchester. They supplied him with goods for sale and he in turn acted as their local talent spotter, providing them with pictures to add to their stock. With Mr Evers acting as intermediary, Ellen was able to sell her paintings to these dealers.

Agnew and Zanetti bought nine pictures of various sizes in 1832 for £4 1s 0d, eighteen small pictures in 1833 for £3 9s 0d and fourteen of various sizes in 1834 for £3. According to Trevor Fawcett's classic study of English provincial art in the early nineteenth century, they ran a typically miscellaneous business as 'carvers-and-gilders, manufacturers of meteorological instruments and mirrors, opticians, printsellers and publishers, dealers in coins and medals, picture restorers, artists' colourmen [and] dealers in old and modern paintings'. By 1829 they had a gallery for public exhibitions and a private room for artists visiting Manchester.[54] Thomas Agnew, the dominant partner, had become bored with dealing in Old Masters and begun to specialise in contemporary English art.[55]

Messrs James and John Dobbs & Co., chemical manufacturers at Wigan, also bought Ellen's watercolours.[56] Why they did so is a complete mystery, but they paid a standard rate of 5s for a small picture. As they bought sixteen in 1832 and thirty-six in 1833, Ellen's receipts from this firm totalled £13. In 1834 she broke into the London market when she sold thirteen small pictures to Ackermann's for £2 5s 6d. Because these dealers paid wholesale prices and Mr Evers took his cut, Ellen's return was modest. Nonetheless in three years she earned £25 15s 6d for the sale of 106 pictures, although she was always paid in goods (artists' supplies, art books and prints) rather than in cash.

It was much more profitable to sell direct to members of the public. John Brook, the Bests' solicitor who was also an intimate friend of William Etty, paid 5 guineas for a picture in 1830. Mr Micklethwaite of Melbourne Hall bought one for £4 10s in 1831, two for £6 in 1832 and another one for £4 in 1833. Mr Benjamin Gott of Armley, a leading manufacturer in Leeds and important patron of the arts, paid 4 guineas for the picture he bought in 1833. However, they did not always cost so much: the Lord Mayor of York, William Oldfield, got away with £2 12s 6d for each of the

purchases he made in 1832 and 1833 and Mr Morris of Carmarthen was only charged £1 10s for a portrait in 1834.

Picture prices were somewhat less in Frankfurt, in line with the lower cost of living on the Continent. Ellen sold fourteen major works while she was there in 1834–35:

Mr Peter Koch [the banker], 1 portrait	£2
Mrs Simpson of Ireland, 2 portraits [one of her herself and one of her son Pearse]	£4
Dr Gustav Adolph Spiess [a doctor and chirurgeon], a double portrait	£3
Madame Brickman, 2 portraits	£3 3s 4d
Mr Sieveking [the ambassador from Hamburg], 1 interior	£2
Madame de Thienen, 1 interior	£1 7s 6d
Madame de Schweitzer, 1 interior	£1 3s 4d
Madame d'Adlerflycht [the society hostess], 1 interior	£1 7s
Madame de Panhuys [the artist and hostess], 1 interior	£1 13s 4d
Mr F. John, 1 interior	£1 3s 4d
Mr Peter Wachs, 1 landscape	11s 8d
Mrs Cartwright [possibly the wife of Thomas Cartwright, who became British ambassador to Frankfurt in 1836], 1 interior	£2 0s 6d

It is interesting to compare these sums with those paid to the most successful professionals. According to Gerald Reitlinger's instructive book, *The Economics of Taste: The Rise and Fall of Picture Prices 1760–1960*, 3,000 guineas was the highest price paid for the work of a living artist between 1800 and 1860. Benjamin West received this princely sum for 'Christ Healing the Sick' in 1811. Sir David Wilkie was the second most expensive painter during these six decades. He received £1,680 in 1830 for his picture of 'George IV receiving the Scottish Nobility at Holyrood' and £1,260 in 1832 for 'John Knox preaching before the Lords of the Congregation'. But these were freakish prices paid for large-scale oils. Most of the top London artists earned less than a thousand pounds for a major picture. William Mulready was paid £714 for 'The Convalescent from Waterloo' in 1838 and Edwin Landseer got £420 for his 'Scene of the Old Time at Bolton Abbey' in 1834. John Constable could not expect to earn more than £250 for one of his large landscapes and many went for less. His picture of 'Weymouth Bay' (now in the Tate) sold for 4 guineas in 1838.[57]

Lesser known artists, especially those working in the provinces, rarely received more than £100 for a painting. A Leeds exhibition catalogue of 1825, which happens to have sale figures marked on it, shows that pictures ranged in price from £1 10s ('Kirkham Priory' by Henry Cave of York) to £63 ('Loch Lomond' by Charles Henry Schwanfelder of Leeds).[58]

At York's first art exhibition in 1836, 60 per cent of the oil paintings and 83 per cent of the watercolours cost less than 15 guineas. The most expensive oil painting was James Inskipp's 'Little Red Riding Hood and the Wolf' (75 guineas) and the most expensive watercolour was George Lance's 'Fruit Piece' (£36 15s).[59] When Ellen's earnings are set in this context, it is clear that she was doing quite well.

Showing her work at public art exhibitions was, of course, another method Ellen used to attract public attention and promote sales. In 1830 she had 'a piece of still-life' in an exhibition of 357 paintings organised by the Northern Society for the Encouragement of the Fine Arts in Leeds.[60] This was an important show which attracted professional artists from all over the country, including such well known figures as John B. Crome, Thomas Christopher Hofland, Edwin Landseer, John Nicholas Rhodes and Frederick Watts. At the Society's next exhibition in 1833, which was on a similar scale, Ellen had two works for sale: a 'Breakfast Table' and a 'Dessert Table'.[61]

Ellen also showed her work in Newcastle. Thomas Robinson was there in August 1831 and noted with excitement in his diary 'To the Exhibition! Ellen Best's Drawings in Water Colours'.[62] This was the fourth exhibition of the Northern Academy of Arts and Ellen's paintings of 'A Woman paring Apples' and a 'Kitchen Table' were among the 274 works on view.[63] If he had travelled to Liverpool in the same year he could have seen six of her still-life paintings of mackerel, fruit, and vegetables displayed at the eighth exhibition held by the Liverpool Academy of Arts.[64]

It was quite an achievement for Ellen to show her work so widely. The selection boards consisted exclusively of men and it was difficult for women to exhibit their work. At the Leeds show of 1830 only twelve of the 145 exhibitors were women and they had painted only 3 per cent of the works displayed. There were 10 women exhibiting at Newcastle in 1831 compared to 72 men, and at York in 1836, 12 women and 158 men.

3 – An Independent Woman

Ellen's enthusiasm for selling her work gradually dwindled after 1835. Partly she did not feel she had to prove herself, but mainly she no longer needed the money. When Ann Norcliffe died in September 1835, she left her daughter Mary a considerable amount of money: £600 in ready cash, £6,250 in trust and a one third share of the value of the contents of her house in Petergate.[1] This meant that Mrs Best now had an additional income of about £350 a year to share with her unmarried daughter.

When Mrs Best died in March 1837, after a long and painful illness, Ellen inherited half of her grandmother's trust.[2] The interest on £3,125 yielded £156 a year to add to the £50 she was already receiving from her father's trust. What was the point of selling watercolours when she could now afford to rent a substantial house in York, employ two servants, buy whatever books and prints she fancied, and travel as much as she pleased? In fact Ellen did continue to sell portraits after her finances became secure, and no doubt other work too. But there were no further sales to dealers and only one more exhibition.

This last show, which was the culmination of Ellen's public career as an artist, opened at Mr J. Tuite's house in Castlegate, York in June 1836. Norcliffe Norcliffe and Henry Robinson were both on the organising committee and this may help to explain why eight of her paintings were accepted. York's most successful artist, William Etty, RA, only exhibited ten pictures and Henry Cave had to make do with three.

58, 59
14
Ellen's entries included four York interiors (the dining-room of Dr Wake's residence in Blake Street, Mr Hood's wine vaults, a cottage by firelight and the south aisle of the Lady Chapel in the Cathedral), a couple of portraits (a German lady from Stuttgart and Ellen's baby niece, Rosamond), a copy of Rubens's 'Infant Child' which she had made in the Städel Institute at Frankfurt, and a still-life. In contrast to all previous exhibitions, however, Ellen's work was not for sale: she now had the honorary status typical of the amateur.[3]

The York art exhibition was a grand affair. It ran for four months, with 442 works on display from 170 different artists, over half of them from London. The organisers were

58 *'Wine vaults by gas light, York', 1836*

This is one of the first paintings in the world to depict gas lighting. Ellen showed it at the York art exhibition of 1836 under the title 'Scene in Mr Hood's wine vaults, York'.

Richard Hood and his sons had a large wine business. They had recently rented the undercroft of the thirteenth-century chapel of St Leonard's Hospital to store their wine, much to the delight of York's antiquarians who were pleased to see the cellars put to such good use.

By lighting the vaults with gas, the Hoods demonstrated that they were at the forefront of technology. For York's first viable gas lighting enterprise had only just been established. The records of the York Union Gas Light Company show that Richard Hood and Sons held fifteen shares in it.

59 *'A cottage by firelight, York', c. 1836*

This was among the eight watercolours Ellen exhibited at the York art exhibition of 1836.

It was unusual for artists to paint cottage interiors in the early nineteenth century. The subject only became fashionable at the end of the century, when the middle and upper classes became interested in the lives of working people and aware that many traditional aspects of rural life were fast disappearing.

This is an urban cottage interior. The coal fire in the open range was the only source of light in the kitchen-parlour. The tallow candles hanging from the ceiling were reserved for emergencies and to illuminate the fireless rooms upstairs. The strange settle by the fire was made out of an old chaise (a light travelling carriage). The barrel on the stand would have contained home-brewed beer and the basket in the corner is full of turnips.

It is five o'clock on a winter's afternoon and the table is laid for tea. Two of the little girls are holding clay pipes, possibly in anticipation of men returning home from work.

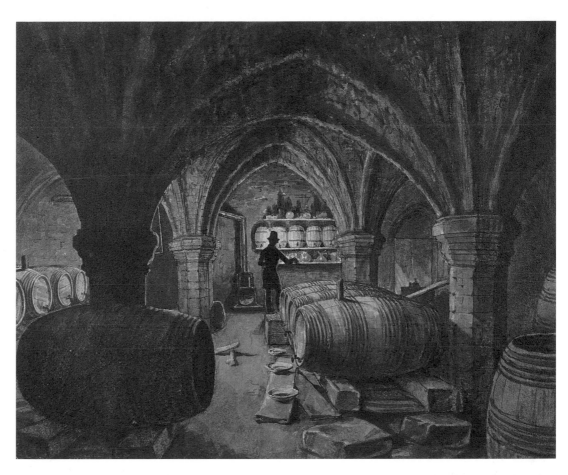

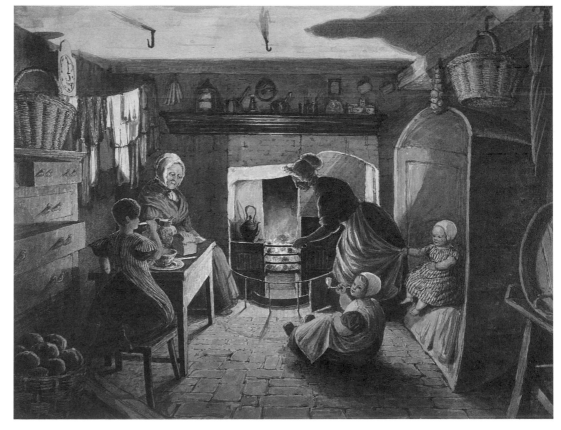

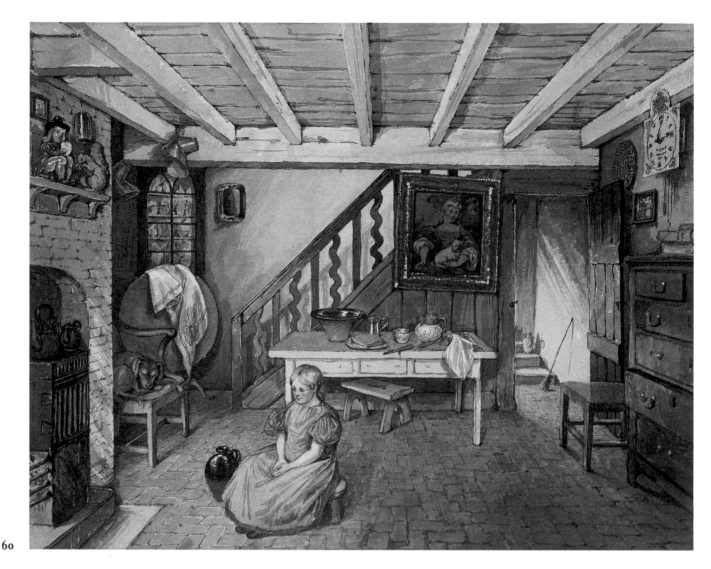

60

60 *'A cottage interior, York', 1836*

It is interesting to compare this kitchen-parlour at three o'clock
in the afternoon with that in 'A cottage by firelight'. A little girl
is resting in front of the open range, after bringing home a pot
of water. The books (one of them a 'Holy Bible'), the painting,
ornaments on the mantelpiece, corner cupboard and tea table
turned upright to save space all suggest that this was a
relatively prosperous household.

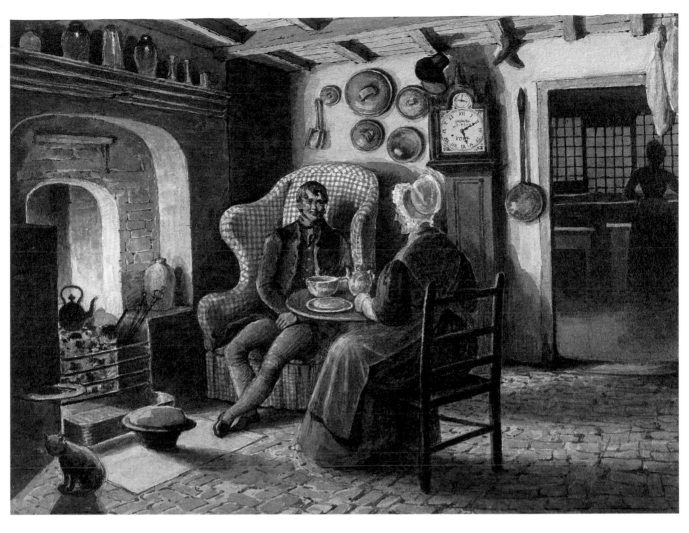

61 *'Cottagers at tea', York or Yorkshire, 1830s*

This is a prosperous cottage: the kitchen-parlour adjoins a
proper scullery and boasts a comfortable wing armchair, grand-
father clock (made in York), warming pan, and hearth mat. It
is ten past five and the kettle is on the fire. The large bowl on
the tea table is for slops: economical cottagers would make at
least two brews of tea from the same leaves. The menu is
suggested by the hams hanging from the ceiling and the
pudding keeping warm in the pancheon in front of the fire.

Note the fixed 'reckon' for suspending pots over the fire, the
'herring bone' brick floor typical of York and the East Riding,
and the highly polished saucepan lids which cottagers hung on
the wall as a decoration.

62 *Portrait of Rosamond Robinson Junior, June 1836*

Ellen showed this portrait of her niece, sitting majestically in her cradle, at the York art exhibition of 1836. When Rosamond was christened on 14 June, her fond mother could not resist commenting that 'Little Rosamond was very pretty at this time; her picture, which was in the exhibition, was an object of general attraction there, and all who saw her said the original far exceeded the copy in beauty'.

Ellen began work on this portrait at the end of March when Rosamond was eight months old, hence the bunch of snowdrops in her hand. It was the only watercolour portrait to be singled out for praise in a review of the exhibition which appeared in the *Yorkshire Gazette*.

very conscious that York had fallen behind its neighbours in the fashionable business of mounting art exhibitions. Leeds, Newcastle, Liverpool, Carlisle, Whitehaven, Hull, Manchester and Birmingham had all done so during the 1820s, but not York.[4] They therefore took great pains to ensure that the city's first effort was a success. The *Yorkshire Gazette* boasted that they had 'obtained a collection of paintings which for number and talent equals, if not exceeds, any exhibition in the provinces; we had almost said in the metropolis . . .'.[5] Although the newspaper was exaggerating, the exhibition catalogue did indeed include many well known names.

Ellen was delighted when her still-life and portrait of Rosamond Robinson were singled out for praise in the *Yorkshire Gazette*'s review of the exhibition.[6] Life had been rather dreary since her return from Frankfurt and her grandmother's death. Going to stay at Langton was no longer much fun, and her activities were constrained by the fact that her mother was now very ill. Mrs Best was bedridden from April 1836 until her death thirteen months later: by November she was too weak to write.[7]

Travel was out of the question. Ellen was confined to York, nursing her mother. Hardly a day went by without one or more of the Robinson children coming round to see them at their lodgings. In February Ellen and her mother had moved from Ellison's Lodgings on the Lord Mayor's Walk to Mrs Palmer's in Gillygate, little expecting that Mrs Palmer's husband would take his life in a fit of insanity while they were living there.[8] A year later they moved again, to the lodgings of Jackson the Jeweller in Coney Street, Mrs Best being carried there in a sedan chair.[9]

It was a difficult time, particulary as Rosamond was not able to spend much time helping to nurse Mrs Best. She had her own family to attend to and, by March 1836, was pregnant again. Ellen had to work hard amusing her nephews and nieces and looking after her mother.[10]

Fortunately, they all enjoyed being read to. Hugh was never averse to hearing the story of 'Waste not, want not'. They also liked posing for portraits. In February 1836 Ellen painted a picture of baby Rosamond in a bead cap as a present for Henry. In August she began another portrait of her in a blue gingham bishop and white muslin bonnet. On 7 October, when Hugh arrived as usual to have his supper with them, she embarked on a portrait of him in his cloth tunic and Polish lancer's cap.

Mrs Best was pleased if Ellen made toys for the grandchildren, as were the recipients! Hugh was particularly delighted with a jockey made out of tape and stuffed with cotton wool to ride on his horse. Mrs Best also liked Ellen to give them treats: to take them out to the toy shops, on walks in the Marquee or Museum Gardens, on boat trips up and

down the Ouse, and on special expeditions to watch glass being blown, to inspect the goods for sale at the Missionary Bazaar, to laugh at the antics of Punch and Judy, to cower before the wild beasts at Whitsuntide Fair, and to ogle at the albinos and giantesses at Martinmas Fair.

In view of all this, it is not altogether surprising that the fifth Robinson child, who was born just before Christmas, was called 'Ellen' at Mrs Best's special request. As Rosamond wrote in her *Family Chronicle*, her mother 'fervently prayed it might prove to *me* all that Ellen had been to *her*'.[11]

Although Ellen was extremely fond of her mother, her death on 17 March 1837 must have come as a relief. Certainly this is the impression conveyed by Thomas Robinson in his diary entry for the day after: 'Out at 7.30. Fine morning. Called at Henry's. He working in the garden. Rosamond and Ellen Best in the house. Ellen came into the garden for the purpose of getting some fresh air & change of scene.'[12]

After a sad funeral at Langton Church – the ground was frozen and it was snowing – Ellen returned to Jackson's Lodgings. She spent the month of April with her sister tidying up their financial affairs. By 1 May she was able to go to Langton for a short holiday with Norcliffe Norcliffe. He and Carlisle Wake then accompanied her to London, from where she went to Bromley Common to spend a month or so with Miss Shepherd and her pupils.

By 15 July she was back in York. As she was temporarily homeless, having given up the lodgings in Coney Street and rented a house at no. 1 Clifton which needed decoration, she went to stay with the Wakes. Ellen's nephews and nieces went to see her there and received the usual panoply of presents from their devoted aunt: a book of 'True Stories from Modern History' for Hugh, a small cabinet and doll's bonnet for Ann, a tray of toy knives and forks for Rosamond, a set of polished wooden tea things for Charles and a pair of blue stamped leather shoes for Ellen.[13]

From 26 July to 11 September 1837 she was staying at Hob Green with her friends the Worsleys. Rose and Thomas Taylor Worsley were spending the summer with her elder sister and his elder brother: Captain James White Worsley, who was bridge surveyor for the North Riding of Yorkshire, had married Frances in 1828 and they had two children, James Stovin and Fanny Maria. After Ellen had painted their portraits, she returned to York to stay at the Robinsons' house. Rosamond and Henry were on holiday with Hugh in Dinsdale and were glad to have Ellen's report on the younger children who had remained at home:

'This morning Cookey [the cook] sent to beg I would go into the kitchen to see all the little darlings at dinner on roast

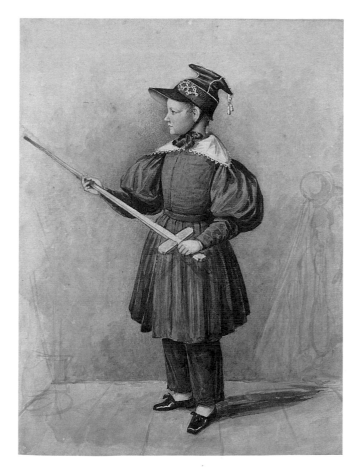

63 *Portrait of Hugh Robinson, aged five, October 1836*

Ellen began this portrait of her nephew on 7 October, after he had eaten his supper at the lodgings she shared with her mother in Gillygate.

Hugh's cloth tunic, skirt and trousers were presents from his great uncle Norcliffe Norcliffe. On his head he is wearing a Polish Lancer's cap which Mrs Best had brought him from Frankfurt.

In later life Hugh went into the army and became a captain in the 43rd Light Infantry. He died unmarried in 1880.

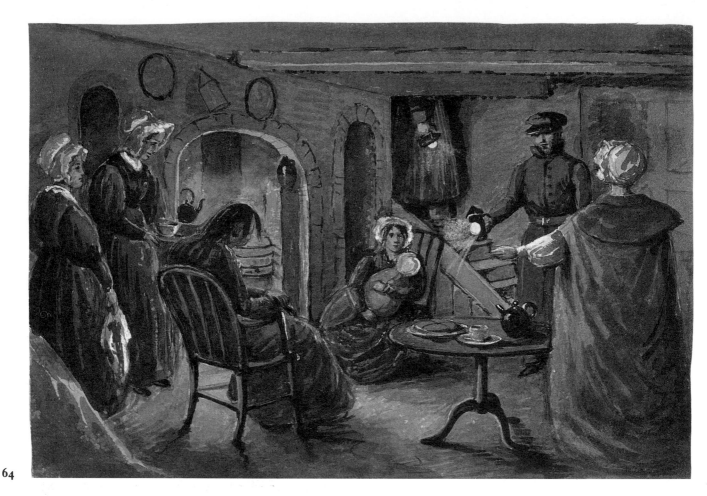

64

64 *'Scene in our own kitchen at midnight between the 17th and 18th of April 1833'*

Ellen and her mother were living at Brookbank's Lodgings, no. 48 Coney Street, when this drama occurred. Unfortunately, neither Rosamond nor the newspapers relate what happened! It is possible that the unkempt young woman in the chair had been attacked in the street outside and had then sought refuge in the house. This is the only known example of Ellen depicting a dramatic incident or making a direct allusion to violence and evil.

mutton & Yorkshire pudding – a happier sight I never saw. Lenchen's [i.e. little Ellen's] share was as large as any body's, and Biddy called out, pointing to Lenchen, "Diddledy eat pudding!"

My sweet little Roddy [Rosamond] came to bed to me yesterday morning and lay placidly looking at me, when she said in a sweet voice, "Olly Dum soon?" meaning would Olly Dum [i.e. Alice Alderson, Ellen's servant] come for her? I gave her a pottery toy from Ripon; she was to carry it downstairs herself: – the first two falls it had were on the stair-carpet, but the third being on the stone, the toy was smashed before the pet had had it a minute. I was obliged to give my own little Biddy a slap today for pushing & fighting. She is the joy of my heart, and has found it out, saying triumphantly "I Tinty pet". The darlings are pleased with the yellow parasols I brought them.'[14]

Ellen may have tired of all this baby talk because she left Clifton on 19 September, to have a seaside holiday in Whitby with her five-year-old niece, Ann, and Alice Alderson. Rosamond was, of course, eager to hear about the journey, which was Ann's first experience of travelling by train, and received the following letter from her sister:

'Poor dear little Anny was very good, but heartily tired of her journey, and has told Alderson if she had but known how very miserable she should be, she would never have come. However, an exceedingly hearty supper has caused a revulsion in her feelings, and she is gone smiling to bed, confessing herself reconciled & comforted from her misery, though she still does not seem to believe she is quite at Whitby. It was so dark the latter part of the journey, that much of the beauty of the Railroad scenery was lost to us, but the carriage was large & luxurious, made to accommodate 8 people, and contained only Mr Dowkin & Alice, Anny & me. Mr D. was very kind to Womie, making a nice bed for her on the seat, and tucking her in with Alice's cloak, which she kicked off every minute while she slept.'[15]

They settled into Mrs Craig's Lodgings and, after a week of breathing in the sea air, Ellen wrote to her sister again:

'Anny is uncommonly well, only she does not quite lose her cough. I have given her one warm sea-bath, and Alderson spunges her from head to foot in cold sea-water every night and morning, sometimes her head also; she is very fond of it. Her spirits are grown quite uproarious. She romps & tears about the room, shouts and sings, and eats enormous meals. At breakfast her cries for "more bread!" come so thick & fast I am afraid of her bursting. She has just knocked her forehead very hard against a table, and made a bad bruise. She was sitting on her favourite perch on the arm of a very wee sofa which she had instinctively adopted as her own,

65

65 *'Mary Richardson, aged 15 years, York, August 1836'*

Mary was a servant to Ellen and her mother when they lived at Mrs Palmer's Lodgings in Gillygate. A Mr and Mrs Richardson acted as butler and housekeeper for Ellen's aunts at no. 9 Petergate and Mary may well have been their daughter.

Ellen often painted pictures of servants. This one is reminiscent of her portrait of Frederike Cramer in Frankfurt.

when her weight overbalanced it, & she fell against her table, but Dum having put brown paper & vinegar to it, she has fallen into a sound sleep on her little sofa.'[16]

On 4 October Ellen and Ann left Whitby to spend a week with Mr and Mrs John Mainwaring and their small children at Middleton Hall near Pickering. It was a happy household, but not one where guests could expect to enjoy much peace and quiet. Ellen therefore decided to do a painting of the Mainwarings' cellar, one room where she was not likely to be disturbed. She then returned to the Robinsons' house at Clifton to attend the christening of her god-daughter, Ellen, and paint a portrait of her in the arms of the new nursery maid, Nancy Wright. Since her house was still not ready to move into, she accepted an invitation from Colonel and Mrs George Cholmley to stay with them at Howsham Hall for a fortnight.

Finally, at the beginning of December, Ellen found herself in her new home. Charles and Rosamond went to dine and drink tea with their aunt on the 4th, and Hugh quickly discovered that she welcomed him with a cup of coffee if he dropped in at breakfast time, on his way to Miss Lovegrove's school in Minster Yard. To celebrate her new found independence, Ellen had the five Robinson children and three of their cousins for tea and a romp at her house on the 7th: the children got through sixteen tarts and twenty-four buns. By 15 December she was at work in her 'painting room'. Rosamond records that 'Our dear little Ellen was a year old today, and my sister began a portrait of her in my dear Mother's album, which proved an inimitable likeness'.[17] Ellen's friend Anne Laye was her house-guest over the Christmas holidays.

One suspects that Ellen did not want to be left alone at this point in her life. For as soon as Anne Laye left on 12 January 1838, she was off on another round of visits: to her uncle at Langton, the two Worsley families at Hob Green, Captain and Mrs Watts at Littlethorpe and her great uncle, the Reverend James Dalton, his wife Maria and their children, John and Isabella, at Croft rectory. When Ellen returned to York on 22 March, she was roped into feeding the elder Robinson children as many meals as possible, to alleviate the domestic strain afflicting Rosamond who had just given birth to her sixth child, Mary. In April she had the Worsleys to stay and took Anne Laye and Georgiana Ombler on a trip to Langton, where they had the run of the house in Norcliffe Norcliffe's absence. The following month she returned to York to attend Mary Robinson's christening, paint a portrait of Ann which was long overdue, enjoy Queen Victoria's coronation celebrations and prepare for her second tour of the Continent.

66

66 A children's game, consisting of a lady's costume set

Ellen made changeable costume sets to entertain her nephews and nieces and her own children. The game consists of placing a variety of painted costume cut-outs over the figure of a young woman. Ellen did not usually paint contemporary fashions, but those of the past and of foreign lands.

There was a particular vogue for costume sets in the early nineteenth century. S. and J. Fuller of the Temple of Fancy, Rathbone Place, London, advertised a 'Protean Figure' with twelve different 'Metamorphic Costumes' for one guinea in 1813. The set included a 'Walking Dress, Mourning Suit, Turkish Costume, Quaker's Habit, Officer's Uniform (Land Forces), Full Dress of the Year 1700, Monk's Habit, Naval Uniform, German Hussar, Knight in Full Armour, Gentleman's Evening Costume, French Uniform (Imperial Guard)'. Prospective buyers were told that much amusement could be obtained by exchanging articles of dress from one character to another. The Quaker, for example, could be fitted with an Officer's hat and plume and the Monk forced to parade in Hessian boots and a Hussar's cap. Amateur artists were urged to add costumes of their own.

The appeal of change-of-costume sets was certainly not limited to young children. Princess Charlotte of England spent part of her eighteenth birthday (in 1814) 'looking at a little picture of herself, which had about thirty or forty different dresses to put over it, done on isinglass and which allowed the general colouring of the picture to be seen through its transparency'.

Change-of-costume toys have been popular in England since the seventeenth century, but few early samples survive.

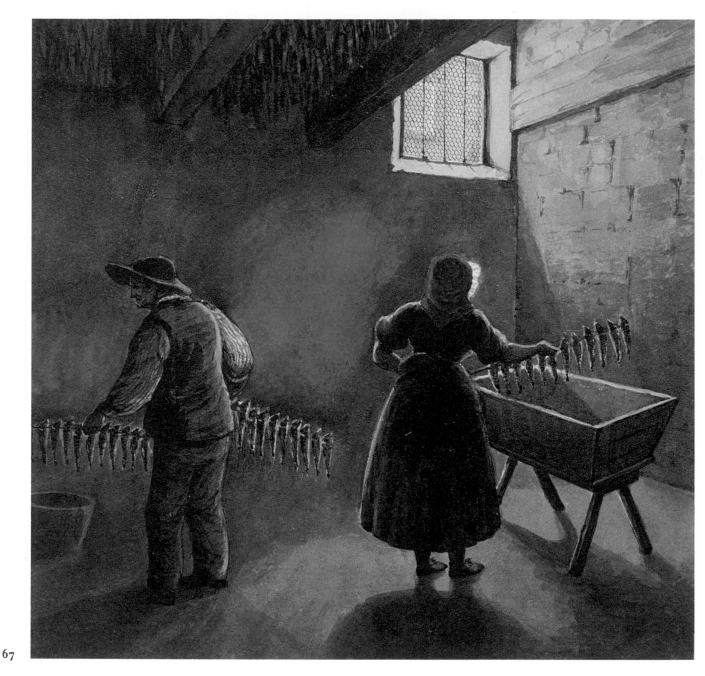

67

67 *'Smoking herrings' or 'Herring house at Whitby',*
September or October 1837

Ellen stayed at Mrs Craig's Lodgings, Whitby, with her niece Ann Robinson and her maid Alice Alderson for twelve days. During this holiday, Ellen did not have much to do except for making sure that Ann was sponged with sea water three or four times a day (this treatment was thought to strengthen children's limbs and improve their health). She thus had ample time to observe the port's fishing industry.

Whitby was famous throughout Britain for its succulent kippers. They were prepared in small family concerns. The herring, fresh from Scottish boats, were split down the back, gutted, and put into baskets which were swirled round in a tub of water to clean the fish and remove their scales. The herring were then put into a salt and water mixture for 15 to 30 minutes, drained in a trough, and put onto tenterhooks fixed to long bars. The kippering of the herring took place in special smoke houses, such as the one shown in Ellen's picture. Several fires made out of shavings, sawdust and oak chippings were lit on the floor to smoke the tightly packed rods of fish suspended from the rafters. After this process, which took eight to ten hours, the kippers were ready to eat. A small family business could produce around 3,000 kippers a day.

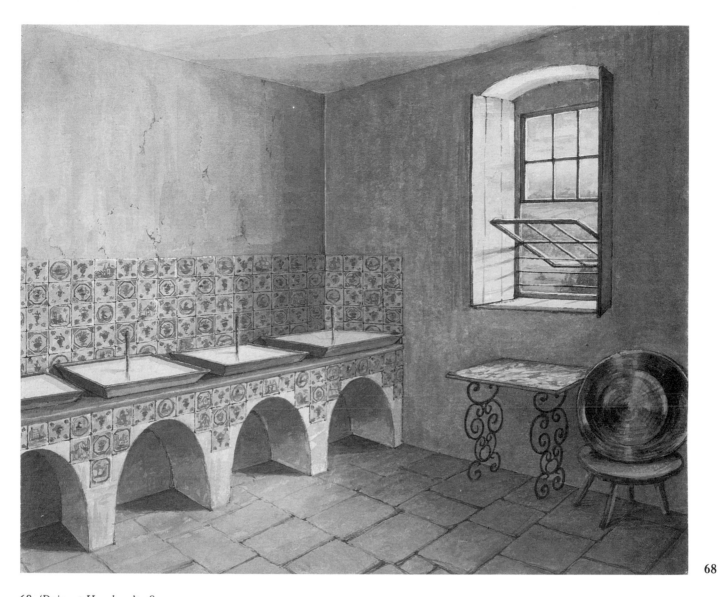

68 *'Dairy at Howsham', 1830s*

Dairies were often lined with tiles at the beginning of the
nineteenth century. Unfortunately, this attractive, airy example
with its blue and white Delft tiles does not survive.

The rectangular trays are 'settling dishes' made of lead.
Fresh milk was left in them for a day, while the cream rose to
the top. The long wooden plug in the centre of each tray was
then removed, allowing the skim-milk to run out into bowls
placed below the arches. The cream left adhering to the lead
surface of each tray was then made into butter.

The brass cheese kettle on the right was used for warming
milk to blood heat before adding rennet.

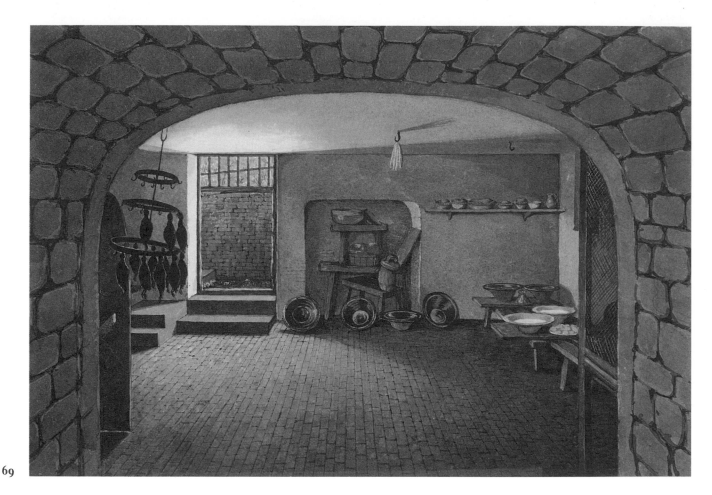

69

69 *'Cellar at Middleton Hall', October 1837*

Mr and Mrs John Mainwaring and their children lived at
Middleton Hall, a Georgian house in the village of Middleton
near Pickering in Yorkshire. Ellen painted this watercolour
while staying there in October 1837 with her niece Ann
Robinson.

The room was used for storing cooked food (there are
several pies on the shelf), game (partridges hang from the
three-tiered rack), meat (part of a meat safe can be seen in the
right hand corner), earthenware settling pans (cream was
skimmed off the surface of the milk), candles and benches.

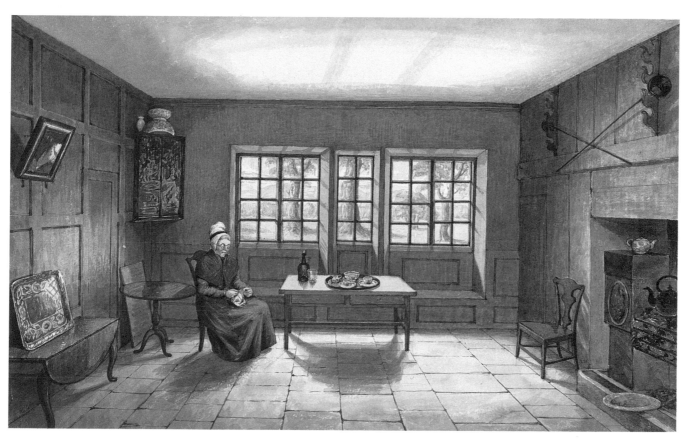

70 *Unidentified Yorkshire interior, probably 'Room at Bewerley Hall', 1830s*

Ellen took an unusual interest in the working lives of ordinary women, particularly servants. In this painting she records the lonely, isolated existence of an elderly housekeeper who has taken to drink (note the empty wine bottle in front of her).

Like most housekeepers in country houses, this woman had a room of her own where she could do her knitting and sewing, drink tea, entertain and so on. Such rooms often contained old-fashioned furniture which the family no longer wanted upstairs. Hence the fine pieces of Chippendale which can be seen here. Although this woman's employers allowed her the comfort of a fire, they did not provide any other luxuries: there is no rug on the cold stone floor or easy chair for her to sit in. Note the punch bowls stored on top of the lacquered corner cupboard and the decorative but practical arrangement of spits over the fire.

Bewerley Old Hall, which is north-west of Harrogate, was built around 1600. In the 1830s it belonged to a local landowner, John Yorke, Esq., who also had some smelt works. It was demolished between the two world wars.

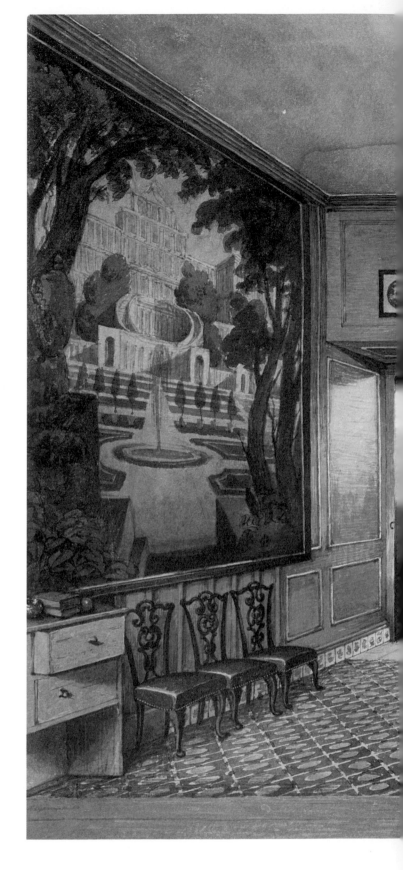

71 *'Housekeeper's room in Whitby Abbey', January 1840*

Colonel George Cholmley of Howsham Hall invited Ellen and Anthony to spend the first week of their honeymoon at his second home, Whitby Abbey House. This was a sixteenth-century house next to the ruins of Whitby Abbey. The Cholmleys only stayed here occasionally, when they wanted a spell by the seaside in autumn, or had business in Whitby.

Whitby Abbey House was expanded and refurbished in the early seventeenth century and the panelling and Delft tiles in Ellen's watercolours date from this time. The room has three unusual features: a tapestry of what appears to be a sixteenth-century Italian or South German garden, an 'invisible' cupboard with small ventilation holes to the right of the fireplace and a very simple chest of drawers which anticipates the 'Arts and Crafts' style.

The blue plaque over the mantelpiece reads 'Jubilee/ William Wilson/Steward at Howsham for 50 years' suggesting that this was his room. In 1839 Colonel Cholmley described Wilson as 'the responsible servant at the Abbey House'.

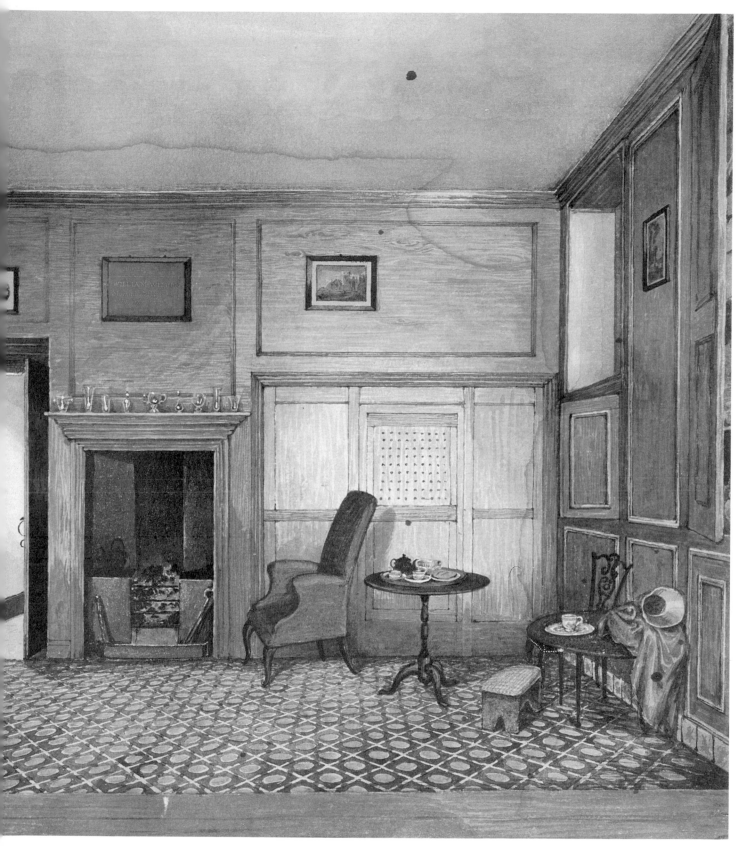

72 *Portrait of Ann Robinson, aged six, June 1838*

According to Rosamond, it was on 25 May that 'Ellen began a portrait of Annie in her costume of last winter, crimson silk bonnet, figured [i.e. printed] merino cloak, and holding the bag my dear Mother made her'.

Rosamond provided her children with fashionable new winter outfits each year. Ellen gave Ann the cloak.

73 *'Painting room in our house at York', c. 1838*

This is a fascinating watercolour because Ellen has painted herself at work. Her easel, box of watercolour tablets, palette, water mug and portfolio are all before her on the table covered with an oil cloth by the window. Prints are lying on the grained bird's-eye maple table to the left and a pile of small sketch-books on the shelf of the bookcase above.

Ellen spent more time in this room than in the drawing-room and it is full of homely touches such as Azor, the dog she had brought back from Frankfurt and her parents' portraits over the fireplace. She had inherited the small cabinet in the corner from her grandmother, Ann Norcliffe.

Like the drawing room, the painting room has matching wallpaper and curtains. The carpet, however, is protected by a grey floor cloth or 'drugget'.

Ellen is dressed in mourning for her mother, which suggests that she painted this picture in 1838.

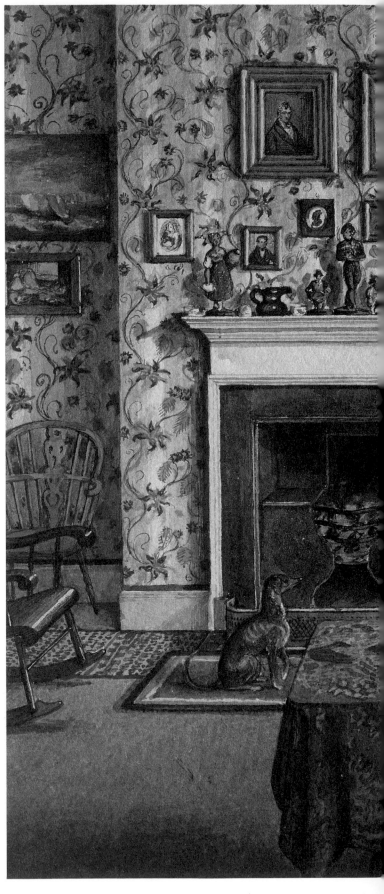

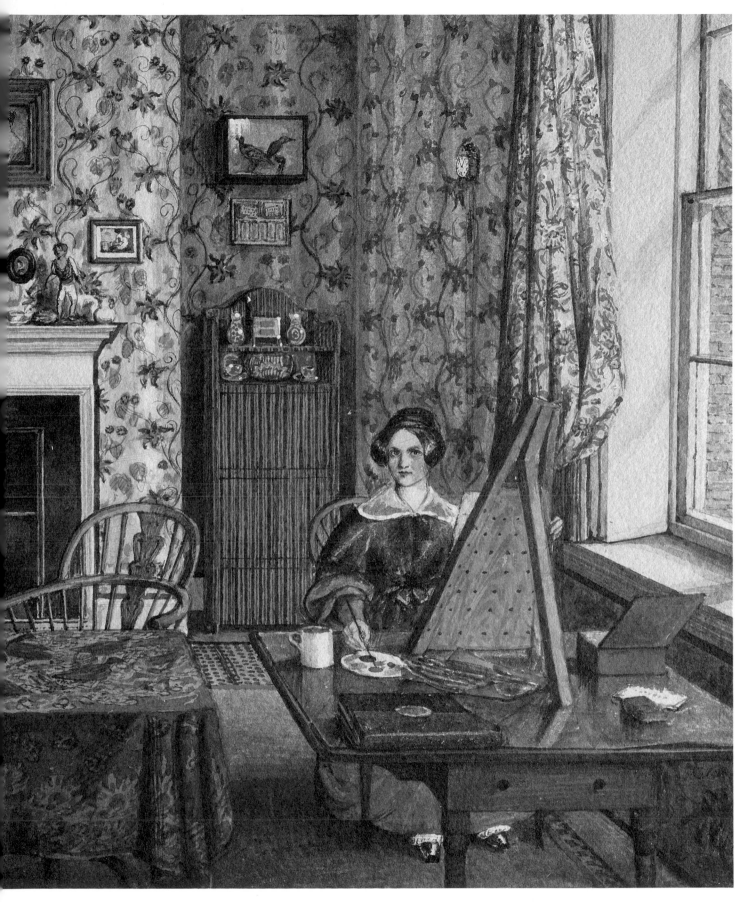

74 *'View of a canal [the Mauritskade] at the Hague, July 1838'*

While she was in The Hague, Ellen copied two sixteenth-century portraits in the Royal Picture Gallery at the Maurits-huis: an unknown woman wearing a black coat and yellow head-dress by Hans Holbein and Anna, two-year-old daughter of Ferdinand of Hungaria and Bohemia, by Albrecht Dürer. She also painted a street market and a maid servant at her hotel.

75 *'Interior of a cottage at Schiedam', 6 July 1838*

Schiedam, a town west of Rotterdam, was famous for its distilleries which produced high quality geneva, a spirit distilled from grain and flavoured with juniper berries (similar to gin). Such large quantities were produced in the town that 30,000 pigs were fed on the refuse grain.

Although Schiedam was 'never free from the smoke issuing from its numerous tall chimnies', this interior shows no signs of pollution. The decorative chimney cloth is snow-white and the tiled walls are spotless. The tiles show that a bourgeois family lived here, as does the servant in her wooden clogs, who is peeling turnips. On the wall above her head hang two brass lamps for burning rapeseed oil.

Because it is summer, there is no need for a full-scale fire. The *vuurpot* or brazier containing burning peat is sufficient for simple cookery. The earthenware geneva bottles in front of the fireplace held rainwater for drinking and cooking.

Ellen embarked for Rotterdam from Hull on 4 July 1838 with Elizabeth Alderson, the faithful family servant whom she had known since early childhood. (Alice Alderson, who was probably Elizabeth's niece, was too young and inexperienced to make an adequate chaperone; she went home to the family farm for a holiday.)

The two women spent two enjoyable months exploring Holland, which Ellen had hardly seen on her first continental tour. The main attractions were all close together and transport, by canal, river and road, was easy and pleasant. After exploring Rotterdam, they went to Schiedam, Gouda, Dordrecht, The Hague, Scheveningen, **74** Leiden, Haarlem, Zaandam, Amsterdam, Utrecht and Arnhem.

The differences between English and Dutch culture intrigued Ellen and she took every opportunity to record her impressions. The colourful costumes of the people from Friesland and the island of Marken and the enormous straw hats of the Scheveningen fisherwomen had no counterpart in England. Nor had she ever witnessed such scenes of industry as in the cottages she wangled her way into. The cottagers of Yorkshire were lay-abouts in comparison! Everything about Holland – from the beauty of the tiled **76** kitchens in the hotels they stayed at, to the curious street markets and fairs which they scoured for gifts – was so charmingly at variance with what she could see in England or Germany.

Like most visitors, then and now, Ellen loved the neatness and order of Holland. The extraordinary cleanliness of the inhabitants seemed to suggest a moral purity which was not to be found in England. Their Christian feeling was certainly borne out by the excellence of their charitable institutions, which put the ones Ellen knew in York to shame. Ellen noted that many of the Dutch charities were run by women, unlike those in England, and made a point of **78** visiting them.

For years Ellen had admired Dutch seventeenth-century genre painting and one of the main purposes of her tour of Holland, apart from enjoying herself and finding new subject matter, was to study plenty of good examples *in situ*. She was delighted when she came across interiors which had hardly changed in two centuries and which might easily have been immortalised by artists like Pieter de Hooch. **81**

After a leisurely progress through Holland, Ellen and Alderson boarded a Rhine steamer at Arnhem on 28 August **82** and made their way to Frankfurt. They stopped off at Düsseldorf, which was an important art centre in Germany, with a lively Academy of Painting and an association known as the Rhineland and Westphalia Art Society which promoted the work of local artists by arranging commissions and distributing prints of their work.

Schiedam July 6, 1834

76 *'Kitchen of the Zwijnshoofd Hotel at Arnhem, August 1838'*

The kitchen of the Boar's Head Inn is clean, well lit and tiled,
like all the others Ellen painted in Holland. It is equipped with
a water pump and sink (in the left hand corner) and two
modern stoves with hot plates for boiling water kettles etc.
fitted into the fireplace. The mantelpiece is decorated with a
frilled chimney cloth.

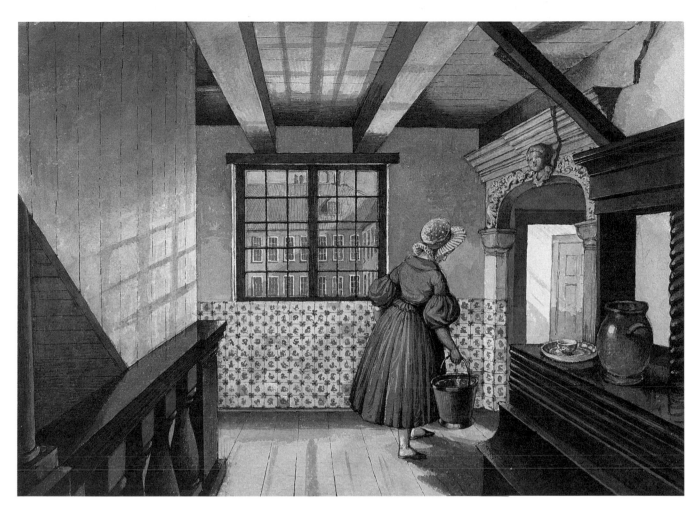

77 *'In the hotel, the Heeren-logement, at Leyden, August 1838'*

The Heeren-logement (literally 'gentleman's lodgings') was
originally built as a hotel for municipal guests in the second
half of the seventeenth century. When Ellen stayed there it was
no longer an official building but a private hotel. It has recently
been restored and is now Leiden public library.

Ellen frequently painted women servants at work during her
continental tours. This one, in her neat dress and cap, is
carrying a painted tin basket.

The large press in the corner was used for pressing linen
sheets and table cloths after they had been washed, starched,
ironed and folded.

Ellen's use of the golden mean in forming her compositions
is particularly easy to spot in this watercolour.

The two women stayed at the comfortable Gasthof zu den drei Reichskronen in the market square. The inn keeper, Christian Beeking, and his wife Antonette spoke French and were extremely friendly. Ellen was soon on such good terms with them that she painted twelve portraits of their children and relations. The Beekings introduced her to other people in Düsseldorf, including Gerhard Spatz, a Royal Lottery Collector and wine merchant, who was very interested in art. He and his family lived round the corner in Haus Karlsplatz on the main shopping street, Flingerstrasse.[18]

Before Ellen and Alderson continued their journey to Frankfurt, they were persuaded to return to Düsseldorf on their way home to see the picturesque street processions associated with the Feast of Our Lady of the Rosary and to visit the nearby manufacturing town of Elberfeld.

Their next stop en route to Frankfurt was Cologne, where Ellen painted a tower in the Roman brick wall and the crypt in the Church of St Gereon. They then went to stay in the Hotel de Trèves at Koblenz. Ellen painted a portrait of the beautiful young cook there, Apollonia Braubach, and the tomb of Kuno von Falkenstein, Archbishop of Trèves, in the Church of St Castor. Finally they ended up in Frankfurt where Ellen enjoyed seeing her old friends, particularly Lilly Eckhard.

Elizabeth Alderson returned to York on 22 October to announce the imminent arrival of a basket-work carriage mounted on wooden wheels which Ellen had bought the Robinson children in Rotterdam. Ellen meanwhile had gone to visit her maternal great uncle, John Dalton, a former army colonel, who lived at Fillingham Castle in Lincolnshire. He had nine children and some of Ellen's cousins were at home: James, a naval commander, and Frances Elizabeth with her husband, the Reverend John Walker Harrison of Norton-le-Cley, and five of their offspring, George Francis, Henry Dalbiac, Cecil Wray, Susan and Emily. Ellen was kept very busy painting all their portraits. An advantage of painting in watercolours was that when Ellen went to stay with people, she could easily take her equipment with her. She knew that her sketches made excellent 'thank-you' presents and that nearly everyone had an album which they were anxious to fill. Fortunately, she could work at remarkable speed when she needed to.

Ellen returned to York on 15 November, distributed her other presents (which included three books of coloured engravings) and was off to Langton to spend a week with Norcliffe Norcliffe on the 19th. After a one-day turn around in York, she hurried to Harrogate to visit Rose Worsley. Then, after two weeks or so at home, she went to Croft to spend Christmas with her other great uncle, the Reverend James Dalton.

78 *'The council room of the female governors, in the orphan house at Haarlem', 1838*

Although Ellen specialised in painting women, she did not often have the opportunity to represent them in positions of power and authority like this.

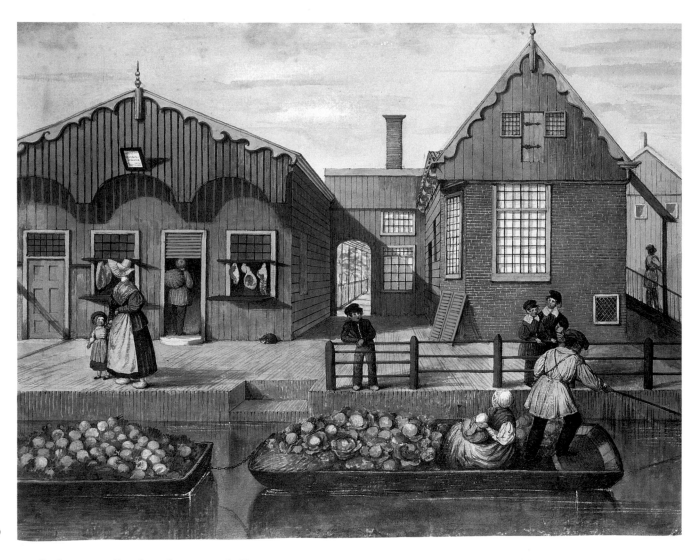

79 *'In the street at Zaandam, August 21, 1838'*

80 *'Stall in a kermis on the road between Rotterdam and Schiedam July 1838'*

Ellen visited this village on the River Zaan on a day expedition from Amsterdam. Zaandam was a well known tourist attraction. The extraordinary neatness of its painted timber-clad buildings, lattice-work fencing and brickwork quayside gave it the appearance of a toy village.

The butcher's shop on the left has a mirror hanging from the eaves to enable people inside to see who was approaching. English visitors to Holland often commented on the Dutch fondness for such mirrors. William Chambers, for example, wrote that: 'In our various walks we were much amused with observing that every house has one or more mirrors in frames, fixed by means of iron rods on the outsides of the windows, and at such an angle as to command a complete view either of the doorway, or of all that passes on the street. These looking-glasses are universal in Holland, both in town and country . . .'

According to Robert Batty, who visited the Rotterdam *kermis* or fair in 1828, 'the wider streets were filled with booths for the sale of trinkets and children's toys, cakes, and gingerbread, with all manner of eating and drinking, tossing of pancakes, and the same kind of exhibitions and amusements are as seen in one of our own country fairs of the better kind.'

Ellen's picture shows an *oliebollenkraam* or fritter stall. This was a temporary wooden structure with a cloth roof which travelled from fair to fair (every village and city in Holland had an annual fair to honour its patron saint and most still do). Each stall had one or two separate rooms curtained off at the back, with tables and benches, where people could eat their fritters undisturbed. There is a townswoman wearing her Sunday best in the left of Ellen's watercolour and, on the right, a village woman from the north or west of Holland with a typical golden cap (*oorijzer*) over a lace one underneath.

The brass pots contain batter for three kinds of food traditionally served at a fair: *oliebollen, poffertjes* and *wafels* (waffles).

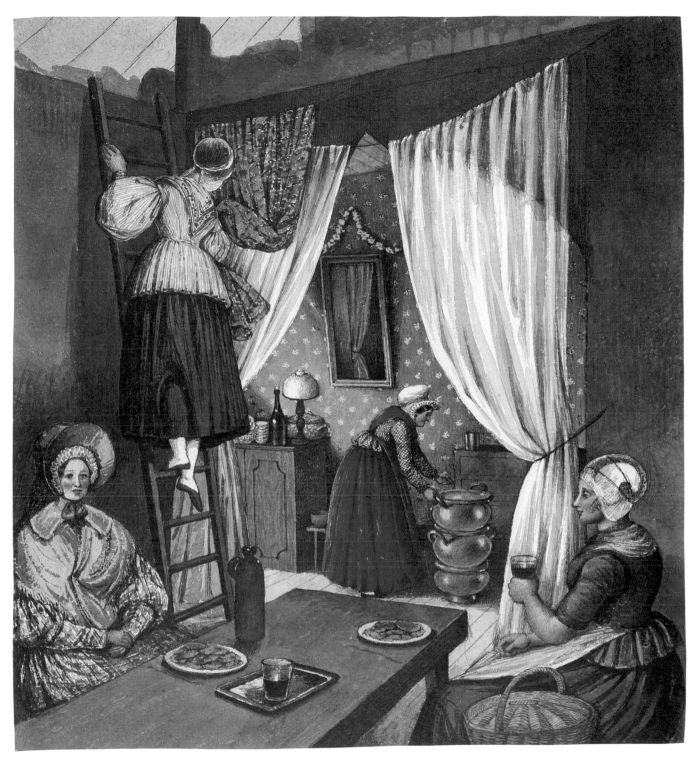

RECIPE FOR OLIEBOLLEN

200 gm wheat flour; 1 egg; 25 gm yeast; about 175 ml milk; 120 gm raisins, currants and candied lemon peel; 5 gm salt; cooking oil

Make a batter and mix in the raisins, currants and candied lemon peel. Let it rise for about one hour. Heat oil in a very hot pan until it smokes. Then take a little bit of batter between two spoons and let it carefully slide into the hot oil. Cook each *oliebollen* until browned (about 5 minutes). Then remove it from the pan and drain it on a sheet of absorbent kitchen paper. Sprinkle the fritters with castor sugar before serving.

81

81 *'In a public house, the "Rotterdamsche Welvaren" at Gouda, July 12 1838'*

There are notices on each side of the entrance advertising diligences to Amsterdam and steamboats to Rotterdam.

The composition, colour scheme, mellow lighting and inclusion of details like the reflection in the mirror and view onto the street through an open doorway are reminiscent of countless seventeenth-century paintings of Dutch interiors. Ellen's admiration for this genre and her strong desire to emulate it are particularly evident in this watercolour.

82 *'Night scene on board the Rhine steamer, August 28 1838'*

This is one of Ellen's most original and successful night-time watercolours.

By the late 1830s there were numerous steam boats bearing tourists up and down the Rhine. The guide books were unanimous in recommending this form of transport as the most efficient and pleasant way of seeing Germany: people could stop off at as many or as few places as they wanted and they could also travel in considerable comfort.

William Chambers thought that the steam boats on the Rhine were 'as neat and commodious' as those on the Thames or the Clyde and praised their 'remarkably careful management'. Each vessel was under the care of a captain who superintended the navigation, a gentlemanly clerk who took care of the passengers, and a steward who provided good meals at moderate prices. When ascending the river against the current, steam boats travelled at about 5 miles an hour; when descending they managed 15 miles an hour.

The effectiveness of steam power was demonstrated as early as 1816 when a Dutch boat halved the ten-day journey from Rotterdam to Cologne. But it was not until the Rhine Naviga-tion Treaty of 1831 abolished the myriad of different rules and tolls imposed by different towns that travellers were able to take full advantage of it. The journey time between Rotterdam and Cologne was then reduced to two or three days.

In the 1840s steam boat travel on the Rhine began to decline with the coming of railways.

83

84

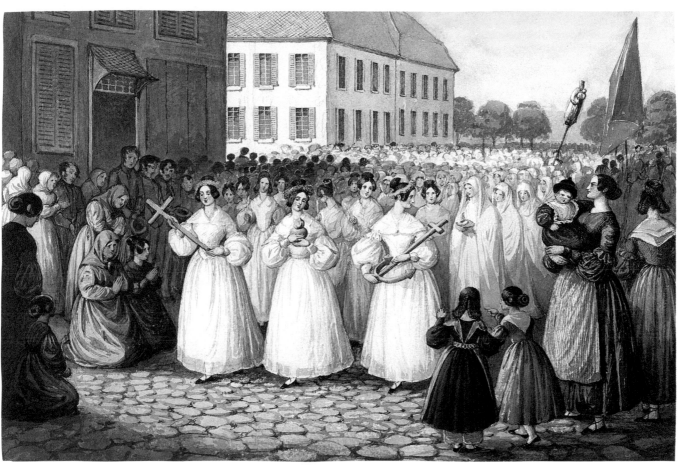

84

84 *'Procession at Dusseldorf, October 14, 1838'*

Foreigners were invariably impressed by street processions in Germany. The processions celebrating different religious feasts were similar in character but the most remarkable were held on Corpus Christi Day. Anna Mary Howitt witnessed one while she was an art student in Munich in 1850:

'The air was filled with the sound of hymns and the pealing of bells; altars were erected at the corners of the streets, at the fountains, and before the churches. Through the gay street wound the long train; priests in their gorgeous robes, scarlet, white and gold, under gorgeous canopies; Franciscan monks in their grave-coloured garbs; Sisters of Mercy; various brother-hoods in quaint picturesque attire, all with gay floating banners and silver crucifixes. Then came young girls with wreaths of myrtle on their heads, with lilies and palm-branches in their hands, or bearing books, tapers or rosaries; then troops and troops of little children, all in white, and their heads covered with flowers, and all raising their pure youthful voices in hymns of praise!'

The particular procession in this watercolour celebrated the Feast of Our Lady of the Rosary. Although its official date was 7 October, the feast was celebrated throughout the month. Typically, Ellen painted the young girls and nuns in the gathering, rather than the priests.

83 *'Crypt in the Church of St Gereon at Cologne, September 1838'*

This Romanesque church was dedicated to St Gereon and his companions, a group of fourth-century martyrs venerated in Cologne. The circular stone in front of the altar marks the spot where, according to legend, their bodies were thrown into a well. Archaeological research has not confirmed this tradition.

The coloured glass balls placed on the capitals and the Renaissance stone altarpiece were a popular lighting device in the eighteenth and early nineteenth centuries: candles were placed behind the balls, which were filled with water.

85

This frenetic round of visits continued in the New Year. On 29 January, Rosamond reported that her children had tea with Alderson, who was on her own, 'my sister being in the south at this time, visiting London, Bromley Common, etc.'[19] Ellen's life calmed down a little when she returned from London on 23 February. But the end of March was enlivened with a visit from Rose Worsley.

At the beginning of April Ellen gave a 'bun feast' for the three eldest Robinson children, their cousins and friends, which, according to Rosamond, was a great success: 'She amused them with "Snap the Tongs", "The Fisher of the Sea", "Hunt the Slipper", and a quadrille, and finally opened a huge cocoa-nut which Fenton Wake had brought her.'[20] She spent the rest of April with her great uncle James at Croft. His daughter Caroline was there, along with a naval lieutenant, Ralph Milbanke, and his wife. Ellen painted their portraits and the Milbankes took her to see Moulton Hall, a seventeenth-century manor house with a magnificent carved staircase. The house had not only once belonged to the Milbanke family, but also to one of Ellen's relations by marriage.

Excursions such as these, however, did not satisfy Ellen's itch to travel. On 12 June 1839, Rosamond reported that her dear sister had gone to Hull, 'accompanied by Alderson, to embark in the Sea Horse for Rotterdam for a three months' tour on the Continent'.[21] On this occasion, Ellen did not linger in Holland, although she spent several days in Delft painting the town gate, a snuff mill and the staircase of the Prinssenhof where William of Orange had been assassinated. She was bound for Düsseldorf to see the Beeking and Spatz families and to paint the town's colourful costumes. She also wanted to visit places in Germany which she had not yet seen.

She and Alderson therefore adopted an ambitious route which took them south to Neuwied, where they stayed at the Gasthaus zum Goldnen Anker, and north-east to Elberfeld, Kassel, Göttingen, Seesen, Brunswick and Helmstedt. The roads were often bad, but they could at least afford to travel in a private diligence and stop when and where they pleased. Ellen was particularly taken with Kassel, where she painted the old palace, the vulgar marble baths and the local costumes to be seen in the market. She was also pleasantly surprised by Brunswick, which retained a completely unspoiled mediaeval atmosphere.

After Helmstedt, they headed into what is now East Germany, pausing to see Magdeburg cathedral, the Royal Palace at Berlin, the stupendous art collections in Dresden, the Pleissenburg in Leipzig, and the nunnery at Erfurt. They reached Frankfurt in early September.

When Ellen left the city a few weeks later, she was engaged to marry Johann Anton Phillip Sarg, an impecuni-

85 *The staircase at Moulton Hall, near Richmond, Yorkshire, April 1839*

This magnificent oak staircase with its elaborately carved panels, vases and hanging pendants was built between 1654 and 1670. It still exists today: it rises, in six short flights, to the second floor of the house, which belongs to the National Trust. However, due to architectural changes made in Victorian times and some rearranging of the panels and vases, it is not clear from which level Ellen painted the staircase.

Ellen may have visited her cousin and school-fellow Susanna Dalbiac here at various times between 1815 and 1836. The house then belonged to Lieutenant-General Sir James Charles Dalbiac, who had married the eldest daughter of Ellen's great-uncle Colonel John Dalton. In 1836 he sold the house to provide a dowry for Susanna, who married the sixth Duke of Roxburghe. When Ellen painted the staircase in 1839 the house was not occupied by family or friends, but by tenants of the new owner.

Moulton Hall April 30 1830 H.E.B.

85

86

86 *Interior of St Peter's Church, Croft, Yorkshire, 1830s*

Ellen's great uncle, the Reverend James Dalton, was rector of
Croft from 1805 to 1843. Ellen often went to stay with him
and painted the fourteenth-century church several times.

The interior is still dominated by the ostentatious raised
family pew on the right: it was put up for the Milbanke family
of Halnaby Hall in the seventeenth century. But much else has
changed. The box pews and pulpit in the left hand corner have
been replaced with Victorian Gothic ones. The whitewashed
plaster on the walls has been removed to expose the underlying
stonework and the stone flags in the centre replaced with
concrete. There is a new Victorian stained glass window on the
far wall and an extra window has been cut into the wall over
the far left arch. The painted coat of arms has gone, its place
taken by a host of Victorian memorial plaques.

ous German schoolmaster and amateur musician who, at twenty-nine, was almost a year younger than herself. It appears to have been a whirlwind romance and must have seemed quite extraordinary to Ellen's contemporaries.

Johann came from a modest family in Nuremberg. His father, Franz Xaver Sarg (1777–1844), was born in Hünningen in Alsace, the son of a master saddler. He had served an apprenticeship in the materials trade in Strasbourg, but left this at the outbreak of the French Revolution to join the Comtresches Corps. In 1796 he went into service in Switzerland. His employer brought him to Nuremberg and, after this job came to an end, he remained in the city, serving Major Hammer for two years from 1801 and Duchess Caelis for two and a half years from 1803. In 1806 he became a waiter at the Harmonie Gesellschaft, a club which provided entertainments for its members, as well as a social and cultural meeting place. He supplemented his monthly income of 15 gulden from this job by book-keeping and teaching French on the side. By 1822, however, he was a full-time French teacher.[22] Little is known about Johann's mother apart from her name (Maria Barbara, née Steinmetz), occupation (seamstress), religion (Protestant, unlike her husband who was Roman Catholic) and the dates of her birth and death (1776–1843).[23]

Johann's older brother, Johann Friedrich Heinrich (or Franz) Adalbert (1803–1876), became a waiter like his father, working in Karlsruhe and Heidelberg before he came to Frankfurt in the early 1820s. He was an intelligent, ambitious young man and soon became head waiter at the Gasthaus zum Weidenhof. By February 1827 he was engaged to Margaretha Stier, the daughter of a prosperous local butcher. He was going up in the world: not only did he aspire to be a restaurant owner and wine merchant, but he also wanted to become a citizen of Frankfurt.[24] Fortunately, he had the backing of his future father-in-law. In March 1827 Johannes Stier bought him and Margaretha an elegant but run-down hotel as a wedding present. It was called the Russischer Hof and was strategically situated on the spacious Zeil, Frankfurt's main shopping street. Something of the hotel's atmosphere can be gathered from the auction particulars:

'The house consists of about sixty rooms, comprising reception rooms, smaller rooms, cabinets and chambers. The reception and main rooms are fitted with the most beautiful mirrors and everything is in the best of taste and furnished with no expense spared. The doors of the grand salon are rosewood veneered. In the chambers there are ten fireplaces, many busts and marble statues, including a most artistic copy of the Medici Venus. The main staircase, admired by everyone who has seen it, has two large marble

87

87 *Portrait of Magdalena, Annette and Elisa Beeking Düsseldorf, 1839*

Ellen painted many portraits of the Beeking family when visiting Düsseldorf in the summers of 1838 and 1839. Mr and Mrs Christian Beeking kept the well known Gasthof zu den drei Reichskronen in the market square, where Ellen stayed.

The youngest girl in this group portrait was their daughter Elisa, born in 1828. The girls at the piano may have been her cousins.

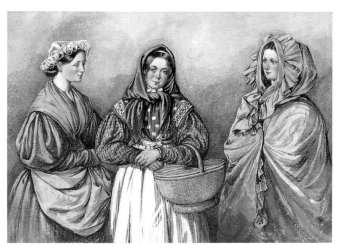

88

88 *'Costumes of Dusseldorf', 1839*

The costumes of women from three different social classes are represented in this watercolour. The woman in the middle, wearing a green scarf and carrying a basket, is a country woman who would have come into Düsseldorf to sell farm produce and to shop. Her companions, however, are both from the town: the woman in the white cap comes from the middling ranks of society and the cloaked figure from the upper class.

Early nineteenth-century artists liked to paint picturesque local costumes, which were fast disappearing under the impact of industrialisation, and Ellen was no exception.

lions on pedestals. The building has two large courtyards and a small one, stabling for six horses in a separate stone building, other outbuildings, a laundry, water and rain pumps, and a beautiful bathroom. Also a large cellar for wine and a cold store.'[25]

Under the young couple's clever management the Russischer Hof (or Hotel de Russie as it was also known) was rapidly transformed into one of the top hotels in Frankfurt. By 1834 the Sargs could afford to buy the house next door and expand into it.

History does not relate how Ellen met Johann Anton Phillip Sarg or when. It is possible that they met during her first continental tour. For Ellen painted a watercolour of the entrance hall of the Russischer Hof in July 1835. She and her mother may have stayed there on arriving in Frankfurt, and they would certainly have attended concerts and other social functions in its grand reception rooms. Since Johann was living with his brother and sister-in-law at the Russischer Hof, there would have been many opportunities for an introduction.[26]

Johann was an enthusiastic musician (he played the violin and the piano) and was undoubtedly involved in organising the concerts and musical entertainments which helped to make the hotel such a popular meeting place. He was not, however, formally employed by his brother. He was teaching at the Englische-Fräulein-Schule between 1834 and 1837. This was the most exclusive and academic girls' school in Frankfurt. Its curriculum consisted of history, geography, German language, natural history, arithmetic, singing, German and French composition, and drawing.[27]

If Johann and Ellen did meet before 1839, there are no signs of an immediate *coup de foudre*. Ellen was in no hurry to get to Frankfurt in either 1838 or 1839; and there is no mention of Johann's name in Rosamond's *Family Chronicle* until he had arrived in York to marry Ellen.

It therefore seems most likely that they met for the first time after she reached Frankfurt in 1839. Ellen and Alderson probably decided to stay at the Russischer Hof and made friends with the Sarg family, just as they had done with the Beekings in Düsseldorf. If so, a meeting with the good-looking Johann was inevitable: he was now working for his older brother as a manager and this brought him into daily contact with the guests.[28]

Ellen's 'List of Portraits' supports this interpretation: while she was in Frankfurt she painted two members of the Sarg family, which was a certain sign of growing intimacy. She also painted the dining-room of the Russischer Hof and a still-life of apples, pears and two ripe figs lying on the table top beside a loaf of bread, jug and wine bottle labelled 'F.A. Sarg 1834 Liebfraumilch Frankfurt a/M'.

It also seems likely that Lilly Eckhard played a part in furthering the match: this may explain why Ellen asked her to come to England, to help prepare for the wedding and to be her bridesmaid. Lilly agreed and the two friends travelled to England via Belgium.

Alderson arrived in York five days before them, on 24 September, with the first installment of presents for the Robinson children. Rosamond, who was Ellen's favourite, received a Berlin iron brooch and a cup of amber Bohemian glass. Ellen handed out the second installment herself over a 'welcome home' dinner at the Robinsons' large new house at no. 30 Clifton, opposite St Peter's Collegiate School. 'Ellen brought the five elder children silk neck handkerchiefs, a German pictorial alphabet for the boys, a white collar from Gottingen worked in red wool for Anny, a Prussian nankin coat for Rosamond, a p[r] of Berlin shoes for Ellen, a similar pair and p[r] of yellow boots from Brunswick for Mary.'[29]

Rosamond and Lilly took to each other at once and the next three months passed very pleasantly. As Rosamond explained in her *Family Chronicle*, 'She and my sister dined with us frequently, and on Sunday invariably'.[30] Rosamond was pregnant again (her seventh child, Beatrix, was born in December) and she was very glad to have Ellen and Lilly's company. They helped her get together the children's new winter outfits and taught them how to play some novel German games. They also shared the burden of entertaining the Mainwaring family when they came to stay for a few days just before Beatrix was due. Apart from one short trip to Croft, Ellen did not leave York. She was far too busy preparing for her wedding.

At the end of November Lilly and Ellen went to stay with Frances and James White Worsley at Thornton-le-Moor. Thomas Taylor Worsley joined them there and reported to his sister that Ellen and Lilly were 'taking the opportunity of having some friends to dinner whilst they have a party in the house'. He added that Ellen was 'going to be married in a short time to a gentleman of Frankfurt – not a desirable match but all seems to be settled and it is to take place about January'.[31] On their return to York, the two friends entertained the Mainwaring family for a few days. Apart from a short trip to Croft, Ellen did not leave York again that year. She was too busy preparing for her somewhat controversial wedding.

89 *Portrait of Johann Anton Phillip Sarg, February 1840*

To symbolise their unity, Ellen's husband is holding the self-portrait she gave him in December 1839, just before their wedding. The red upholstered chair was a present from Colonel George Cholmley of Howsham Hall. It often appears in Ellen's watercolours of her drawing rooms.

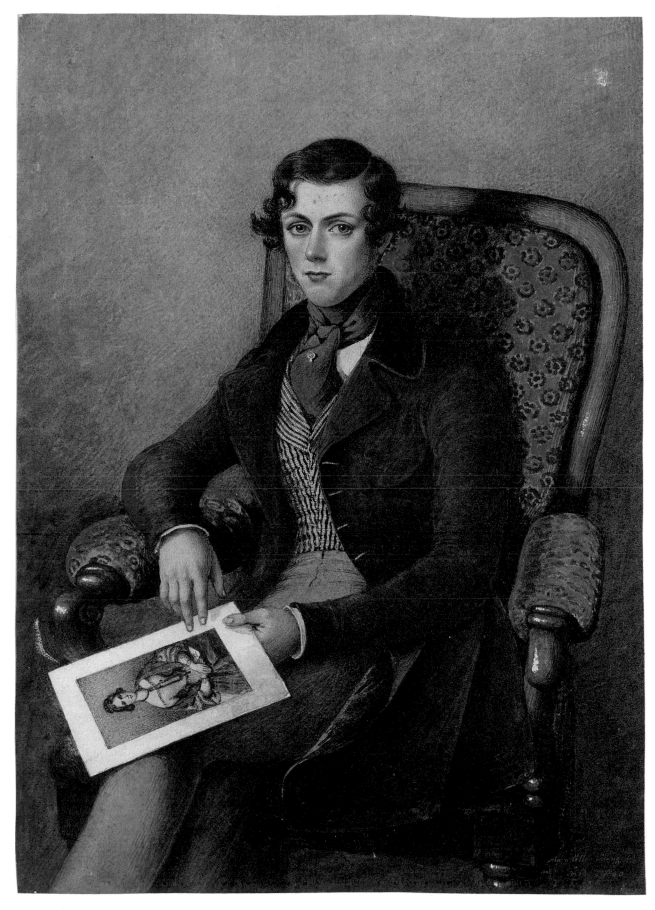

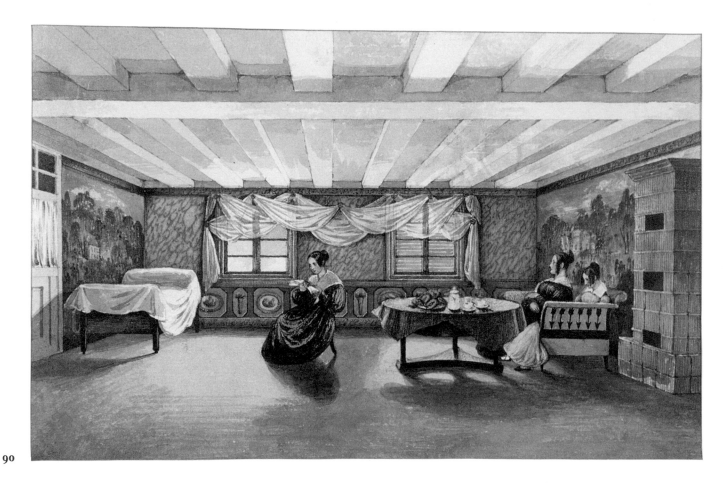

90

90 *'Gasthaus zum Goldnen Anker. Recollection of a day spent at Neu Wied, July 11th, 1839'*

Ellen (in the yellow dress) is having coffee and cakes with two friends in her hotel bedroom. Although the walls are sumptuously decorated with painted stipple work, panels, borders and landscape scenes, the furnishings are sparse and functional. English and American travellers often complained bitterly about the narrowness and hardness of German beds and their uncomfortable bolsters and duvets, but the example in the corner does not look too uninviting!

In the 1830s, Neu Wied was unlike most of the tourist centres on the Rhine: it was a 'new town' (the oldest building dated from 1737) and it attracted settlers of every religious denomination.

Neu Wied made a convenient stopping-off point for travellers on their way to and from Frankfurt.

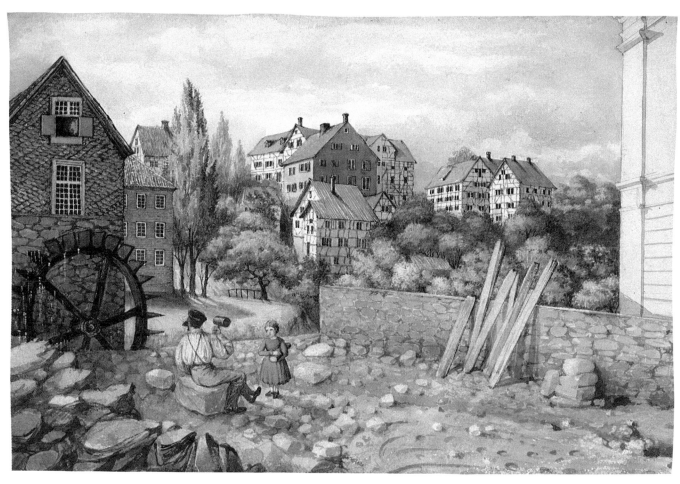

91 *'View at Elberfeld', 1839*

Elberfeld, which is now part of Wuppertal, a vast industrial
area east of Düsseldorf, was a fast-growing manufacturing
town in the 1830s. It was so famous for its cottons, silks,
threads and red dye that William Chambers called it 'the
Manchester of Germany'.

The stone breaker in the watercolour is working on a new
house on the outskirts of town. Later in the century, continen-
tal artists adopted the figure of the stone breaker as a symbol
of the proletariat. The child standing in front of him is holding
a loaf of bread.

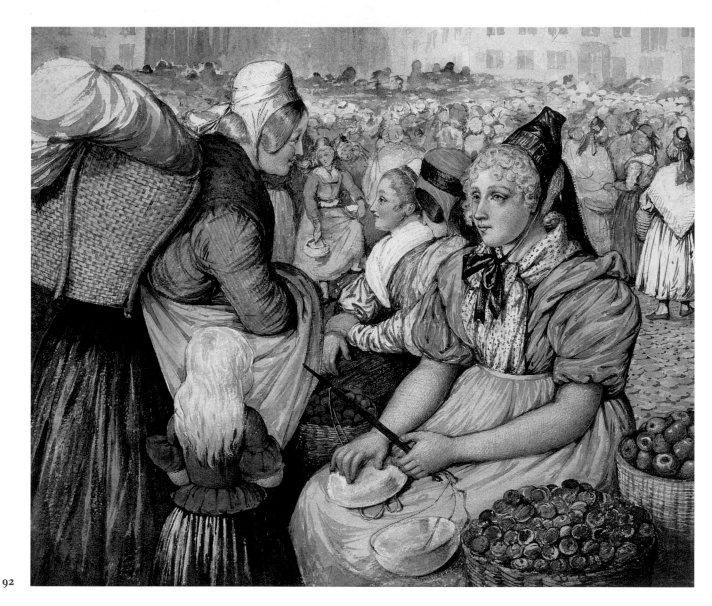

92

92 *'Market costumes, Cassel', 1839*

Ellen was particularly fond of painting market women. In this study she has concentrated on a young woman selling green-gages and damsons who is staring vacantly, ignoring the woman and girl standing before her.

In painting this disquieting picture, Ellen may have been influenced by the artist George Lewis. In *A Series of Groups, illustrating the physiognomy, manners and character of the people of France and Germany* (1823) he argued that markets were the best place to study the character of 'the middling and lower orders' but warned against a superficial approach based on costume alone:

'Hitherto, in the delineation of costume, it seems to have been considered necessary to represent little else than mere dresses; and if these, which are generally arranged after the antique, were accurate as to colour and shape, it was thought sufficient. It will however be admitted, that much more than this is wanting to give a correct idea of the characteristic appearance of different nations.'

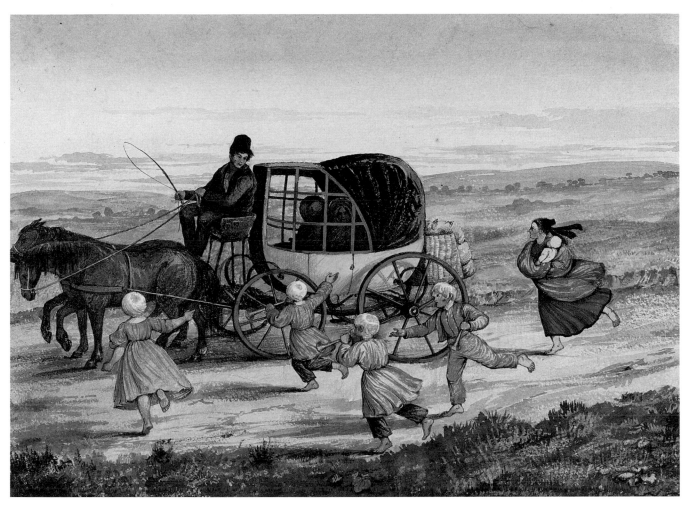

93 *'Children begging, scene on the road between Gottingen and Brunswick', 1839*

Ellen and her maid Elizabeth Alderson can be seen in the carriage on the dirt road. Many main roads were not yet macadamised in Germany, much to the chagrin of English tourists who were not used to such bumpy journeys. Three of the four barefoot children are holding trumpets, which suggests that they are not ordinary beggars but come from a family of travelling players.

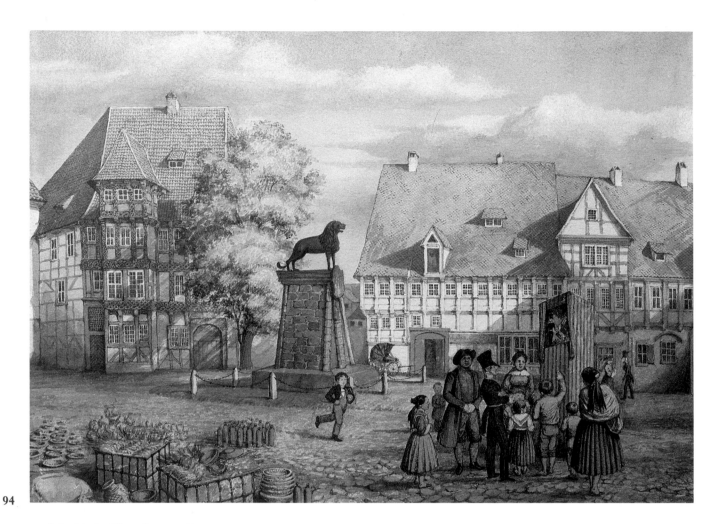

94 *'The Market Place, Brunswick', 1839*

There is not much activity in the cobbled Burg platz: some crates of pottery are being unpacked for sale and a 'Kasperl-theater' puppet show is attracting a small crowd of miscellaneous adults and children. Kasperl was a clown/fool figure renowned for his common sense and earthy jokes, not unlike the 'Mr Punch' of English Punch and Judy shows.

The heraldic bronze lion standing majestically in front of the sixteenth-century half-timbered houses was erected by Henry the Lion, Duke of Bavaria and Saxony, who settled in Brunswick in 1166.

95 *'Collegiate building at Helmstadt' [i.e. Helmstedt], 1839*

The university building in the foreground is the Juleum, a masterpiece of German Renaissance architecture designed by Paul Francke and erected between 1592 and 1597. Its unusual tall stair tower on the south front can be seen peeping out behind the gables. The Juleum is now a cultural centre and it has been painted bright red.

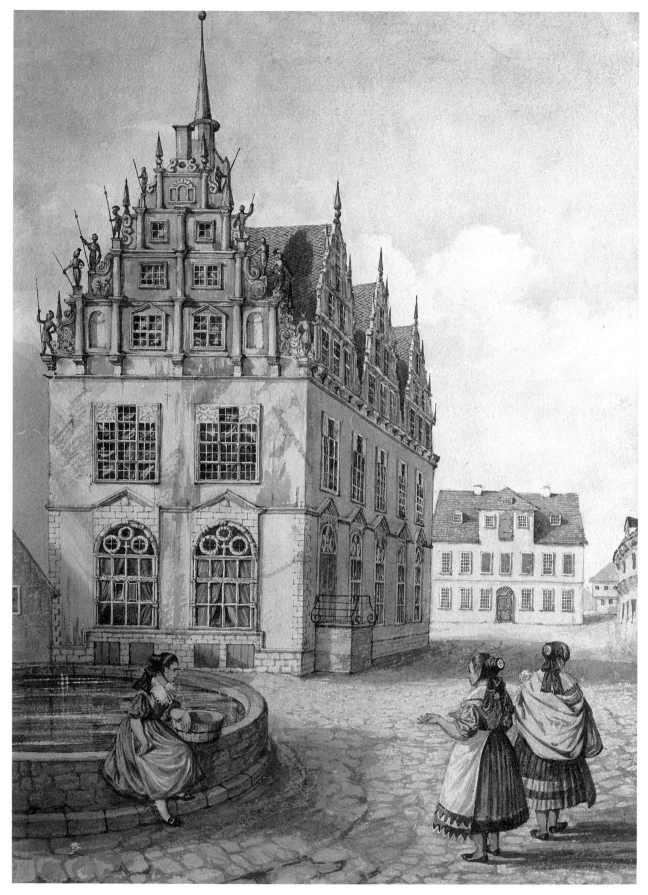

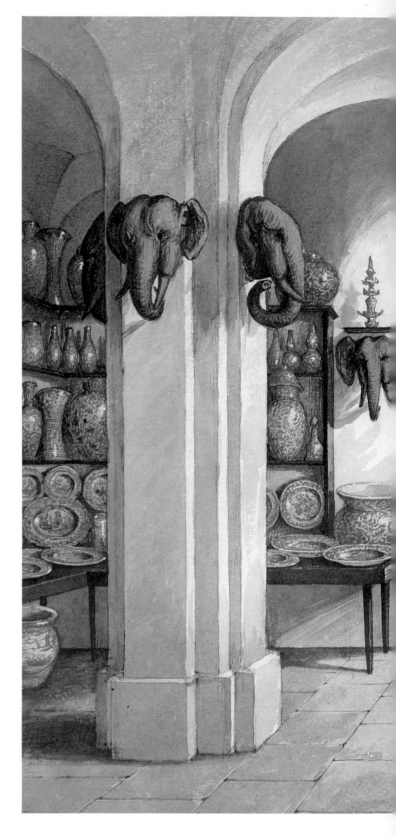

96 *'The Porcelain Museum, Dresden', 1839*

A small part of the enormous porcelain collection of Augustus the Strong, Elector of Saxony between 1694 and 1733, can be seen here in one of the cellars of his specially built museum, the 'Japanese Palace'. The Elector collected more than 20,000 pieces from China and Japan and from the famous factory he helped to establish at Meissen in 1710.

The Elector drew up detailed plans for displaying his porcelain in over thirty galleries which were to have figures and vessels decorating the walls. Although his plans were never realised – the Palace was incomplete at the time of his death and his successors relegated much of the collection to the vaults – Ellen's watercolour shows that similar pieces were displayed together as he had wanted, in this case Chinese ceramics made in the reign of the Emperor Kangxi (1662–1722).

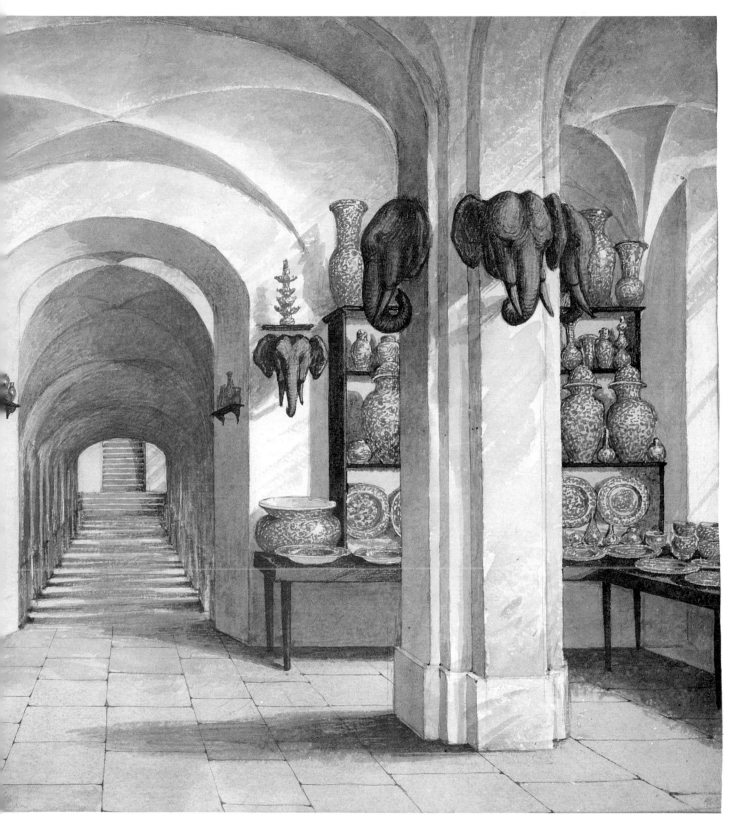

96

97

97 *'Historical Museum, Dresden', 1839*

This superb display of armour and weaponry collected by the Electors of Saxony was exhibited in the Zwinger, a building begun in 1711 but never completed. In addition to containing the Historical Museum, it housed a Museum of Natural History and Cabinet of Prints and Drawings.

Visitors were invariably impressed by the dramatic and imaginative way in which the armour was displayed. Parker Willis, an invalid who 'rambled' round Germany in 1845, noted that the suits of armour were 'put on manikins and mounted on wooden horses' so that a tour of inspection was 'like walking down a line of knights in the saddle'. Captain Edmund Spencer, who visited Dresden in 1834, was astonished to see 'a whole army of warlike princes, and noble knights, fully caparisoned, and looking fierce, as in life, mounted on prancing steeds'. Apparently, every effort was made to identify the warriors who had owned particular suits of armour or weapons and to show what they looked like.

The Dresden armoury is one of the oldest and finest in Europe, its origins dating back to 1425. The Electors, however, did not begin to collect systematically until the mid-sixteenth century and there were few notable acquisitions after the death of Augustus III in 1763. Although Dresden was destroyed by the Allies in 1945, the contents of the Historical Museum were saved and some 10,000 pieces can still be seen in the rebuilt Zwinger.

98 *'Entrance room of the Ursuline Nunnery at Erfurt,
September 4 1839'*

Ellen visited this nunnery, which provided a free education for
orphan girls, because she was very interested in philanthropical
institutions run by and for the female sex. She may well have
read John Russell's account of his visit to the convent in the
early 1820s. He was typically English in being both fascinated
and repulsed by Roman Catholicism:

'The Abbess of the Ursuline convent in Erfurth very affably
receives the world, though she never comes into it. The
convent machinery is entire. When you knock, a key is sent out
by a turning box, and the key itself admits you no further than
the parlour grate. The grate, however, is no longer the *ne plus
ultra* of the profane sex. A withered dame, whose consecrated
charms could bear with perfect impunity the gaze of worldly
eyes, admits the visitor to the presence of the Abbess in the
parlour, a spacious, but empty, bare, comfortless room . . . A
black gown, like a sack, anything but fashioned to show the
shape, descended from the shoulders to the toes in one
unvarying diameter. A thick white bandage wrapped up the
neck to the very chin, and was joined below to a broad tippet

of the same colour, which entirely covered the shoulders and
breast. The eyebrows peeped forth from beneath another white
bandage, which enveloped the brow, covered the hair, and was
joined behind to the ample black veil, which the Abbess had
politely thrown back.'

When Russell visited the convent, the seventeen nuns made
work-bags, pin-cases, pin-cushions and similar trifles which
were laid out for sale on the parlour table. However, these are
not to be seen in Ellen's picture, although the parlour grate
and nun's habit are as he described.

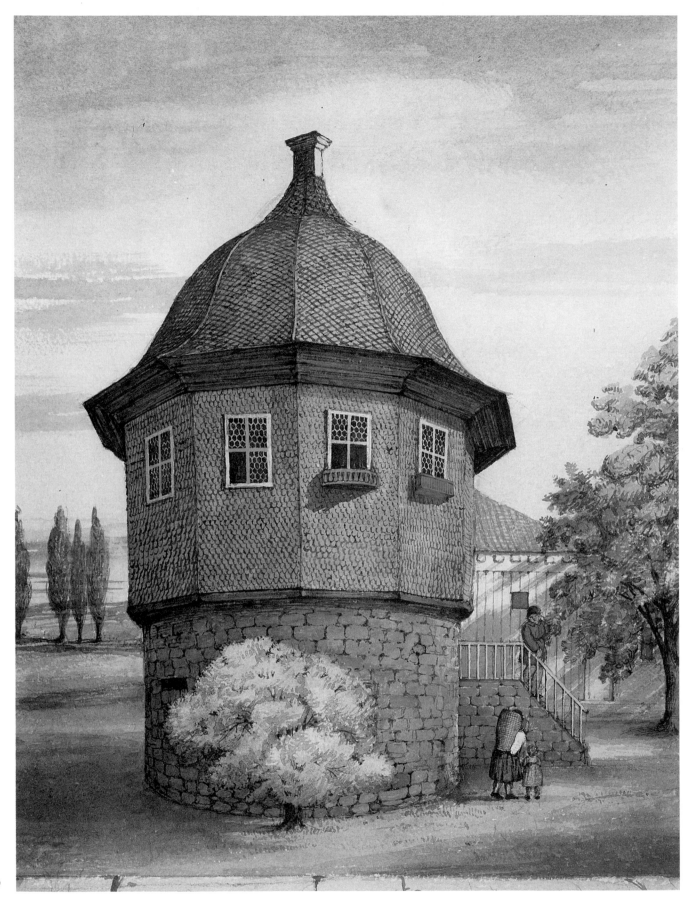

99

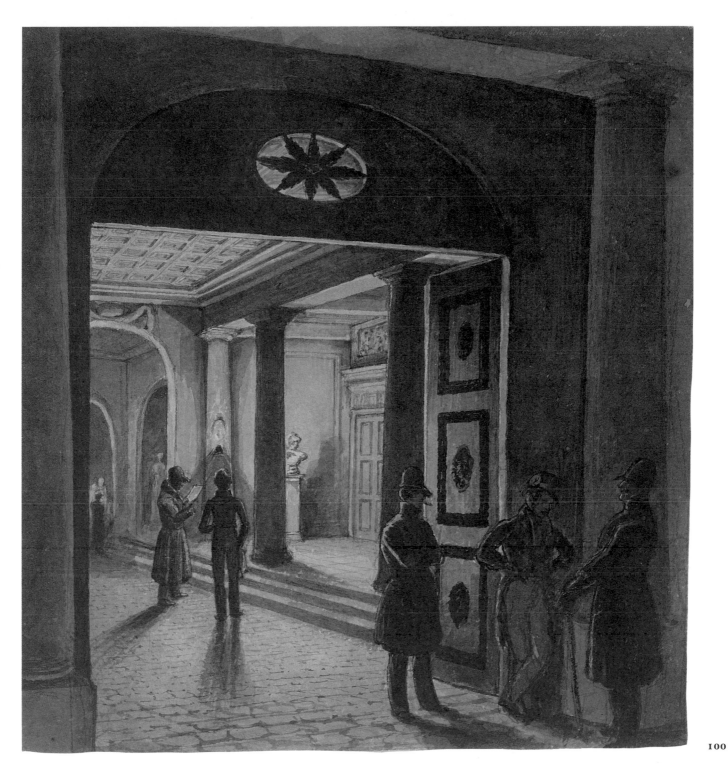

99 *'Summer house in Neuhof, near Fulda, September 1839'*

Summer or garden houses were particularly popular in Holland, though this is a German example. Frequently octagonal in shape, they were built in positions which commanded a good view of the main road. In fine weather families would repair to these pleasure houses in the evening and amuse themselves by observing and conversing with passers-by. They would drink beer, coffee or tea, the men often smoking their pipes and the women knitting.

100 *'The great entrance to the Hotel de Russie, in the Zeil, Frankfurt – sketched at night, July 1835'*

By 1835 the Russischer Hof had become one of the grandest hotels in Frankfurt under the Sargs' management. The hotel, which was built in the 1780s to the design of Nicolas de Pigage of Lorraine, so impressed Goethe that he had a model made of it. And when Bismarck was the Prussian envoy in Frankfurt in the 1850s, he tried to buy it as his private residence. Carriages passed through the arched and columned hall shown here.

4 – Marriage and Life on the Continent

Johann Anton Phillip Sarg, Ellen's 'affianced husband', arrived in York on 21 December 1839. He stayed with the Robinsons, but spent a great deal of time at Ellen's house. On Christmas Eve he and Ellen held a party for the Wakes, Lilly Eckhard and the Robinson children. The occasion was a curious mixture of English and German customs: they ate 'frumenty', a dish made out of hulled wheat boiled in milk, sweetened with sugar and seasoned with cinnamon, as well as other traditional fare such as mince pies and gingerbread, but sat round a 'German' Christmas tree opening Christmas boxes filled with surprises from abroad.[1]

The wedding took place at St Olave's Church on 15 January 1840. The atmosphere must have been tense, for most of the guests were involved in 'the great will cause' which was to be heard in York's Prerogative Court the following day. The Worsley family and indeed most of Yorkshire society were bitterly divided over the will of the late Miss Frances Worsley of Hovingham Hall, who had left the residue of her will, about £10,000, to her executors Dr Baldwin Wake, her physician, and the Reverend Ralph Worsley, rector of St Olave's. (The court eventually rejected the allegation that they had unscrupulously taken advantage of their professional relationship with the elderly spinster.)[2]

Rosamond, however, does not mention the impending court case in her description of Ellen's wedding:

'This being my dear Sister's Wedding-day, we assembled at her house soon after 9. The bridal party, consisting of Ellen and Mr Sarg, Col. Norcliffe and his son, Capt. and Mrs James Worsley and their two children, Miss Eckhardt, Carlisle Wake, my Husband and myself, went in three carriages to St Olave's Church, where the Rev^d John Heslop united Mary Ellen Best to Johann Anton Phillip Sarg of Nuremberg in Bavaria. The Bridesmaids were Miss Eckhardt and little Miss Worsley. On our return from Church, we breakfasted at Ellen's house, where Mess^rs Brook and Travis [i.e. John Brook, their old friend and family solicitor, and John Travis, another family friend] joined us. The newly-married pair went to Whitby Abbey, accompanied by Harriet Alderson . . . Capt. and Mrs Worsley and their children spent the evening with us; also Lilly Eckhardt, who now came to stay entirely with us for a month. She helped me to receive bridal calls, and to hand cake and wine for several days, and afterwards accompanied me to return them all.'[3]

It is disappointing that Rosamond does not supply more details of the wedding, or say what she made of Anthony, as Ellen called her husband. One would like to know whether she liked him (she did not conceal her affection for Lilly) and whether she thought he would make a good husband. Did she hold Anthony's modest background as a school teacher and hotel manager against him? Or suspect Anthony of marrying Ellen for her money? Rosamond was a shrewd woman and would have quickly divined that he had no capital of his own. His French was excellent, but was his English sufficiently good to make conversation a pleasure? Was she impressed by his playing of the piano and violin?

Unfortunately, Rosamond's *Family Chronicle* does not contain a single hint of what her feelings were, unless one interprets her silence as a sign that she had her reservations about the marriage. It certainly would not have been surprising if she had mixed reactions. Being happily married herself, she must have hoped Ellen would marry and have children too. On the other hand, she was extremely fond of her sister and thoroughly accustomed to having her around: the thought of Ellen marrying a foreigner and deciding to leave York permanently for the Continent cannot have pleased her.

In speculating about Rosamond's state of mind, it is important to remember that she was losing not only her closest friend, but also her most useful and reliable child-minder. Much is revealed by her comment that Ellen's departure from York was 'a great loss to our little ones, who had been such frequent and welcome visitors at her house'.[4]

If Ellen's other relations and friends took a dim view of her marriage, there is no evidence that they did anything to stop it. They all came to meet Anthony, the closest of them attended the wedding ceremony, and Colonel George Cholmley made Whitby Abbey, his highly romantic second home, available for the honeymoon. Some people must have thought that Ellen was lucky to find a husband so late in life. The majority of women married in their late teens or early twenties and Ellen was thirty! They may even have been struck by her fashionable choice. Less than a month later, on 10 February, the whole country was to celebrate Queen Victoria's wedding to her German cousin, Prince Albert. The Robinson children had a holiday from school that day and were taken by their parents into York to see the illuminations in the evening.[5]

The Sargs also joined in these celebrations. They had

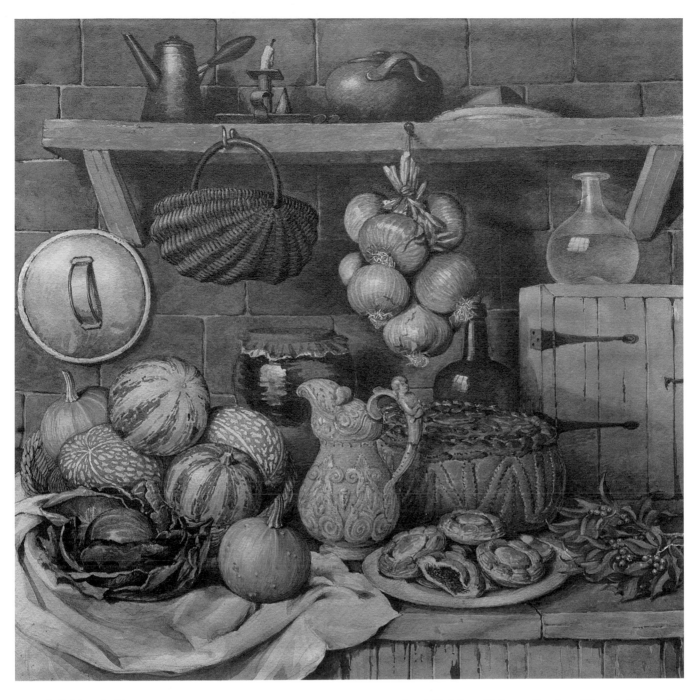

101 *Still-life with Christmas food, December 1839*

Yorkshire was famous for its magnificent Christmas pies such as the one dominating this picture. The most elaborate ones contained a boned pigeon folded within a partridge within a fowl within a goose within a turkey, but simpler versions were also made just using goose. They were usually prepared on the feast of St Stephen, 26 December. Mince pies made with puff pastry were also traditional Christmas fare. Note the preserve pot covered with blue sugar-cone paper and the holly berries.

Recipe for *A Yorkshire Christmas-Pye* from Hannah Glasse, *The Art of Cookery made Plain and Easy*, 1747.

First make a good Standing Crust, let the Wall and Bottom be very thick, bone a Turkey, a Goose, a Fowl, a Partridge, and a Pigeon, season them all very well, take half an Ounce of Mace, half an Ounce of Nutmegs, a quarter of an Ounce of Cloves, half an Ounce of black Pepper, all beat fine together, two large Spoonfuls of Salt, mix them together. Open the Fowls all down the Back, and bone them; first the Pigeon, then the Partridge, cover them; then the Fowl, then the Goose, and then the Turkey, which must be large; season them all well first, and lay them in the Crust, so as it will look only like a whole Turkey;

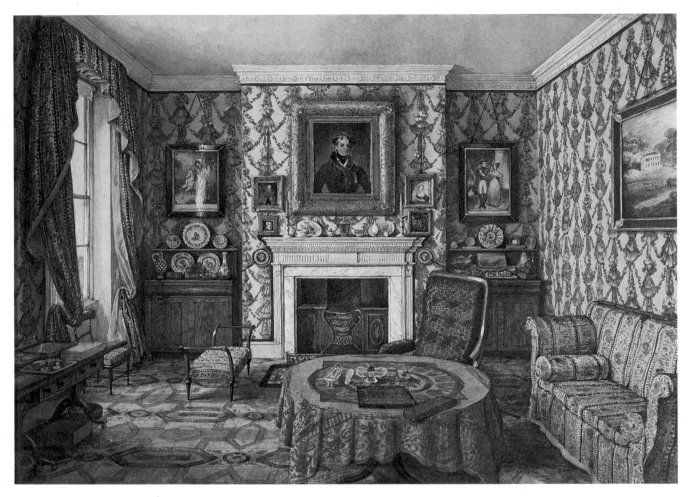

102

then have a Hare ready cased, and wiped with a clean Cloth. Cut it to Pieces, that is jointed; season it, and lay it as close as you can on one Side; on the other Side Woodcock, more Game and what Sort of wild Fowl you can get. Season them well, and lay them close; put at least four Pounds of Butter into the Pye, then lay on your Lid, which must be a very thick one and let it be well baked. It must have a very hot Oven, and will take at least four Hours.

This Pye will take a Bushel of Flour. These Pies are often sent to London in a Box as Presents; therefore the Walls must be well built.

A Standing Crust for Great Pies
Take a Peck of Flour, and six Pounds of Butter, boiled in a Gallon of Water, skim it off into the flour, and as little of the Liquor as you can; work it well up into a Paste, then pull it into pieces till it is cold, then make it up in what Form you will have it. This is fit for the Walls of a Goose-pye.

102 *'Our drawing room at York'*, c. *1838–1840*

After her mother's death in March 1837, Ellen was an independent woman and an heiress. She rented a house at no. 1 Clifton, had it decorated to her taste, and moved in at the end of November. Because she was married from this house in January 1840 and because her husband stayed here, albeit briefly, Ellen counted it as her first married home. (Hence the 'our' in the title of the picture.)

The drawing room was the most formal room in the house: it was where Ellen entertained her guests and wrote letters. The room is warm and harmonious, with all the colours blending well together. There is a print of the Duke of Wellington to the left of the fireplace and a painting of Langton Hall over the sofa covered with chintz.

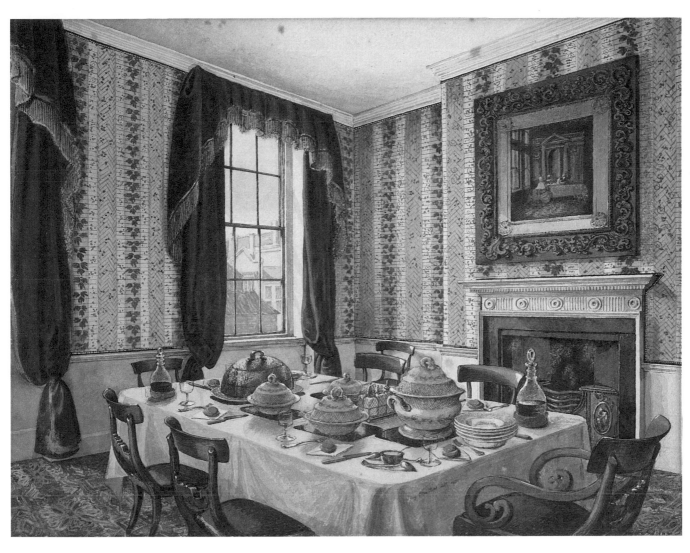

103 *'Our dining room at York', 1838*

Although a great deal is known about English food in the early nineteenth century, there is surprisingly little information about how people set their tables and served their meals. The table setting in this watercolour is therefore of great interest. It is laid for Sunday dinner, the main meal of the week. The servants have brought on the soup tureen and bowls for the first course, as well as the roast meat and vegetable tureens for the second course. (People were not as fussy about having their food hot as they are now.) The main dishes are placed in a rectangle in the middle of the dining table, on mats to protect the tablecloth, with oddments like serving spoons, horseradish, and wine decanters in the corners.

The presence of two courses at the same time and the symmetrical arrangement of the table is typically eighteenth-century. The new fashion for serving one course at a time and laying the table around a decorative centrepiece had not yet reached York.

Although there is a matching dinner service, there are no side plates: ceramic manufacturers had yet to think of this refinement. The rolls of bread are thus on napkins arranged diagonally between the knife and fork. (The rolls are a typical York shape which can be traced back to the sixteenth century.) Contrary to modern practice, the wine glasses are placed to the left of the fork, perilously close to the edge of the table.

It appears that Ellen's servants have forgotten to lay a soup bowl for the sixth person, as well as the soup spoons!

returned to York from their honeymoon and were installed in Ellen's house. Anthony was busy getting to know his wife's friends and relations. On 6 February he and Ellen attended the Robinsons' goodbye party for Baldwin Wake, who was to leave York the following day to join his new ship, the *Pearl*. Rosamond describes how they all 'had a great deal of fun over hot cockles and old times' and how the children dressed up for the occasion, 'Hugh as a Highlander, Ann as a Columbine, Charles and Ros^d with flowers of mine and gowns of Harriet's' and Mary as 'a capital little Parish Beadle, in Charley's tunic, trowsers, and straw hat'.[6]

Anthony was also occupied with the complicated, bureaucratic business of divesting himself of his Nuremberg citizenship and transferring his 'household' to York. This procedure did not signify any intention to settle in England, but a desire to simplify their lives when they moved to the Continent. Anthony needed to be a citizen of York if he was to draw funds in Germany from Ellen's private income and attain the desirable status of 'rentier' or 'privatier', which would make it easy for them to travel freely and settle wherever they wished. He therefore spent much time composing official-looking documents in German and persuading the Lord Mayor of York to sign them.[7]

Ellen, meanwhile, found a new tenant to take over the lease of her house and arranged for her possessions to be sent to Germany. Fortunately, this did not take long. The Sargs left their first home on 5 March 1840 and moved briefly, with their two maids, into the Robinsons' house. (Rosamond found that having nineteen people sleeping in the house was quite a squash, even though Lilly Eckhard and two of the children slept in the attic.) After a farewell visit to Langton, the Sargs left York on the 10th for London, travelling by rail via Leeds, Manchester and Birmingham. After spending three months in the metropolis, they departed for Nuremberg, Germany, Lilly Eckhard accompanying them as far as Frankfurt.[8]

The mediaeval city of Nuremberg was a sleepy place, very much living off its past glory, when Ellen and Anthony arrived there in June 1840. Once an independent, self-governing imperial city, Nuremberg had lost all political importance since the abolition of the Holy Roman Empire and its absorption into the kingdom of Bavaria. It was also suffering from the ill effects of a long and seemingly irreversible cultural and economic decline. During the fifteenth and sixteenth centuries Nuremberg had been famous for its artists and writers and the superb quality of its metalwork, clocks, watches, maps, and musical instruments. But by the 1840s, the city's cultural life was stagnant and its only products of note were children's toys, pill boxes and lead pencils.[9] John Murray's guide book to southern Germany was quite accurate in describing Nuremberg as 'a dull provincial town' which happened to be 'a sort of Pompeii of the Middle Ages'.[10]

Despite its miraculous state of preservation, Nuremberg was off the tourist track. Anna Jameson, the art historian, explored the city in 1833 and was surprised that it was not more frequently visited by the English. She found the city deeply romantic and its extraordinary character made a strong impression on her:

'Nuremberg – with its long, narrow, winding, involved streets, its precipitous ascents and descents, its completely Gothic physiognomy – is by far the strangest old city I ever beheld; it has retained in every part the aspect of the middle ages. No two houses resemble each other; yet, differing in form, in colour, in height, in ornament, all have a family likeness; and with their peaked and carved gables, and projecting central balconies, and painted fronts, stand up in a row, like so many tall, gaunt, stately old maids, with the toques and stomachers of the last century.'[11]

The sights which inspired this passage, and which Anthony showed Ellen when they arrived in Nuremberg, were a remarkable collection: the castle which dominated the city's skyline, St Sebald's Church, the public gallery in the former chapel of St Maurice where 140 Old Masters of the German School were displayed, the fourteenth-century 'Beautiful Fountain' in the market place, and St John's cemetery where the tomb stones of many famous artists could be seen, including that of Albrecht Dürer.

Anthony and Ellen lived in lodgings within the city's walls, first in Kaiserstrasse and then in Aegidienplatz.[12] **106** Here they rented an apartment in a grand sixteenth-century house belonging to a prominent Nuremberg merchant **107** called Georg Zacharias Platner. His many financial interests included Germany's first railway line which ran from Nuremberg to Fürth and opened in 1833.[13]

Although Ellen produced some fine work in Nuremberg, she did not make friends with local artists or exhibit. There was even a slight drop in her usual output. During her fifteen months in the city, she only painted eleven interiors and views of Nuremberg, two still-lives, and twenty-one portraits. There were other claims on her energy: adjusting to married life in a foreign land, coping with her in-laws who must have seemed very dull, learning German and, above all, child-bearing. Ellen was already three months pregnant with her first child when she arrived in Nuremberg (Frank **109** was born on 21 December 1840) and four months pregnant with Caroline when she left.

In contrast to her other work, Ellen's Nuremberg paintings are curiously empty of people. They give the impression that she was living in a ghost town, even though

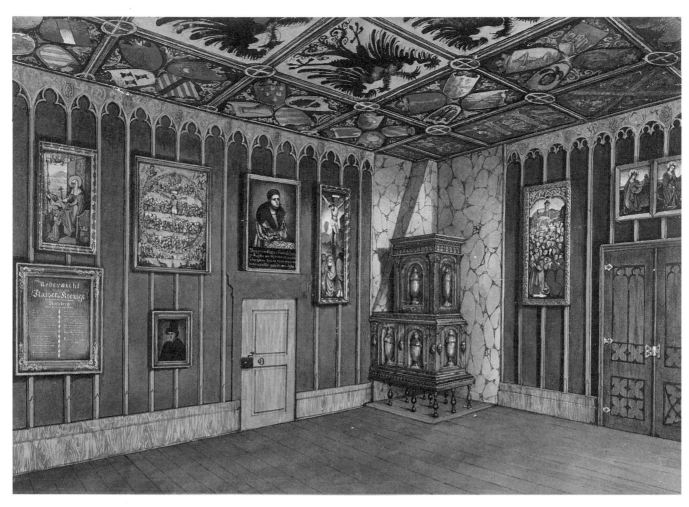

104 *'Royal Apartment in the Burg, Nuremberg', 1840 or 1841*

This is one of three rooms that Ellen painted in Nuremberg's famous castle. Some of the reasons why she was attracted to the former imperial stronghold are suggested by Mrs Anna Jameson, who visited it in 1833:

'The old castle, or fortress, which stands on a height commanding the town and a glorious view, is a strange, dismantled, incongruous heap of buildings. It happened, that in the summer of 1833, the King of Bavaria, accompanied by the queen and the princess Matilda, had paid his good city of Nuremberg a visit, and had been most royally entertained by the inhabitants: the apartments in the old castle, long abandoned to the rats and spiders, had been prepared for the royal guests, and, when I saw it, three or four months afterwards, nothing could be more uncouth and fantastical than the effect of these irregular rooms, with all manners of angles; with their carved worm-eaten ceilings, their curious latticed and painted windows, and most preposterous stoves, now all tricked out with fresh paint here and there, and hung with gay glazed papers of the most modern fashion, and the most gaudy patterns.'

In this room, the decorators appear to have restored the ceiling, which shows the extent of Charles V's empire in about 1520: four imperial double eagles are surrounded by the coats-of-arms of his numerous dominions. They have also repainted, if not created, the Gothic wall panelling and put up the 'gay glazed paper' behind the green porcelain stove.

Despite war damage, the interior of the Emperor's Reception Room, as it is now called, has not changed much. The ceiling has faded, the pictures have gone, and the doors, stove and floor are replacements.

105 *'A private sitting room, Nuremberg', 1840 or 1841*

The room is decorated with magnificent eighteenth-century rococo plasterwork and carving and has an exceptionally fine floor inlaid with parquet. The elaborate curtains and sober Empire furnishings are in the Biedermeier style fashionable in the 1820s and '30s. As was then customary in German homes, the furniture is arranged against the walls, leaving the centre of the room clear.

The cacti on the window sills and potted plants on the table are an unusual feature.

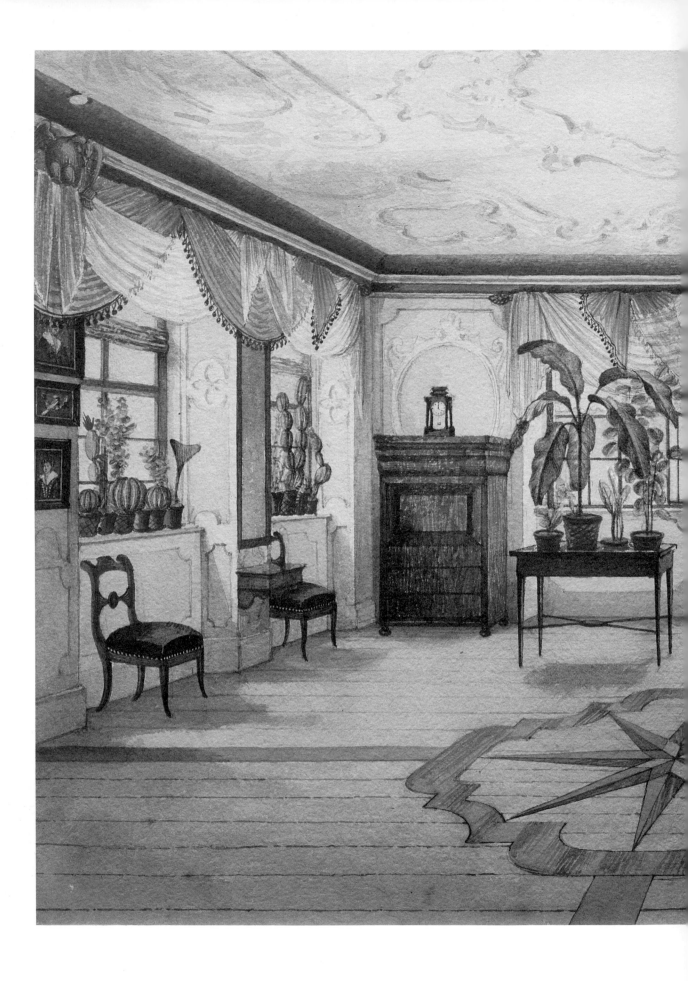

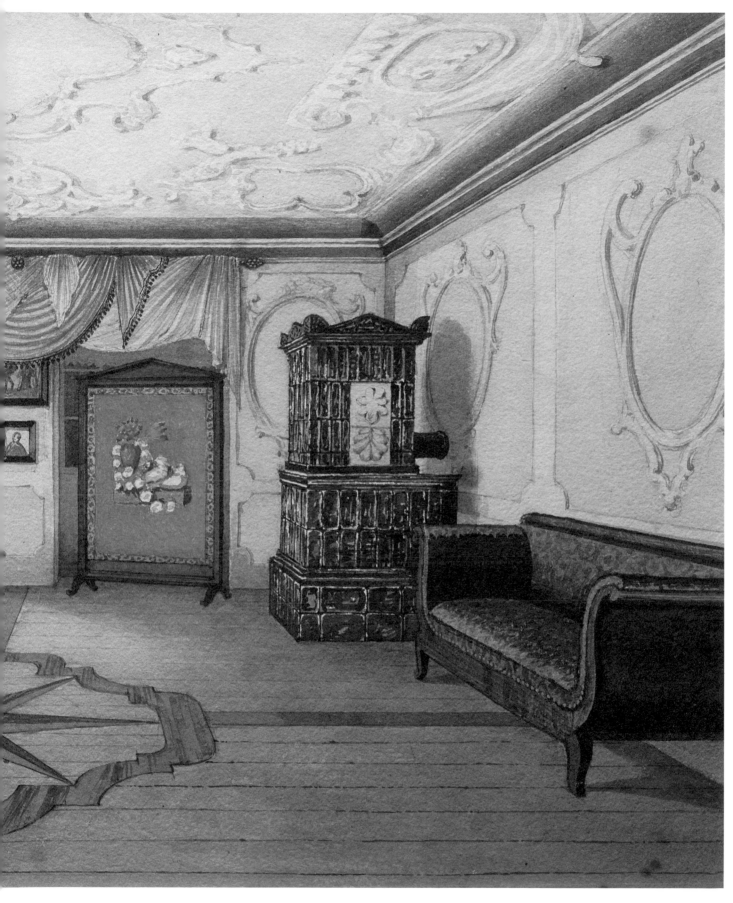

105

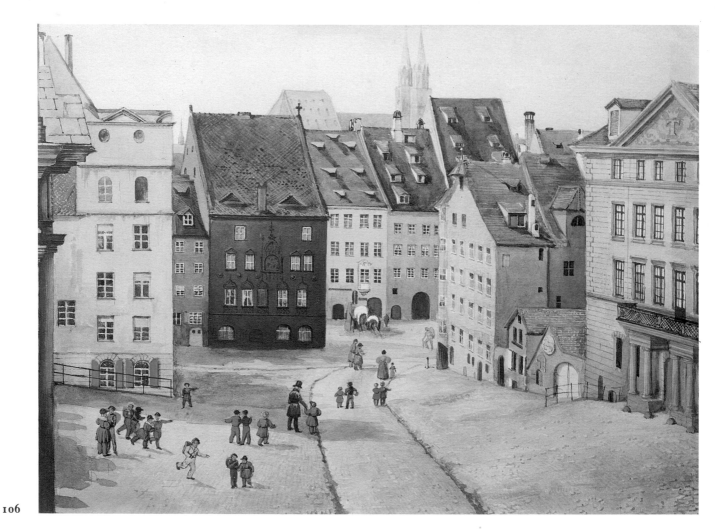

106

106 *'The Egydien Platz, Nuremberg', 1840 or 1841*

This was the square where Ellen and Anthony lived during most of their time in Nuremberg and the picture shows the view they had of it from the apartment they rented in Platner's House. A pillar and part of the roof of their local church, St Giles, can just be seen on the left. The schoolboys are streaming out of a gymnasium (grammar school) hidden by the church.

Although the bombing of Nuremberg during the Second World War destroyed much of Aegydienplatz, including Platner's House, the square can still be recognised today. It was rebuilt according to the old lay-out. The modern roofs, however, slope less steeply and have lost most of their gable windows. The arched carriage entrances have disappeared and the windows are slightly larger. The pleasing diversity of nineteenth-century paint colours has also been lost: today's buildings are a uniform pinky-grey.

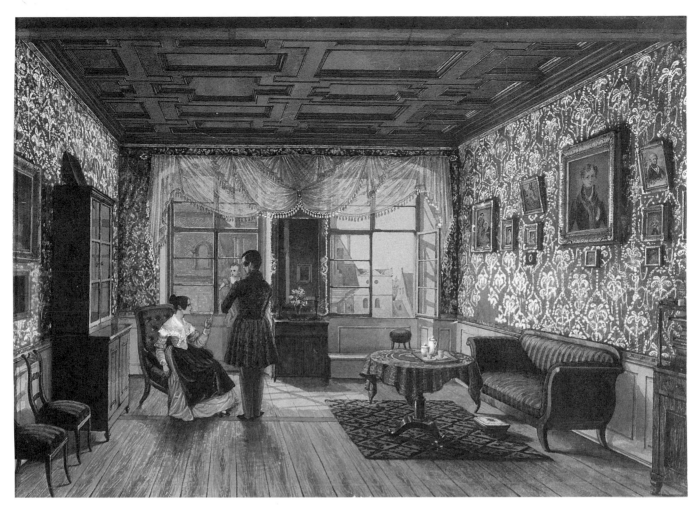

107 *'Our own drawing room in Platner's House, Nuremberg, 1841'*

Platner's House had recently been restored and refurbished by its wealthy owner. The fine Renaissance ceiling in this room was left intact, but the windows look new and so does the wall paper.

In contrast to England, large houses in Germany were frequently divided into apartments and rented out to different families. William Howitt, who lived in Germany between 1840 and 1842, found that there were 'commonly two or three families of the most respectable and wealthy class in one house'.

Ellen and Anthony furnished their apartment themselves, with English pieces brought from York and contemporary German furniture. Many of the items to be seen here recur in Ellen's later interiors.

In this watercolour, Anthony is holding Frank in his arms while Ellen, in a nursing apron, rests in her red arm chair from York. The coffee, flowers and open window suggest that it is a spring morning.

Ellen painted her view of Aegydienplatz from the stool on the raised platform beneath the window on the right.

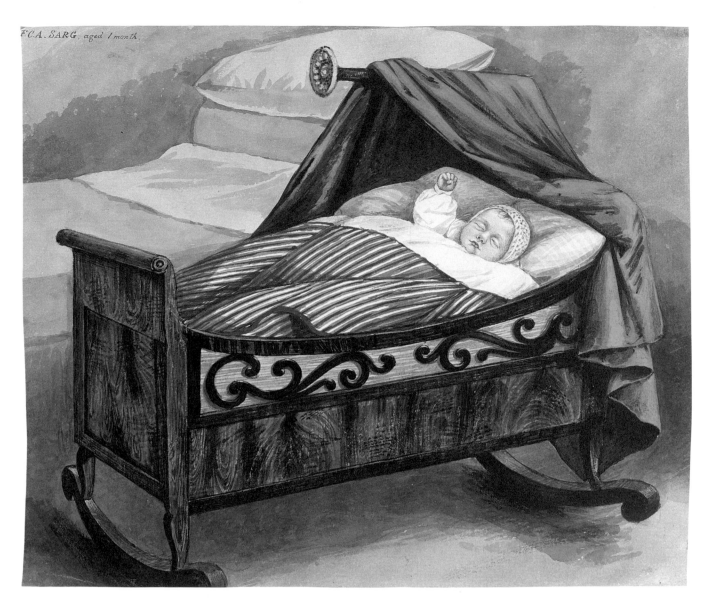

108 *'F C A Sarg aged 1 month', 21 January 1841*

Although Frank's eyes are tightly closed, he is showing signs of life by waving an arm from his elaborate cradle. Nurse Schmidt's bed is in the background.

109 *'Francis Charles Anthony Sarg born December 21, 1840', 29 January 1841*

This sketch shows how Frank was kept warm in a homemade padded 'steckkissen'.

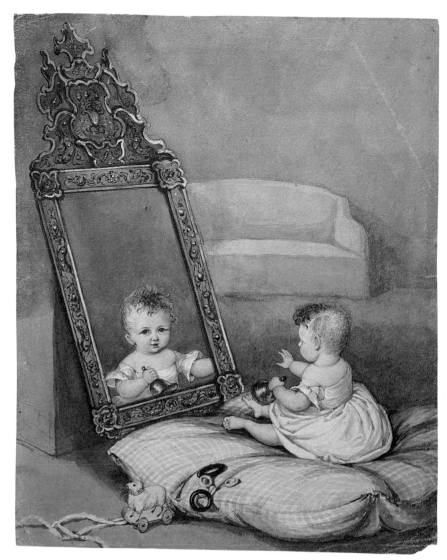

110

110

110 *Portrait of Frank, 1841*

Frank is looking at his reflection in an
ornate Bohemian mirror. His teething rings
are slipping onto the floor, to join a toy
sheep on wheels.

Nuremberg was the centre of toy manu-
facturing in Germany. Baroness Blaze de
Bury, who visited the city in the 1840s, was
astonished by the exciting range of goods on
sale at Messrs Roth and Rau's toy shop:
'dolls looking like live babies, dogs and cats
that bark and purr, geese that cackle, lambs
that skip, birds that fly, fish that swim,
musical snuff boxes that play Beethoven's
symphonies, bull finches that spring with
outspread wings out of golden eggs, and
warble Rode's air with variations, regiments
of soldiers, in all the different uniforms of
the countless German states . . .'

Ellen developed a passion for collecting toys
and puppets while living on the Continent
and bequeathed a magnificent collection to
Frank's eldest son, Tony Sarg, who was
to become a well-known illustrator and
cartoonist in the United States.

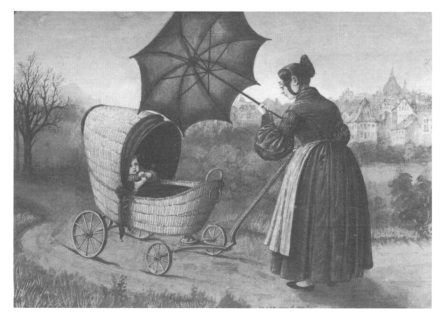

111 *'Frank aged 4 months', April 1841*

Inscribed *verso*: *Master Sarg taking the air in
his state coach.* Nurse Schmidt has paused to
adjust her parasol while pulling Frank's
coach along a pathway outside Nuremberg.

nothing could have been further from the truth (the city in fact had a population of about 40,000). This sense of isolation is reinforced by the list of portraits Ellen painted in Nuremberg: sixteen out of twenty-one are of her family or household servants and two of the remaining five depict young children. These subjects suggest that Nuremberg did not have much to offer the Sargs in the way of social life or intellectual stimulus and help to explain why they departed for the much livelier atmosphere of Frankfurt in August 1841.

The Sargs rented a first floor apartment in the centre of Frankfurt for a short while, before moving to a substantial villa with a large garden in the suburbs. Once Frankfurt ceased to be a fortified town in 1809, the double ditch and wall encircling the city were demolished, creating space for gracious new houses and a public promenade, or Anlage, which was landscaped in the best English country house tradition. The Sargs, like many well-to-do people, wanted to live in this charming area and chose a house on Bockenheimer Landstrasse just outside one of the 'new' city gates.[14]

They soon settled down to a pleasant, fairly indolent life. Thanks to Ellen's private income, Anthony could be a typical gentleman of leisure, free to while away his days visiting his tailor, devising new musical entertainments for the Russischer Hof, reading novels, playing cards, and performing chamber music.

Although they had servants, Ellen was occupied with looking after the children: Caroline was born on 18 January 1842 and Fred followed on 16 August 1843.[15] She gave them an enormous amount of attention and delighted in painting portraits of them at each stage of their development. Anthony was also a devoted parent and spent many hours playing with the children, taking them out on expeditions, and giving them music lessons.

In contrast to Nuremberg, Anthony and Ellen had a good social life in Frankfurt. They kept up with old friends like the Eckhard sisters, the Downie family and Mlle Veronica Acker, the French teacher at the Englische-Fräulein-Schule where Anthony had once taught. They also made new ones, such as Herr Christian Lössel, a trade representative, who lived nearby.[16] Although Ellen had now learned German, she still felt happier speaking French and most of their new friends were either French, or Germans who spoke French.

As might be expected, the Sargs saw a great deal of Anthony's brother Friedrich Adalbert, his wife Margaretha and their three children Elise, Auguste and Karl. The Russischer Hof continued to flourish and they introduced Ellen to English guests who were staying there. Ellen met yet other English people through the Reverend Thomas Harvey, the Anglican minister who conducted services at the Church of the French Reformed Community in Frankfurt and who baptised Caroline and Fred.[17]

Despite this domestic bliss, Ellen continued to enjoy travelling and in 1844 she and Anthony had a summer holiday in the old imperial town of Speyer about fifty miles south of Frankfurt. There they indulged in the German habit of sitting in cafés and listening to music. They also examined the town's magnificent Romanesque cathedral built of pink stone. One of the watercolours which survives from this trip is particularly interesting because it shows that Ellen still saw herself as an artist, even though she now had less time to paint and worked almost exclusively for herself; she ceased to exhibit after 1836 and stopped selling her paintings after her marriage in 1840. The group of inquisitive bystanders crowding round her demonstrates that Ellen was aware of how other people saw her. In Germany, as in England, women painters were unusual and aroused considerable curiosity.

In 1845 Ellen felt it was time to visit England. Since leaving York in March 1840 she had not seen Rosamond and Henry or any of her ten nephews and nieces (four had been born in her absence). Her uncle, Francis Best, had died in April 1844 and the contents of the rectory at South Dalton had been sold and dispersed. She must have tired of making do with letters and word of mouth reports from visiting English friends. Besides, she wanted to introduce Frank, who was now four, to his English cousins.

Anthony, Ellen and Frank arrived in York on 7 May 1845. Rosamond, who had had no reason to write about Ellen since she had left York and the day-to-day lives of the Robinson family, made the following entry in her *Family Chronicle*:

'My dearest sister arrived at our house, with her husband and her eldest boy. She had not been in England for five years. They were laden with presents, amongst which I may record silk and satin parasols for Ann and Ros[d], blue silk hand[kfs] for Ellen and Mary, with a p[r] of white kid shoes for the latter; a silk hand[kf] and pencil for Hugh, an opera glass for Charles, a kittel for Henry, and various toys for all the younger ones. Their first visit to us was for three weeks, and a great enjoyment it was. Frank was three months older than our Henry, a fine boy, but spoilt.'[18]

In a chronicle where words of criticism are almost unknown, her description of Frank as 'spoilt' was pretty daring!

The Sargs' visit passed very quickly. Ellen and Anthony kept Henry Robinson company on the day he went to collect Norcliffe Norcliffe's rents at Langton. They also accompanied the Robinsons to a grand tea at Alderson's Farm: some

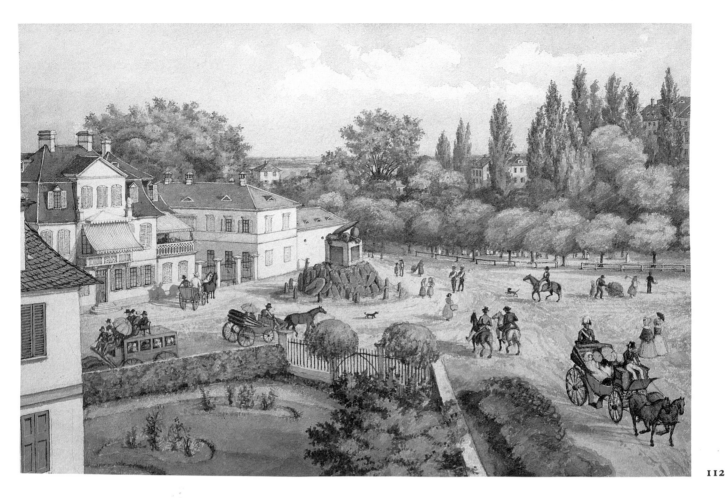

112 *Hessen Denkmal and Frankfurter Anlage, Frankfurt,*
c. *1842–1845*

This shows the suburban area beyond one of Frankfurt's 'new'
city gates, the Friedberger Thor. The Sargs moved to a house
near here in 1842.

The villa with blue awnings was one of the grandest in the
neighbourhood; it belonged to the Bethmann family, who were
prominent Jewish bankers. The monument in the centre of the
picture, the Hessen Denkmal, was erected in 1793 to com-
memorate a minor victory over the French, who had occupied
Frankfurt the previous year. Frederick William II, King of
Prussia, dedicated the monument to 'the noble men of Hessen
who fell here in victory in the struggle for their fatherland'. It
soon came to symbolise the ideal of a unified German nation
state and became one of Frankfurt's tourist sites. Captain
Edmund Spencer, who saw it in 1834, described it as follows:

'A colossal mass of granite rocks are grouped together, on one
of which is inscribed the names of the officers and soldiers,
over which there is placed a lion's skin, with a sword, shield,
and battering ram, encircled with laurel, cast from the cannon
taken from the French; the whole surrounded by weeping
willows, that impart a pretty rural appearance to the landscape.'

The woods in the background were part of the three-mile
'Anlage' or public promenade which surrounded Frankfurt. It
was crowded every afternoon with pedestrians admiring its
trees, shrubs, flowers, miniature lakes and statues.

of the party went to West Huntington in a fly, some walked and others took turns riding a donkey. Ellen found that she had the time and inclination to do a little portrait painting. Rosamond was delighted with the likeness she did 'of little Henry, drest in the blue merino kittel she gave him'.[19] She also painted Mr James Palmes, while spending a few days with his family at Naburn, and the famous missionary traveller Joseph Wolff who had just published a sensational account of his journey to Bokhara.

At the beginning of June, Anthony and Ellen went to Carlisle, to visit Dr Baldwin Wake's widow Sarah leaving Frank to stay at Alderson's Farm. They then went on a tour of other friends and relations: Captain and Mrs James White Worsley at their house in Thornton-le-Moor, the Reverend John Walker Harrison's family at Norton-le-Cley and the Reverend George Holdsworth's family at Aldborough. After a short rest in York, they took Frank to Langton for five days to see Norcliffe Norcliffe and his son Thomas. There Ellen was prevailed upon to paint Thomas, a villager called John Dunn, and Mr Hide, the gamekeeper.

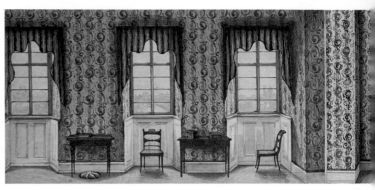

From Langton the Sargs joined the Robinsons for a seaside holiday at Whitby. The group was so large that they had to stay at different places, the Robinsons opting for Mrs Keld's Lodgings on the Pier and the Sargs choosing Wear's Lodgings on the quay. On one morning Rosamond got up at 5.30 and was touched to find that Annie 'had been at work ever since 4 upon a doll she was dressing for her little cousin Caroline Sarg'.[20]

The Sargs returned to York on 5 July for a final five days before departing for London, where they had arranged a rendez-vous with Miss Shepherd and Rosamond Junior, who was attending her school at Bromley Common. On 13 July the Sargs sailed to Antwerp and settled for a time in Belgium.

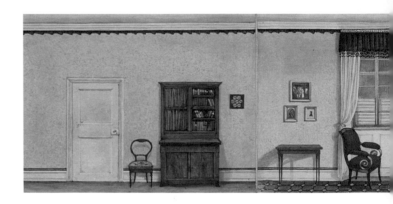

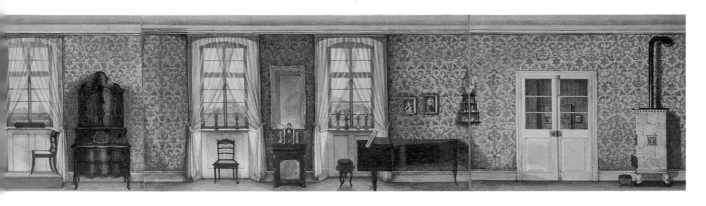

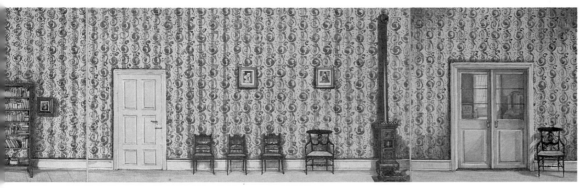

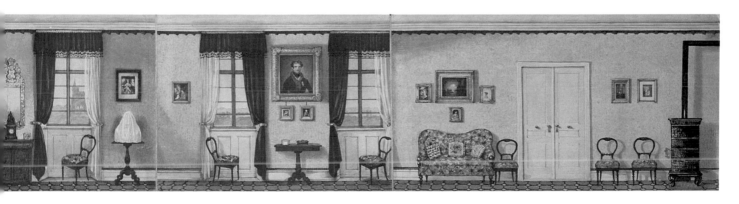

103 *Three stand-up interiors of reception rooms in the Sargs' first residence in Frankfurt, late 1841 or early 1842*

The effect of playing with these stand-up interiors is quite magical. First of all, one erects the strips, folding them into squares, to create complete four-sided rooms. One then realises that the rooms inter-connect if placed next to each other. The result? A charming bird's eye view of the main reception rooms in the apartment which the Sargs rented on their arrival in Frankfurt.

Ellen may have got the idea of making these stand-up interiors from seeing German dolls' houses. She may also have been inspired by the contemporary vogue for panoramas in pull-out strips. If she allowed the children to play with the interiors, she must have supervised them very strictly for they are still in perfect condition!

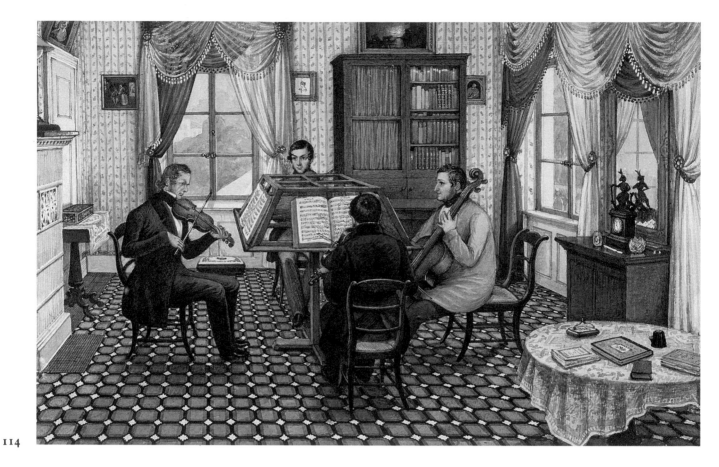

114

114 *Anthony and three friends playing a string quartet, Frankfurt,
1842–1845*

This, and the companion picture opposite, show how Anthony
liked to spend his time at home. Thanks to his wife's income,
he was very much a gentleman of leisure.

Wall-to-wall carpeting was a luxury in Germany in the
1840s and shows the influence of Ellen's English taste as well
as her money.

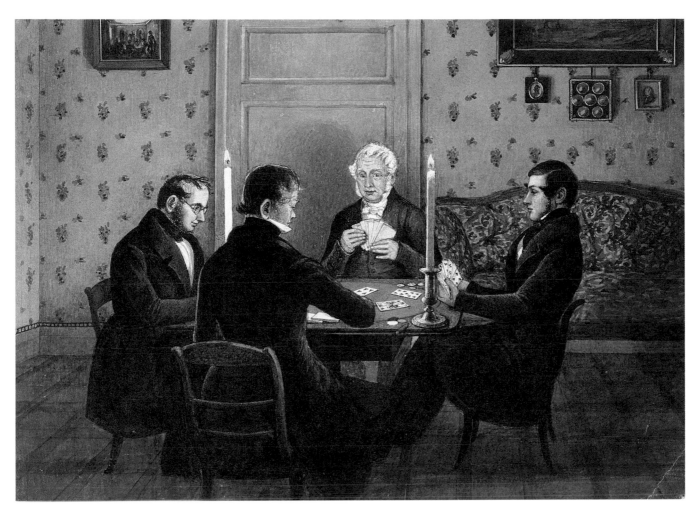

115 *Anthony playing cards with his friends, Frankfurt, 1842–1845*

Anthony is on the right.

116 *Still-life with blue and white coffee pot and cake, Frankfurt, 1843*

This table can also be seen in the room where Anthony and his friends played quartets, covered with books and the same pinkish table cloth. The brown Wedgwood milk jug also occurs in Ellen's still-life of peeled oranges: it was a favourite possession from England.

Coffee and guglhupf cake were light refreshments traditionally served to visitors in Germany. *Der Deutsche Pilger durch die Welt* ('The German pilgrim through the world') was a morally uplifting tract published in Stuttgart in 1843.

117

117 *Ellen and Anthony with Frank and Caroline in their home on the Bockenheimer Landstrasse, Frankfurt, 1842*

An early morning scene. Anthony, in his dressing-gown, offers Ellen a cup of coffee. She is wearing a nursing apron and has the newly born Caroline in her arms. But the centre of attention is Frank, who is taking his first steps.

118 *'Scene in our kitchen, vor dem Neuen Thor Frf^t [i.e. Frank-furt] Children's supper ready', c. 1843*

The nurse maid allowed Frank and Caroline to continue playing as they ate their supper. The view from the windows shows that the Sargs' villa outside the 'New Gate' had a large garden.

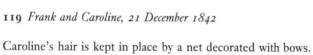

119

120

119 *Frank and Caroline, 21 December 1842*

Caroline's hair is kept in place by a net decorated with bows.

120 *Portrait of Caroline, aged two years one month, February 1844*

Inscribed 'Caroline Elizabeth Sarg aged 2 years 1 month "Adieu! ich gehe in die Stadt!"'

Caroline is saying 'Bye bye, I'm off to town!' while arranging a bandanna round her shoulders as if it were a shawl: she has reached the stage of wanting to imitate adult behaviour. Her choice of words confirms that the Sargs lived in a house outside the centre of Frankfurt.

121 *Anthony, Frank and Caroline sledging on the ice, accompanied by the family dog, 30 December 1844*

It is clear from this and similar pictures that Anthony was an enthusiastic father and enjoyed playing with the children. However, it is noticeable that Anthony always appears as a shadowy, indistinct figure. Ellen was much more interested in her children than her husband.

122 *The Altpörtel, Speyer, c. 1844*

Ellen can be seen at work in the foreground, surrounded by curious onlookers. One little boy has even climbed onto the water pump to get a better view of her! The tower, which provides the main entrance to the west of the city, was begun in the thirteenth century. The gallery floor was added in 1514, the pitched roof in 1708 and the clock in 1761. It still looks much the same, although windows have been added and the archway made more pointed. A passageway for pedestrians has been knocked through the side of the yellow building to the right.

123 *'Part of Speyer Cathedral Aug 21, 1844 looking down from a gallery window'*

It is typical of Ellen to find an unusual view point from which to paint part of this magnificent Romanesque cathedral. The north transept now looks rather different: the plaster covering the walls and monument has been removed to expose the original pink building stone beneath, the tiles on the floor replaced with paving stones, and windows inserted into the four arches in the background.

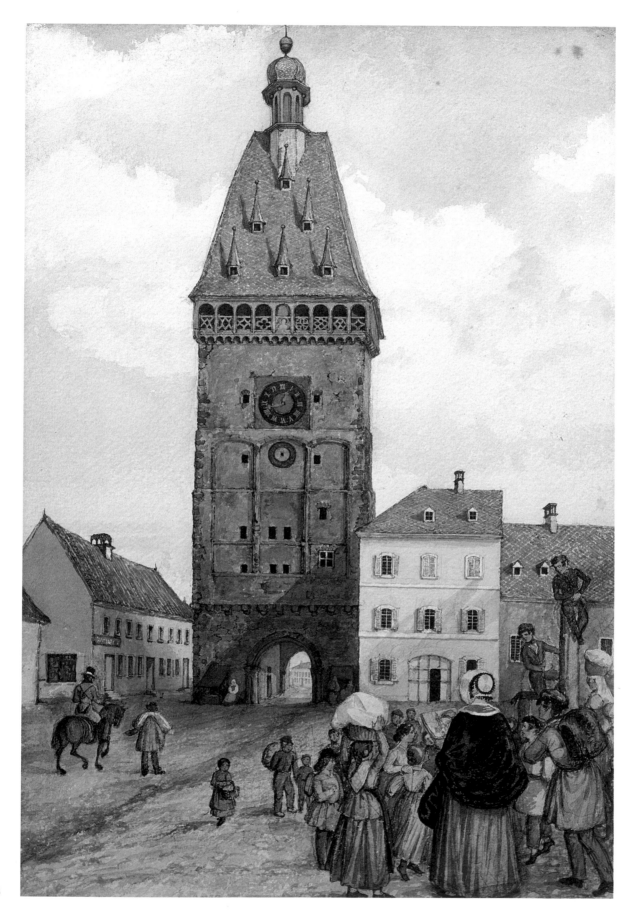

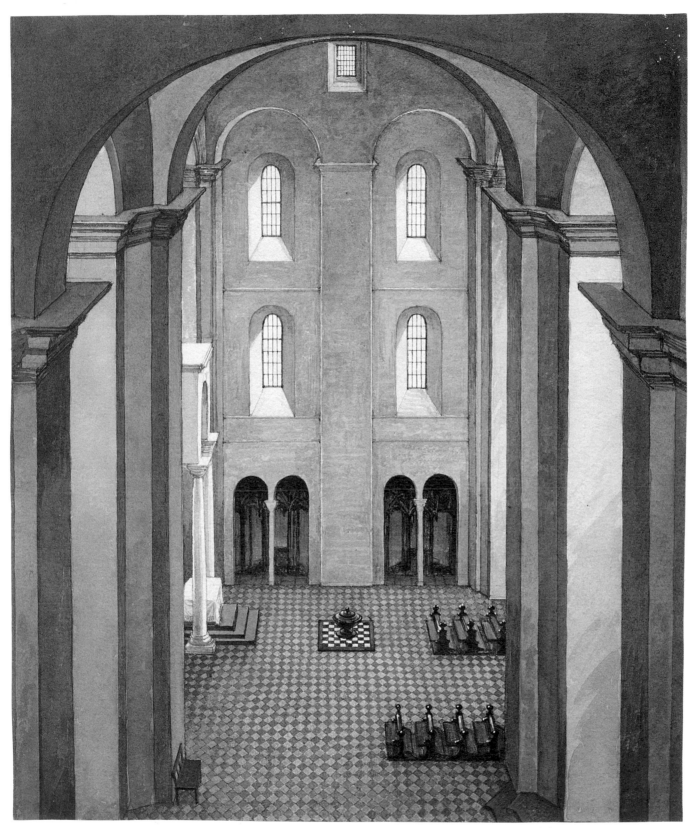

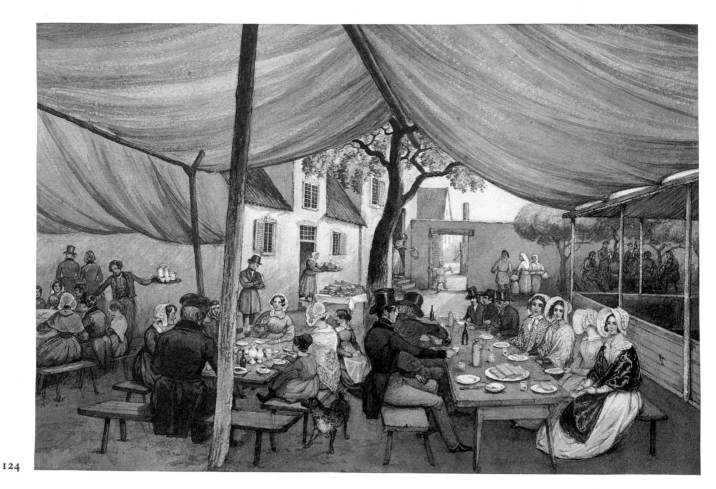

124

124 *An outdoor café in Germany, probably at Speyer*, c. *1844*

Ellen and Anthony are sitting at the end of the table on the right, drinking wine and eating bread and dripping. There are musicians in the background, behind the band stand.

Cafés with bands were extremely popular with all social classes, as can be seen in this picture. William Howitt found that: 'The enjoyment of music and social pleasures in the open air is the grand summer enjoyment of Germany. It is the universal passion from one end of the country to the other. It is the same in every village, in every town, in every capital.'

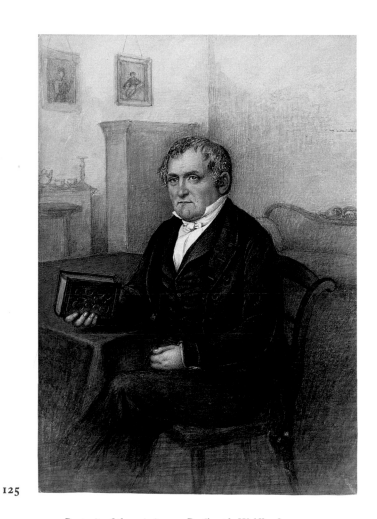

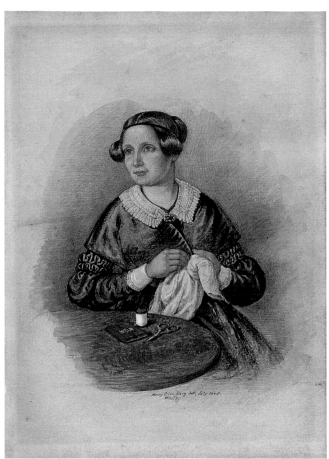

125

126

125 *Portrait of the missionary Dr Joseph Wolff, 1845*

Dr Joseph Wolff (1795–1862) was one of the most extra-ordinary missionaries of the nineteenth century. Born in Germany, the son of a Jewish rabbi, he converted to Christian-ity in 1812 and set himself the task of learning Arabic, Syriac and Chaldaean so that he could convert the heathen. He left Germany in 1816 and, after a flirtation with Roman Catholi-cism in Rome, came to England and entered the Church of England. During the 1820s and '30s he travelled widely as a missionary (in the Middle East, India and America) and had many fantastic adventures, including shipwreck, slavery and a 600-mile march without any clothes on.

Ellen met Dr Wolff and his wife Lady Georgiana after they settled in Yorkshire in 1838. (Dr Wolff was rector of Lin-thwaite until 1840 and curate of High Hoyland until 1847.) They had a zest for travel and affection for German culture in common.

When Ellen painted Dr Wolff's portrait, he was a national hero, having just returned from a daring expedition to Bokhara. This was a strategically important territory north of Afghanis-tan which the Russians and the British were vying to control. Wolff's purpose in going there was to discover the fate of two British envoys, Captain Conolly and Colonel Stoddart, who had disappeared after being thrown in prison.

The men had in fact been executed by the blood-thirsty Emir Nasrullah, but Wolff did not know this. As might be

expected, Wolff had many strange experiences on his mission and narrowly escaped the same fate as the two men he had hoped to rescue. His *Narrative of a Mission to Bokhara*, published in April 1845 on his return to England, was a bestseller.

In Ellen's portrait the great eccentric is dressed soberly in black, sitting forward in his chair, full of nervous energy. Ellen did another portrait of Dr Wolff in 1846, for Lady Georgiana.

126 *Portrait of Mrs Henry Robinson, July 1845*

Rosamond is shown here at the age of thirty-seven. By 1845 she had been married to Henry Robinson for fifteen years and borne ten of their thirteen children. She was a devoted and conscientious mother and Ellen has portrayed her making a dress for the eleventh 'little darling' (Thomas) due in Septem-ber. (The material is carefully placed to hide the bulge.)

She is dressed in mourning for her uncle and godfather, Francis Best, rector of South Dalton, who had died the previous year, making her his principal beneficiary.

Ellen's appetite to see Belgium had been whetted by what she had seen of the country when returning to England from Germany in the summer of 1839. Prolonged tours, however, were difficult to arrange once she and Anthony had children. By far the most practical way of exploring Belgium was to go and live there *en famille*. Since Anthony did not work and money was plentiful, there were no obstacles standing in their way.

The Sargs chose Malines (Mechelen in Flemish) as their base. It lay at the centre of Belgium's railway network, which was then the most advanced in the world, so that communications with other towns which they wanted to explore, such as Antwerp, Louvain, Ghent and Liège, were excellent. Malines also had the merit of being an exceptionally beautiful and unspoilt mediaeval town, encircled by canals and ancient city walls, with many picturesque sights for Ellen to paint. The Grand Place, for example, contained the famous cathedral of St Rombaud, and an extraordinary turreted civic building called Les Halles which dated back to the fourteenth century. Another architectural gem which Ellen painted was the palace where Margaret of Austria, Governor of the Low Countries, died in 1530 and where her successor, Cardinal Granvella, lived briefly before fleeing home to Spain. From Anthony's point of view, Malines was a good place for music. The town abounded with musical societies with names like 'La Philarmonie' and 'Royale Réunion Lyrique' and an Academy of Music had been founded in 1842.[21]

A *voiture de déménagement* (removal van) in one of Ellen's watercolours of Malines suggests that they rented a house **129** on the famous Quai aux Avoines, overlooking the River Dyle and a fish market on the other bank. Just a little further along the quay, by the bridge known as Pont de la Grue, was the well known Devil's House, so called because of the monstrous carving which adorned its facade and three terrifying demons which stood guard over the doorway. The Sarg children must have hurried past it on their way to and from the Grand Place.

Although Ellen painted many watercolours while she was in Belgium, there are no signs that she made friends with local artists or became involved with Malines' Société pour l'Encouragement des Beaux Arts. Indeed she seems to have had very little contact with anyone in the town. This was partly because most of the inhabitants spoke Flemish rather than French and partly because Anthony lacked an occupation which caused them to meet people.

Given the Sargs' social isolation and their desire to give Frank a proper education, it is not surprising that they returned to Germany in mid 1846, shortly before the start of the new school year. According to an entry in Rosamond's *Family Chronicle*, they sent a load of presents before leaving

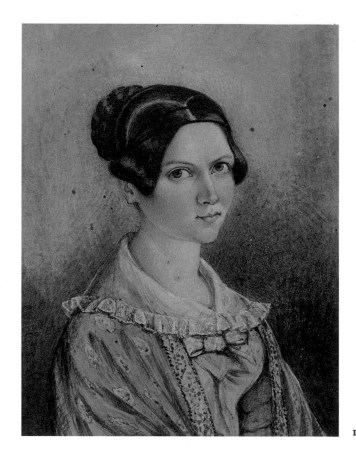

127

127 *Self-portrait, 1845 or 1846*

Ellen was now in her late thirties. This is one of the few self-portraits in which she is not represented as an artist.

128 *Portrait of Frank, Caroline and Fred, November 1845*

Ellen, like her sister, took great pride in fitting out her children with smart new winter outfits each year. In this picture, the boys are wearing fashionable tartan bishops which Ellen must have bought in England the previous summer.

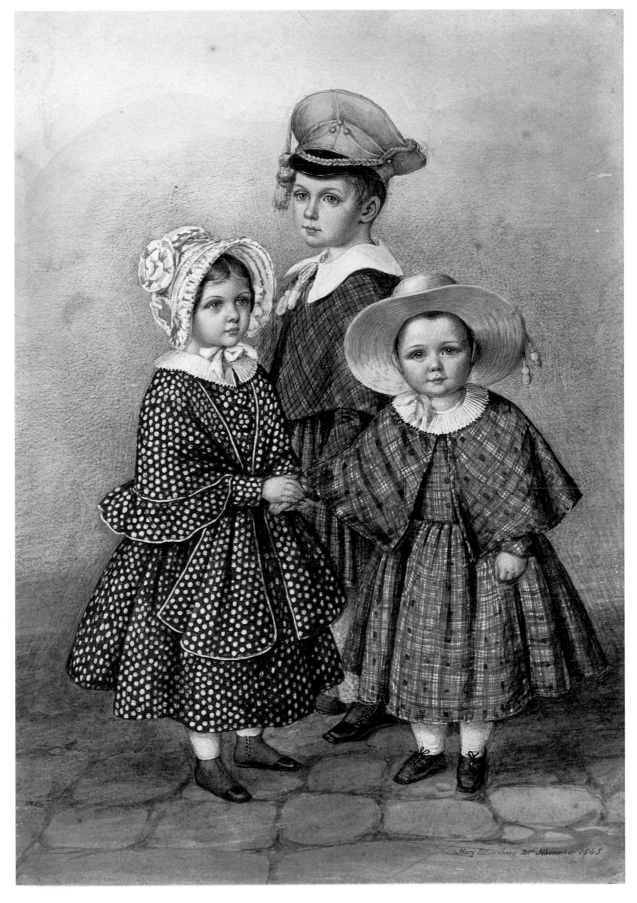

Mary Ellen Best *28th November 1845*

128

129

129 *Quai aux Avoines, Malines, Belgium, 1845 or 1846*

The removal van marked *Voiture de Démenagement de Malines* suggests that the Sargs lived on this picturesque quay over-looking the River Dyle, in the gabled house dated 1560.

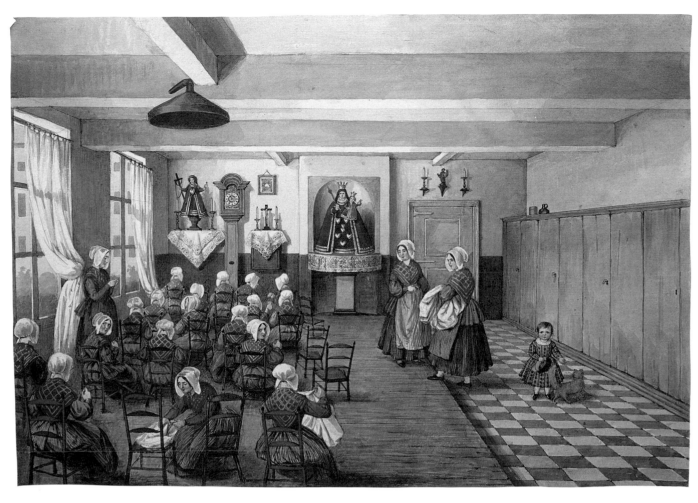

130 *'Ecole St Joseph. Mechlin', 1845 or 1846*

Ellen continued to visit charitable institutions after her marriage. In this case, she has taken her youngest son, Fred, and the family dog to inspect the Ecole St Joseph, a girls' orphanage, whose origins go back to the fourteenth century. The girls are learning how to make pillow lace, a famous local speciality made by winding bobbins of thread round needles set in the pillow in the required pattern. The results could be used to decorate all sorts of linen goods, particularly tablecloths like those on either side of the grandfather clock.

The iron chimney hood suspended from the beam is for funnelling smoke away from a moveable stove.

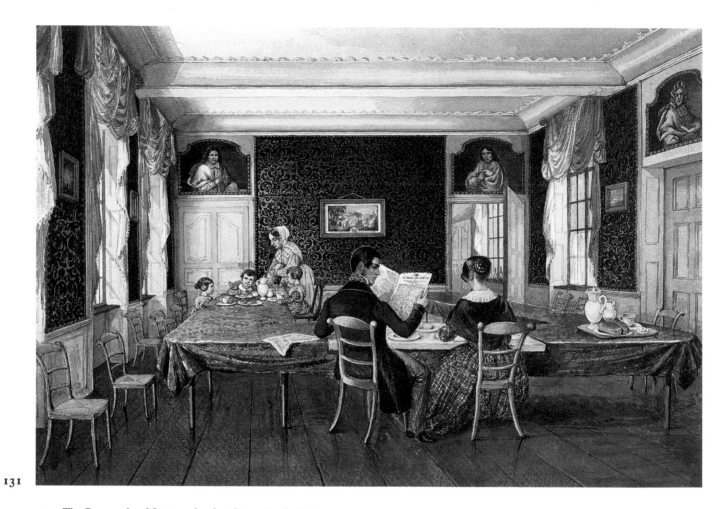

131

131 *The Sargs at breakfast in a hotel at Liège, April 1846*

Anthony is reading the *Journal de Liège et de la province*, Ellen
by his side, while a maid attends to the children who have been
relegated to the far end of the dining table. They are having
coffee and small loaves of bread for breakfast.

The room's proportions and panelling show it to be
eighteenth-century, as do the portraits inset over the doorways.

which arrived in York on 23 March:

'We received from Malines two large bows & arrows for Hugh and Charles from Mr Sarg; a music book for Ellen, a box of cooking toys for Beatrix, one of bedroom furniture for Is[a], one of tin huntsmen, hounds, etc., for Henry; three little white china cups and saucers for Charlotte, a book in 2 vols called "Encouragement de la jeunesse" for Ellen, and 10 vols of "Tour du monde" for Mary.'[22]

The Sargs travelled back to Germany via Liège where Ellen painted an impressive seventeenth-century arsenal, then known as Mont de Piété, which now houses the Maison Curtius Museum.

On this occasion Ellen and Anthony decided to live in Worms, a former imperial stronghold on the banks of the Rhine which was surrounded with vineyards. It was a small town compared to Frankfurt, and much less cosmopolitan, but it appcalcd to Anthony because of its many musical activities and because he was becoming increasingly interested in viticulture. In accordance with their usual practice, Anthony and Ellen rented a house.

There they might have remained if Rosamond and Henry had not become anxious about Hugh's prospective career in the army. In February 1847, whcn hc was fiftccn, they had sent him to Dr Bridgeman's school at Woolwich for some preparatory military training. But this was not a success, as one of Hugh's letters home in March makes plain:

'Now, in winter, we have to be down punctually at ½ past 6 o'clock, and we work till ¼ past 8, when we have a hurried breakfast, where like the Dugald Dalgetty, we have to eat very fast, or get nothing at all. Then we kick our heels in the "playground", a miserable half acre of stunted grass, with the "extensive gymnasium", consisting of two poles and a cross-bar, like a gallows with a bit of ragged rope hanging from it, as if inviting you to hang yourself to end your miseries in this horrid hole. We go in at 9 again, and work till ¼ past one; then we wash our hands, & go to dinner; the grub is very good certainly, chiefly consisting of beef in every shape and form. Then we go into the school room, where the awful list of those who are reported is read over: on average ten per day are caned, and 25 confined to do mathematics for an hour: – today 15 were caned, all for the most trifling offences. This is the "no corporal punishment" of the prospectus.' . . .

'Talking of seeing military life, I saw much more at York than I do here, because I can never get out even for an hour. Today there was field gun practice a quarter of a mile off; the roar of the cannon shook the houses, but not a bit of it could I see. I am very unhappy here, the work is so hard, and the hours of school so long. Then there are no games except a miserable pretence at football. I am not half as strong and well looking as I was when I came here. The only thing I like is the fortification, which I like very much indeed, and take great pains with. Your affect[te] but overworked son, H.R.'[23]

By September, Hugh had sent so many letters of complaint that Rosamond and Henry felt they had to remove him from the school. But where else could they send him? As Rosamond explained in her *Family Chronicle*:

'About this time we formed a plan of sending Hugh on the Continent to learn something of military matters, and we wrote to my sister for information on the subject. She and all her family had been spending two months at Michelstadt for Mr Sarg to try the water cure and they were just going to Aschaffenberg [another fashionable spa]. They recommended Darmstadt as one of the best places for the purpose, being the Granducal Residence, with a military school, riding school, and other advantages, and very kindly offered to spend the winter there themselves, if we should like Hugh to board with them, and attend a German school.'[24]

Hugh was immensely enthusiastic about the prospect of going to Germany and in October 1847, he left York in the company of Dr Friedrich Schödler, a close friend of the Sargs who had been staying with his parents. Dr Schödler taught natural sciences at the Worms gymnasium and had just written a bestseller, which was translated into English in 1851 under the title *The Book of Nature; an elementary introduction to the sciences of physics, astronomy, chemistry, mineralogy, geology, botany, zoology, and physiology.*

After an entertaining journey with Dr Schödler, Hugh joined the Sargs at Aschaffenberg and, at the beginning of November, went with them to Darmstadt, where they rented the ground floor of a handsome house in the suburb of Bessungen. Hugh enjoyed himself at Dr Lucius's school, which he attended for several hours each day, particularly when he found himself playing two parts in Molière's comedy *Le Bourgeois Gentilhomme*. He also took to his riding lessons at the Granducal Riding School. Ellen made sure that her favourite nephew was kept well amused in his spare time.

On 5 May 1848 she wrote to Rosamond as follows:

'For a treat on Hugh's birthday, [he was now seventeen] we took an excursion to the ruins of Frankenstein [a thirteenth-century castle]. We reached the station just in time, & were driven to Eberstadt, whence we walked up the wooded mountain, a very steep long pull. At the top, we enjoyed the boundless view, climbed in the ruins, rested, ate, drank, and talked in the little inn adjoining. On our way back we again rested and drank cider at Eberstadt, & walked home.'[25]

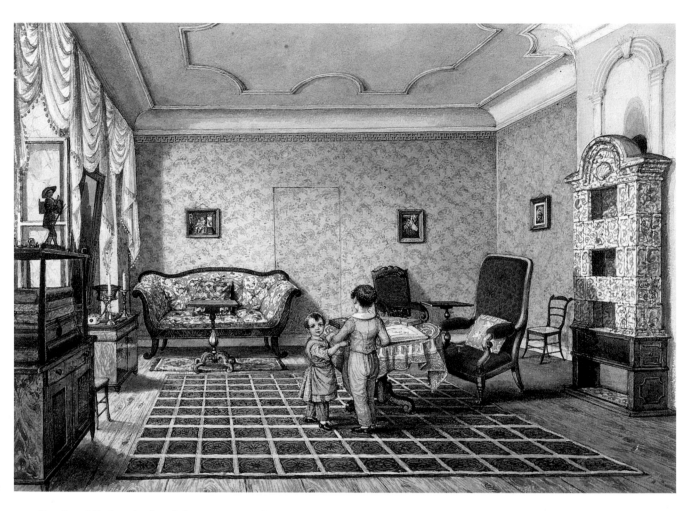

132

132 *Frank and Fred in the Sargs' drawing room in Worms,*
1846 or 1847

This picture shows two of Ellen's less orthodox works. She
had painted a collection of *trompe l'oeil* objects, including a
small plate of fruit, on top of the little table in front of the
sofa, and decorated the tobacco box beneath the mirror with
still-life paintings and the Sarg coat of arms (see 132a).

The stove, curtains, ceiling decoration and 'invisible' door
covered in wallpaper make this a typical continental interior.
There are, however, signs of Ellen's English taste: the arrange-
ment of the red chair beside the round table is identical to that
in her York drawing room.

Frank and Fred are looking at an album of Ellen's water-
colours. She was to give several albums to her children when
they grew up.

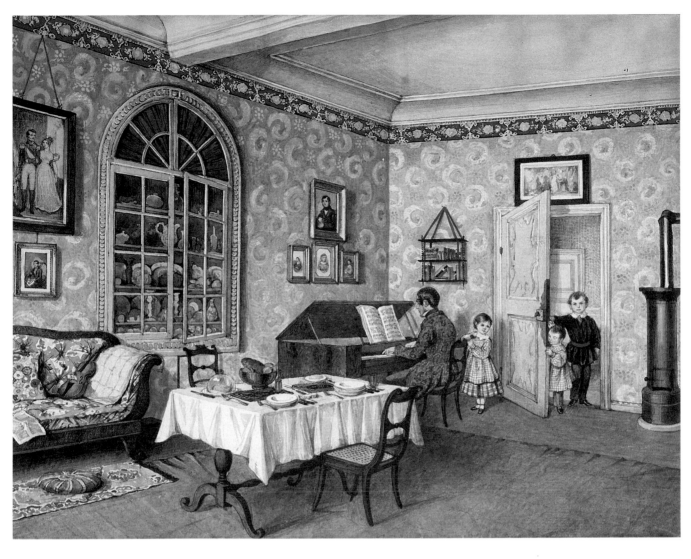

133 *Anthony and the three children, Worms, 1847*

Anthony was very musical and taught his children how to play the piano as soon as they were old enough.

The children are coming into the dining and music room to listen to their father play. The dining table is set for Ellen and Anthony.

The antimacassar protecting the arm of the sofa is a very up to date touch: according to the *Oxford English Dictionary*, the word was first used in 1852. Note that Ellen's wedding portrait of Anthony is hanging just above the sofa.

134

134 *Portrait of Caroline, aged six and a half, December 1848*

Ellen encouraged her daughter to take an interest in drawing and painting, but an album which Caroline gave her cousin Emily Robinson in 1858 shows that she had no talent.

Caroline married Otto Scriba, a German army officer, in 1865. They did not have any children and she died in Darmstadt in 1917.

As Ellen's energy for long walks was limited, Hugh was usually despatched on scenic walks in the Bergstrasse hills or the Odenwald with Anthony and Mr Roland Bramwell, an English clergyman who was living with his family in lodgings next door to the Sargs. Sometimes Anthony took Hugh on excursions lasting several days. In August they went to Heidelberg (which did not meet Hugh's expectations), Rastatt, Baden Baden (where he was impressed by the splendour of the Cursaal, disgusted by the gambling, and fascinated by the dungeons in the castle), Strasburg (where he saw a fair, climbed into the cathedral clock tower and admired a monument to Marshal Saxe), Gernsheim, Landau, Trifels, Gleisweiler (where he tried the cold water cure), Dürkheim (where he saw the extensive salt works) and Mannheim.

In October 1848, a month before Hugh returned home, Ellen wrote to Rosamond with her usual dry humour:

'He has certainly made some proficiency in French and German tho' I must confess *not* that which a youth of greater application would have made in the same time. Last night Hugh and Anthony went to the Casino ball, the former with excessive ill-will, yet as many of his associates were there, and he was seen to laugh heartily, I do not believe it was so totally detestable as he expected.'[26]

The Sargs remained in Darmstadt until October 1849. On the 26th, which was Ellen's fortieth birthday, they moved into a delightful house they had bought for £1,250 on the outskirts of Worms. The Remaier Hof, as it was called, made 'a most excellent and commodious residence, containing five excellent sitting rooms, abundance of bedrooms, kitchens, rooms for making wine, drying fruit, etc. and outside a stable and coach house, garden and productive vineyard'.[27]

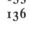

135
136

The Remaier Hof commanded a good view of the thirteenth-century Liebfrauenkirche, or Church of Our Lady, which gave its name to the local white wine, Liebfrauenmilch. Anthony was soon making this wine on a small scale and raising money to restore the church. In 1864 he helped to organise a fund-raising concert given in the church by Cologne's male voice choir.[28] He was also involved in the town's music society, the Casino und Musikgesellschaft, becoming its president in 1855–58 and 1863–64.[29]

With the purchase of the Remaier Hof, the Sargs lost much of their former enthusiasm for travelling. However, after hearing that Henry Robinson had suffered 'a slight attack of paralysis' in October 1850, they resolved to return to England for a short visit and to take Caroline, who was now eight years old, with them. They left their house guests,

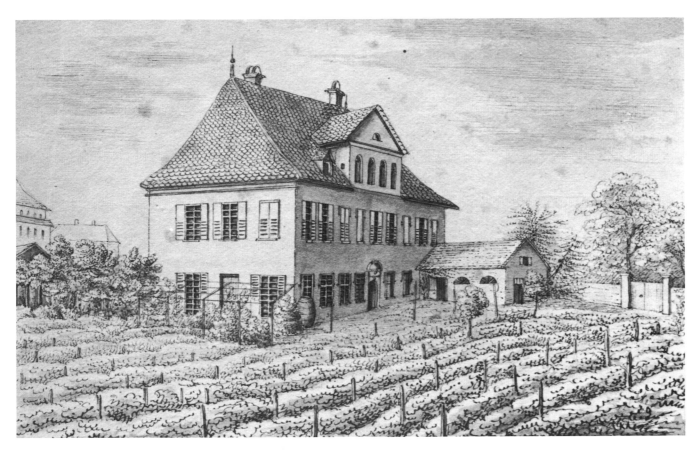

135

135 *'The Remaier Hof, Worms', 1851*

The Remaier Hof still stands on the northern outskirts of
Worms and it is still surrounded by a productive vineyard.
However, it is no longer a family home but a run-down, seedy
warehouse with broken, shutterless windows. The steep
pitched roof and third floor have gone: a corrugated iron roof
keeps out the rain. The view of the Rhine and the Liebfrauen-
kirche (Church of Our Lady) enjoyed by the Sargs, is now
hidden by a semi-circle of concrete tower blocks.

Captain and Mrs Baldwin Wake, in charge of the Remaier Hof and arrived in York on 1 May 1851.

The Sargs spent their time in Yorkshire much as they had done on their previous trip. They based themselves at no. 9 Petergate; Rosamond had inherited her aunts' house and the Robinsons had moved there from Clifton. From here they visited the Palmes at Naburn, the Holdsworths at their new vicarage in Aldborough, Captain and Mrs James White Worsley at Thornton-le-Moor, the Dixons at the vicarage in Bishopthorpe, the Aldersons at their farm in West Huntington, and so on. Anthony took 'Lina', as Caroline was called, and her cousins Ellen and Isabella to see Hengler's Circus and the Robinson boys on a boat trip to Poppleton.

The flavour of the Sargs' time in York is well summed up in Rosamond's entry in the *Family Chronicle* for 3 June:

'Mr and Mrs Sarg dined with the Rev[d] John Robinson, and at 3 o'clock went to singing practice at St Peter's School. At 6 my sister and I, with Lina, Annie, Ros[d] & Mary, went to Miss F. Barlow's, where we had a beautiful tea, and a supper of cakes and ices. In our absence, our husbands played at whist with Charles and Carleton.'[30]

When the Sargs left York a few days later, to visit Miss Shepherd who was spending her retirement years at Brook House near Tonbridge, it had been agreed that they would take Charles to the Continent for four months. They had invited him on a tour of Belgium, and to stay with them at Worms, because Rosamond and Henry thought that he needed a change of scene. Charles was a delicate eighteen-year-old and often had to stay home from school because of illness.

Life in Worms had the desired effect: according to Rosamond, Charles 'enjoyed the fine air, new scenes, pleasant society, Rhine bathing & excellent music exceedingly, & regained his health fast'.[31] He danced twelve times at the Ludwigsballe in Worms, saw Frankfurt and Darmstadt, went on a pedestrian tour of the Odenwald, met Norcliffe Norcliffe in Frankfurt, accompanied Anthony and Captain Wake on a trip to Heidelberg and toured part of Bavaria with Anthony. Charles had a scholarly disposition (he soon went up to the University of Durham) and, unlike his elder brother, made a model guest. Ellen was not tempted to write letters to Rosamond containing veiled criticisms as she had at the time of Hugh's visit.

136 *The long drawing room in the Remaier Hof, Worms, early 1850s*

The striped wallpaper and parallel lines in the rugs accentuate the length of this room which ran across the front of the house, commanding a good view of Anthony's vineyard.

Most of the furnishings are old friends from the Sargs' previous houses. But the pink and white curtains and folding screen decorated with prints are new elements in the décor.

Anthony's violin case can be seen in the corner and Ellen's painting equipment on the small table in front of the window.

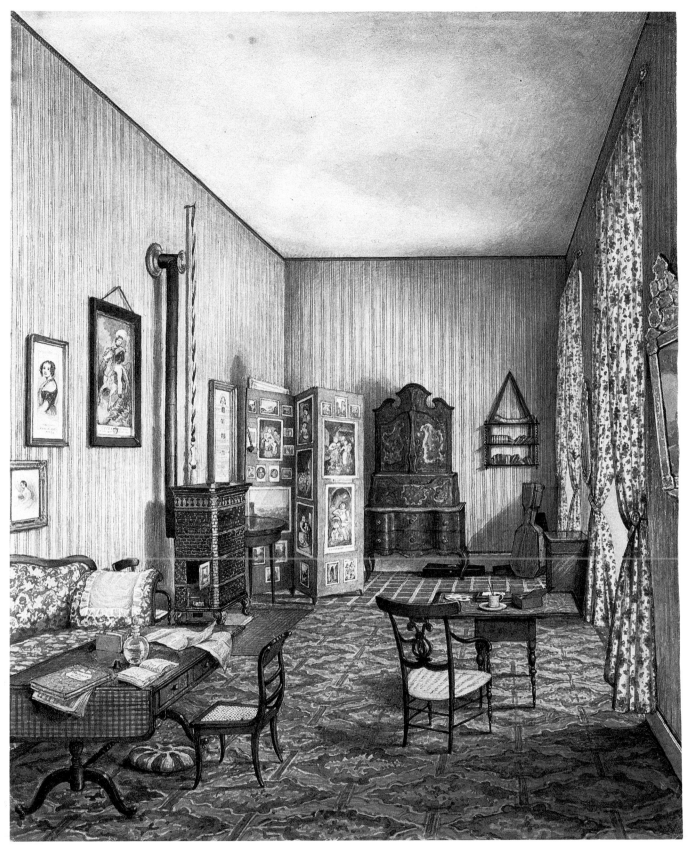

Epilogue

Ellen seems to have gradually given up painting during the late 1840s and early 1850s. Rosamond does not mention any sketches by Ellen during her trip back to England in 1851. There is little evidence of work after this date, apart from a portrait of her god-daughter, Ellen, who visited Worms in 1854, and a portrait of Frank in 1858. Ellen's last known work is of a vase of roses, dated 'Worms June 1860'.

Of course there may be albums of watercolours recording Ellen's life in the 1850s, '60s and '70s which are simply awaiting discovery: not all the paintings that Ellen gave to her husband and children have yet come to light. However, there are reasons for thinking that Ellen did stop painting in her forties.

She had less energy. And, although she was happy, she did not find life as enchanting as she had in her youth, when new experiences and fresh sights had inspired her. By mid century Ellen's children were growing up, she and Anthony had settled in Worms, and her urge to travel was largely satisfied. There was, in a way, not much left to paint.

Ellen's desire to paint was also undermined by the rapid spread of photography. This removed the need to paint people's portraits and provided a much more accurate way of recording the outer appearance of things. It was too late for Ellen to develop a new way of painting. She had always painted exactly what she saw in what, ironically, was an almost photographic fashion. Since leaving school, her style had hardly altered, although there had been many changes in her subject matter.

It is worth noting that Rosamond also ran out of steam in middle age. Although she kept up the *Family Chronicle* until 1851, when the last of her thirteen children was born, the entries of the last few years are often very cursory. One has the sense that she had grown weary of describing the day-to-day events of family life, year in year out, and that she was no longer surprised by anything her children did or said, much as she loved them. After 1851 she wrote no more. Like Ellen, her energy was failing and the novelty of life had worn off.

Ellen and Anthony continued to live in the Remaier Hof in Worms until 1866 when they sold the house to a local woollen yarn spinning business, the Wollgarnspinnerei Actiengesellschaft.[1] Although Anthony had become a citizen of Worms in 1857, they were never rooted to the town.[2] When Frank wrote to them that year from Freiburg (he was now a mining student) they were visiting Brussels.[3]

By 1873 Ellen and Anthony had retired to Darmstadt, where they lived in a succession of lodgings. They wanted to be near Caroline, who had married an army officer, Otto Scriba, in 1865 and settled there.[4] Frank and Fred were far away in Latin America.

As a young man, Frank first pursued his mining career in Argentina, but on a trip back to Europe in 1867 he was persuaded to transfer to Guatemala. Frank formed a partnership with two friends and settled in San Cristobal at the end of 1868. They spent two years investigating the potential of local lead mines before concluding that the ore was not worth exploiting. They then turned to coffee growing, but their partnership collapsed and Frank took a job with a German shipping company in the port of San José.

Fred, who became an agronomist after studying at the agricultural school of Hof Geisberg near Wiesbaden, arrived in Guatemala in 1870 with his German wife, Susanna Egner. They settled in Cobán, capital of the beautiful and fertile Alta Verapaz, and bought a coffee plantation known as *finca* Sachamach.

In 1872 Fred persuaded Frank to join him in Cobán. The following year, after a visit home from Frank, Ellen decided to lend her sons some of the £10,000 she had inherited from her uncle Norcliffe Norcliffe, to develop the plantation and set up an export import business called 'Sarg Hermanos – Comerciantes, Agricultores e Industriales'.[5] The two brothers opened a general store opposite the cathedral which soon became known as 'El Gallo' because of its distinctive weather cock. Frank designed a machete, which was manufactured in England for sale in the store, and Fred invented a successful machine for removing the soft outer pulp from coffee beans, which was made in Darmstadt. It is still known as 'el pulpero Sarg'.[6]

During his trip back to Europe in 1873, Frank married Mary Parker of Penge in South London. Mary's widowed mother organised a large celebration dinner at the nearby Crystal Palace; Frank's family was well represented, and Ellen and Anthony came over from Germany for the occasion.

The two brothers had several children in Guatemala and lived in considerable style. Frank was very interested in science and natural history (he had been taught by Professor Kaup, Director of the Nature Studies Cabinet at Darmstadt) and found much to interest him in the local flora and fauna. He also became a great expert on the Indians and

their customs. Most of the distinguished and eccentric travellers who made their way to Cobán in the 1870s were grateful for his hospitality and help.[7]

At the beginning of the 1880s the brothers decided that life in the Alta Verapaz was beginning to deteriorate. Coffee prices were low, the Indian population was restive, and the area was threatened by a border dispute with Mexico. They sold Sarg Hermanos to their junior partner Moritz Thomae. Fred moved to the up and coming port of Livingston in 1882 and in the following year Frank settled in Guatemala City, where he was appointed Imperial German Consul. The two brothers eventually retired to Germany.

Although Ellen and Anthony maintained close ties with their sons and grandchildren, they never visited them in Guatemala. Anthony died in 1883, at the age of seventy-four. Ellen tried to maintain her independence, but four years later moved in with the Scribas who lived at 23 Wilhelmstrasse (now known as Goethestrasse) in the quiet suburb of Bessungen.[8] She died of pneumonia at their house on 10 May 1891. By then she was an old lady of eighty-one.[9]

137 *Roses in a vase, 'Worms, June 1860'*

Ellen's last known work.

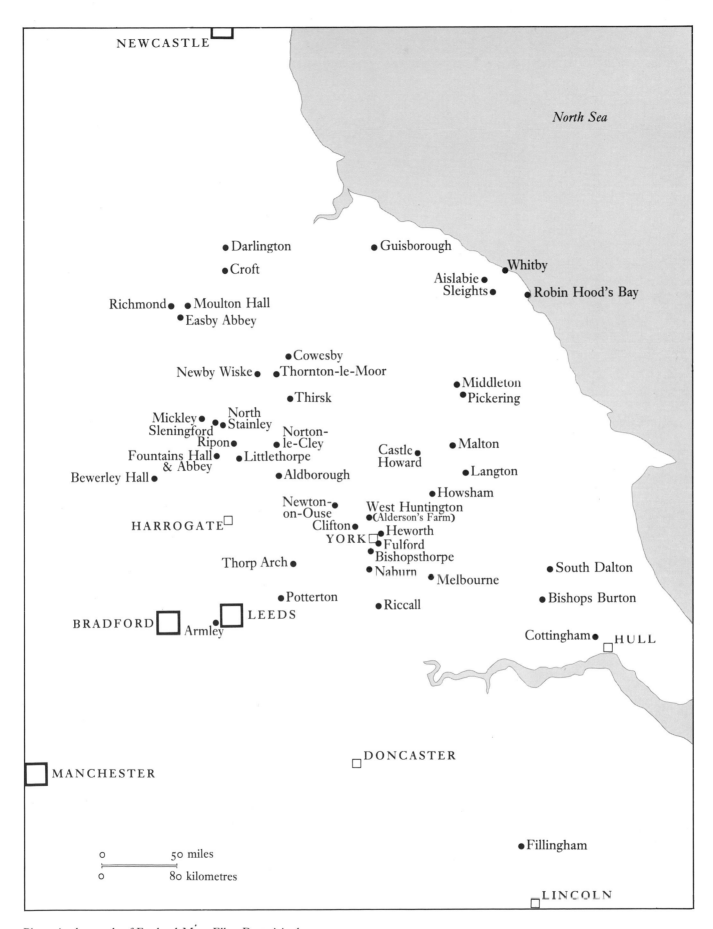

NEWCASTLE

North Sea

• Darlington
• Guisborough
• Croft
Whitby •
Aislabie •
Sleights • Robin Hood's Bay
Richmond • • Moulton Hall
• Easby Abbey

• Cowesby
Newby Wiske • • Thornton-le-Moor
• Thirsk
• Middleton
• Pickering
Mickley • North
Sleningford • Stainley
Ripon • Norton-
le-Cley
• Malton
Fountains Hall • • Littlethorpe
& Abbey
Castle •
Howard
• Langton
Bewerley Hall •
• Aldborough
• Howsham
Newton-
on-Ouse West Huntington
• (Alderson's Farm)
Clifton • • Heworth
HARROGATE □
YORK □ Fulford
Bishopsthorpe
Thorp Arch • • Naburn
Melbourne
• South Dalton
• Potterton
• Riccall
• Bishops Burton
BRADFORD □ □ LEEDS
Armley
Cottingham • □ HULL

□ DONCASTER

□ MANCHESTER

0 ———— 50 miles
0 ———— 80 kilometres

• Fillingham

□ LINCOLN

Places in the north of England Mary Ellen Best visited.

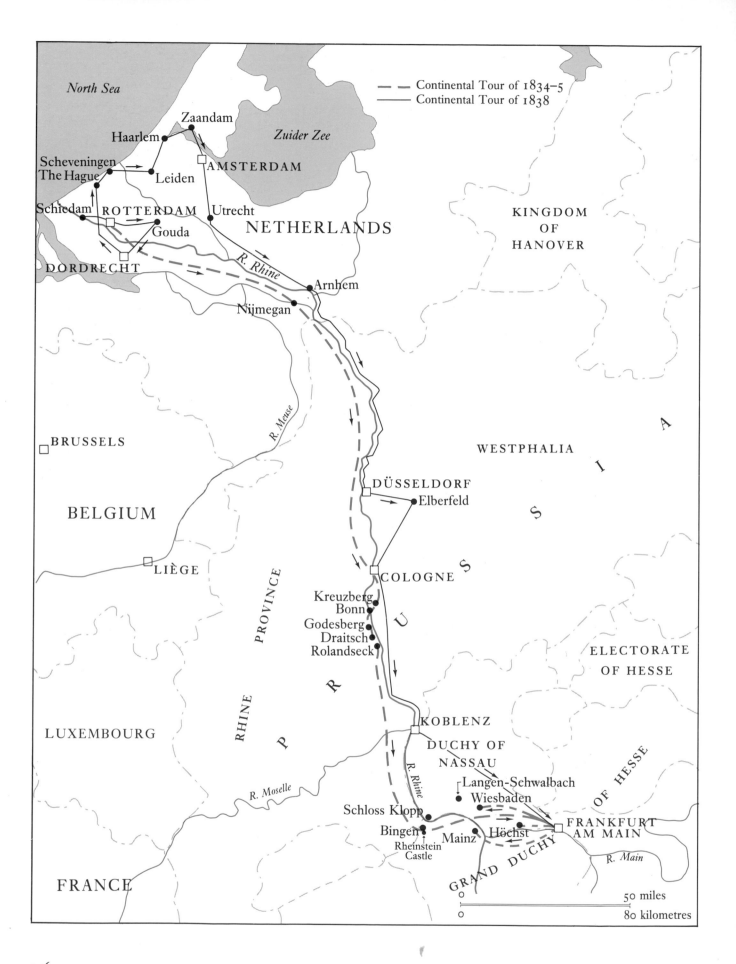

North Sea

Zaandam

Haarlem

Zuider Zee

Scheveningen
The Hague

Leiden

AMSTERDAM

Schiedam

ROTTERDAM

Utrecht

NETHERLANDS

Gouda

DORDRECHT

R. Rhine

Arnhem

Nijmegan

KINGDOM
OF
HANOVER

Continental Tour of 1834-5
Continental Tour of 1838

R. Meuse

BRUSSELS

WESTPHALIA

DÜSSELDORF

Elberfeld

BELGIUM

LIÈGE

RHINE PROVINCE

PRUSSIA

COLOGNE

Kreuzberg
Bonn
Godesberg
Draitsch
Rolandseck

ELECTORATE
OF HESSE

LUXEMBOURG

R. Moselle

KOBLENZ

DUCHY OF
NASSAU

R. Rhine

Langen-Schwalbach
Wiesbaden

OF HESSE

Schloss Klopp

Bingen

Rheinstein
Castle

Mainz

Höchst

FRANKFURT
AM MAIN

FRANCE

GRAND DUCHY

R. Main

50 miles

80 kilometres

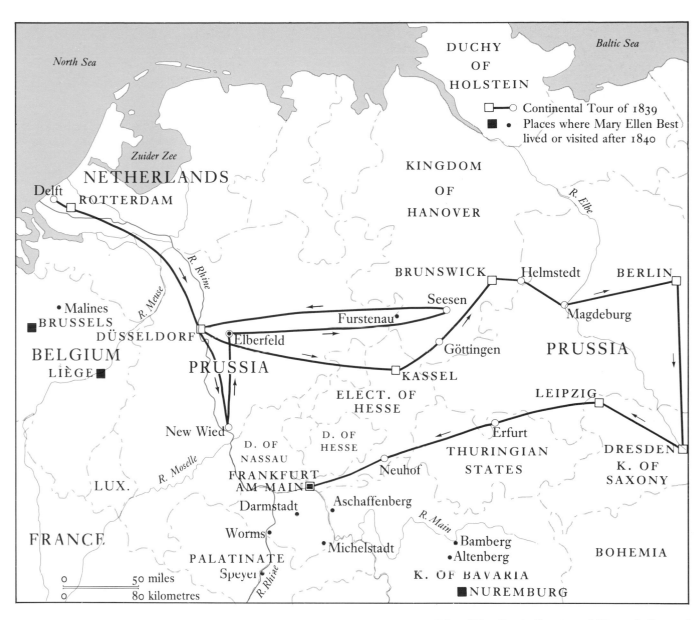

Mary Ellen Best's Continental Tour of 1839 and
the places where she lived or visited after 1840.

Mary Ellen Best's Continental Tours of 1834 5 and 1838.

Sources of information*

Mary Ellen Best, *List of Portraits 1828–1849*. This manuscript lists 651 portraits and identifies the subject and recipient of each picture. It also contains a list of sales and receipts.

Mary Ellen Best, two *Yorkshire sketchbooks* of 1829–30

Mary Ellen Best, *Album of watercolours dedicated to Johann Anton Sarg*, containing sixty-seven English watercolours painted between 1832 and 1839, some of which Mary Sarg Murphy sold through Sotheby's in January 1983.

Mary Ellen Best, *Album of watercolours dedicated to James Frederick Sarg*, containing thirty-nine early works painted in York, Wales and the continent between 1831 and 1836. Other watercolours from this album are dispersed.

Mary Ellen Best, *Album of watercolours dedicated to James Frederick Sarg*, containing forty-five watercolours painted during her first continental tour of 1834–5 and eight other continental subjects painted at a later date. Most of these were sold by Ronald Graney through Sotheby's in October 1984.

Mary Ellen Best, *Album of watercolours dedicated to Caroline Elizabeth Scriba*, containing forty-two continental watercolours of 1838. Contents now dispersed.

Mary Ellen Best, *Album of watercolours dedicated to Francis Charles Anthony Sarg*, containing forty-nine English and continental watercolours painted between 1839 and 1841. Contents now dispersed.

Mary Ellen Best, *Album of watercolours probably dedicated to Johann Anton Sarg*, containing numerous pictures of the Sargs' life in Frankfurt, Malines and Worms between 1842 and 1850. Index now lost and contents dispersed.

Mary Ellen Best, *Family Gallery*, an album of Sarg family portraits from the 1840s. Contents now dispersed.

The *Dalton Album* containing five of Mary Ellen Best's English watercolours, sold by Sotheby's in July 1983. Contents now dispersed.

Folder of miscellaneous correspondence about the York Lunatic Asylum and the death of Dr Best, c. 1810–1820

Rosamond Best, *Folder containing letters from Rosamond Best to her father Charles Best, sister Ellen and mother in Nice about her stay at South Dalton and Bishops Burton, 1810–1816*, Humberside County Record Office, MS DDX 65/31

Folder containing letters to Thomas Norcliffe, Langton, with family matters and local gossip, Humberside County Record Office, MS DDX 65/34

Book containing copies of letters from Charles Hare Wake, 1828–1831, Humberside County Record Office, MS DDHV 73

Thomas Robinson, *Diaries 1831–1838*, Humberside County Record Office, MS DDHV/74

Rosamond Robinson, *A Family Chronicle of Twenty Years in the Life of Mr and Mrs Henry Robinson 1831–1851*. This is the main source of biographical information about Mary Ellen Best.

Rosamond Robinson, *Family Pedigrees, and Genealogical Tables, Arms etc. of my own Lineal Ancestry. Arranged and emblazoned by me, Rosamond Robinson, 9 Petergate, York, 1851*, Humberside County Record Office, MS DDHV 76/9

Tony Sarg, *Album*, compiled in New York, c. 1924. This unpublished manuscript contains information about Mary Ellen Best and Sarg family history and reproduces some of Mary Ellen Best's watercolours. Tony Sarg made several copies of it.

* Manuscripts are in private collections, unless otherwise stated.

Select bibliography

YORK AND YORKSHIRE

Oswald Allen, *History of the York Dispensary: containing an account of its origin and progress to the present time: comprising a period of fifty-seven years*, York, 1845

Edward Baines, *History, Directory and Gazeteer of the County of York*, vol 1 *The West Riding* and vol 2 *East and North Ridings*, Leeds, Edward Baines, 1822 and 1823

Anne Digby, 'Changes in the Asylum: The Case of York, 1777–1815', *The Economic History Review*, 2nd series, vol XXXVI, no. 2, May 1983

Jonathon Gray, *A History of the York Lunatic Asylum*, York, W. Hargrove, 1815

William Hargrove, *History and Description of the Ancient City of York*, York, 1818

– *A Description of York, containing some account of its antiquities, public buildings etc. particularly the Cathedral*, York, John and George Todd, 1823

– *The New Guide for Strangers and Residents in the city of York, being the latest and the best concise historical description of all the public buildings, antiquities etc. of that ancient city*, York, W. & J. Hargrove, 1838

William Parson and William White, *Directory of the Borough of Leeds, the City of York, and the Clothing District of Yorkshire...*, Leeds, Wm Parson & Wm White, 1830

Pigot & Co., *General Directory*, 1816 and 1828

[Procter & Vickers], *The History of Ripon, with historic notices and descriptions of Fountains Abbey, Studley, Swinton Park, Newby Hall...*, Ripon, Procter & Vickers, 1839

[W. H. Smith], *City of York Directory, alphabetical list, classification of trades*, Hull, W. H. Smith, 1843

[Wm Sotheran], *The City of York. A Guide for Strangers and Visitors*, York, Wm Sotheran, 1843

– *The York Guide for Strangers and Visitors*, York, W. Sotheran, 1846.

William White, *History, Gazeteer and Directory of the West Riding of Yorkshire, with the city of York and Port of Hull*, Sheffield, W. White, 1838

– *History, Gazeteer, and Directory of the East and North Ridings of Yorkshire*, Sheffield, W. White, 1840

Yorkshire Philosophical Society, *Annual Reports*, York, 1826–40

George Young, *A Picture of Whitby and its environs*, Whitby, 1824

GERMANY, HOLLAND AND BELGIUM

Zachariah Allen, *The Practical Tourist, or sketches of the state of the useful arts, and of society, scenery, etc. etc. in Great-Britain, France and Holland*, Boston, Richardson, 1832

T. B., *Journal of a tour made by a party of friends in the autumn of 1825, through Belgium, up the Rhine, to Frankfort and Heidelberg...*, Norwich, S. Wilkin, 1828

Robert Batty, *A Family Tour through South Holland; up the Rhine; and across the Netherlands*, London, John Murray, 1831

Frans Berlemont, *Water in de Straten Van Mechelen*, Mechelen, J. Stevens, 1980

John Ross Browne, *An American Family in Germany*, New York, Harper & Brothers, 1866

William Chambers, *A Tour in Holland, the Countries on the Rhine, and Belgium. In the autumn of 1838*, Edinburgh, William and Robert Chambers, 1839

Sir John Forbes, *Sight-seeing in Germany and the Tyrol in the autumn of 1855...*, London, Smith & Elder, 1856

W. E. Frye, *After Waterloo. Reminiscences of European Travel, 1815–1819 ed. by Salomon Reinach*, London, William Heinemann, 1908

Léopold Godenne, *Malines, jadis et aujourd'hui*, Malines, L. & A. Godenne, 1908

Harriet Gunn, *Letters written during a four-days' tour in Holland, in the summer of 1834*, privately printed by Dawson Turner, 1834

Francis Bisset Hawkins, *Germany; the spirit of her history, literature, social condition, and national economy; illustrated by reference to her physical, moral and political statistics, and by comparison with other countries*, London, John W. Parker, 1838

Herbert Heckman und Walter Michel, *Frankfurt mit den Augen Goethes*, Frankfurt am Main, Umschau, 1982

Anna Mary Howitt, *An art-student in Munich*, London, Longman, Brown etc., 1853

William Howitt, *The rural and domestic life of Germany: with characteristic sketches of its cities and scenery, collected in a general tour, and during a residence in the country in the years 1840, 41 and 42*, London, Longman, Brown etc., 1842

Anna Brownwell (Murphy) Jameson, *Sketches of Germany. Art. Literature. Character*, Frankfurt, Charles Jugel, 1837

Wolfgang Klötzer, *Clothilde Koch-Gontard an ihre Freunde. Briefe und Erinnerungen aus der Zeit der deutschen Einheitsbewegung 1834–1869. Bearbeitet von Wolfgang Klötzer*, Frankfurt am Main, Waldemar Kramer, 1969

Marcel Kocken, *Mechelen Volgens Van Den Eynde*, Mechelen, J. Stevens, 1982

Hans Lohne, *Frankfurt um 1850. Nach Aquarellen und Beschreibungen von Carl Theodor Reiffenstein und dem Malerischen Plan von Friedrich Wilhelm Delkescamp*, Frankfurt am Main, Waldemar Kramer, 1967

Henry Mayhew, *The Upper Rhine: the scenery of its banks and the manners of its people...*, London, George Routledge, 1858

John Murray and Son, *A handbook for travellers on the Continent: being a guide through Holland, Belgium, Prussia, and Northern Germany, and along the Rhine, from Holland to Switzerland*, London, John Murray and Son, 1836

– *A handbook for travellers in Southern Germany...*, London, John Murray, 1837

Jan Neckers, *Mechelen Zoals J. B. De Noter Het Zag*, Mechelen, J. Stevens, 1980

Thomas Roscoe, *Belgium: in a picturesque tour . . .*, London, Longman, Orme, Brown, 1841

John Russell, *A tour in Germany, and some of the southern provinces of the Austrian Empire, in the years 1820, 1821, 1822*, Edinburgh, Archibald Constable, 1824

Mary Wollstonecraft (Godwin) Shelley, *Rambles in Germany and Italy, in 1840, 1842, and 1843*, London, Edward Moxon, 1844

Edmund Spencer, *Sketches of Germany and the Germans . . . in 1834, 1835, and 1836 by an Englishman resident in Germany*, London, Whittaker & Co., 1836

Seth William Stevenson, *A tour in France, Savoy, Northern Italy, Switzerland, Germany and the Netherlands, in the summer of 1825 . . .*, London, C. and J. Rivington, 1827

Frances (Milton) Trollope, *Belgium and Western Germany in 1833 . . .*, London, John Murray, 1834

G. Van Caster, *Histoire des rues de Malines et de leurs monuments*, Malines, J. Ryckmans Van Deuren, 1882

– *Malines: Guide historique et description des monuments*, Bruges, Dexlée, De Brouwer et C^ie, 1887

THE ARTISTIC BACKGROUND

Jane Bayard, *Works of Splendor and Imagination: the Exhibition Watercolor 1778–1879*, New Haven, Yale Center for British Art, 1981

Michael Clarke, *The Tempting Prospect. A Social History of English Watercolours*, London, British Museum, 1981

Ellen C. Clayton, *English Female Artists*, London, Tinsley Brothers, 1876

Richard Cobbold, *The Biography of a Victorian Village. Richard Cobbold's account of Wortham, Suffolk, 1860, Edited and Introduced by Ronald Fletcher*, London, B. T. Batsford, 1977

John Cornforth, *English Interiors 1790–1848. The Quest for Comfort*, London, Barrie & Jenkins, 1978

Die Düsseldorfer Malerschule, Kunstmuseum Düsseldorf und Mathildenhöhe Darmstadt, 1979

Gillian Dickinson, *Rutland Churches before Restoration. An early Victorian album of watercolours & drawings. With commentaries and photographs by Gillian Dickinson and contributions from Richard J. Adams, Geoffrey K. Brandwood and R. P. Brereton*, Barrowden Books, 1983

Trevor Fawcett, *The Rise of English Provincial Art. Artists, Patrons, and Institutions outside London, 1800–1830*, Oxford, Clarendon Press, 1974

Joan Friedman, 'Every Lady Her Own Drawing Master' in *Apollo*, April 1977

John Ford, *Ackermann 1783–1983. The Business of Art*, London, Ackermann, 1983

Willi Geismeier, *Biedermeier*, Ebeling, Verlag Wiesbaden, 1979

Alexander Gilchrist, *Life of William Etty, R.A.*, London, David Bogue, 1855

Germaine Greer, *The Obstacle Race. The Fortunes of Women Painters and their Work*, London, Secker & Warburg, 1979

Hazlitt, Gooden & Fox, *Interiors*, catalogue of an exhibition held in London, November 1981

Jens Christian Jensen, *Caspar David Friedrich. Life and Work. Translated by Joachim Neugroschel*, London, Barron's, 1981

Susan Lasdun, *Victorians at Home*, London, Weidenfeld & Nicolson, 1981

Stuart Macdonald, *The History and Philosophy of Art Education*, London, University of London Press, 1970

Gordon Mingay, *Mrs Hurst Dancing & Other Scenes from Regency Life 1812–1823, Watercolours by Diana Sperling*, London, Victor Gollancz, 1981

Marianne North, *A Vision of Eden. The Life and Work of Marianne North*, Exeter, Webb & Bower, 1980

John Lewis Roget, *A History of the 'Old Water-Colour' Society now the Royal Society of Painters in Water Colours*, London, Longmans, 1891

E. M. Thornton, *Marianne Thornton 1797–1887, A Domestic Biography*, London, Edward Arnold, 1956

Peter Thornton, *Authentic Decor. The Domestic Interior 1620–1920*, London, Weidenfeld and Nicolson, 1984

Marina Warner, *Queen Victoria's Sketchbook*, London, Macmillan, 1979

William Vaughan, *German Romantic Painting*, Yale University Press, 1980

Heinrich Weizsäcker und Albert Dessof, *Künst und Künstler in Frankfurt am Main im 19. Jahrhundert*, Frankfurt am Main, 1909

References and notes
to the text

I – A SCANDALOUS CHILDHOOD

1 – She was baptised on 26 October at St Mary's, Castlegate. See *The Parish Register of St Mary Castlegate, York*, Yorkshire Archaeological Society, 1972, vols II, III, IV, p. 174.

2 – *Holden's Triennial Directory, 1809–11*.

3 – R. Robinson, *Family Pedigrees*, p. 93.

4 – 'Pedigrees and Notes on the Best Family at Elmswell', Yorkshire Archaeological Society, MS 775.

5 – 'Minutes of the Carey Street Dispensary', Library of the Royal College of Physicians, MS 2468 D.

6 – Allen, *History of the York Dispensary*, pp. 43, 44.

7 – Digby, 'Changes in the Asylum: The Case of York, 1777–1815', *The Economic History Review*.

8 – Memorandum from one of the governors of the York Lunatic Asylum dated 1 September 1808, containing a letter from Dr Best. Letter from H. Brougham of Appleby to Dr Best dated 29 September 1813.

9 – Allen, *History of the York Dispensary*, pp. 51, 53.

10 – Gray, *A History of the York Lunatic Asylum*, p. 82.

11 – Will of Alexander Hunter, Borthwick Institute, York.

12 – Hargrove, *A Description of York*, 1823, pp. 110–11 and Sotheran, *The York Guide for Strangers and Visitors*, 1846, p. 89.

13 – Sotheran, *The York Guide for Strangers and Visitors*, 1846, pp. 53, 72, 74, 85.

14 – See Digby.

15 – The governors are listed in 'Rules and Regulations for the Management of the York Lunatic Asylum, 27 August 1814', in *Tracts on the Asylum*, pp. 44–6. (Copy in York City Reference Library.)

16 – MS letter in *Folder of miscellaneous correspondence about the York Lunatic Asylum and the death of Dr Best, c.1810–1820*.

17 – Ibid.

18 – Ibid.

19 – MS letter from H. Brougham of Appleby dated 29 September 1813 to Dr Best.

20 – MS letter from Thomas Thompson of London dated 2 July 1814 to Dr Best.

21 – Gray, *A History of the York Lunatic Asylum*, p. 84.

22 – MS letters from Dr Best in London to Mrs Best, dated 27 May, 31 May and 11 June 1815.

23 – R. Robinson, *Family Pedigrees*, p. 93

24 – MS letter from Mrs Best in Nice dated 11 June 1816 to Mrs Ann Norcliffe.

25 – MS letter from Mrs Best in Nice dated 17 September 1817 to Francis Best.

26 – Dr Best's will was proved in London in August 1818 and can be seen in the Public Record Office, London, MS B11/1607 RC/1712. It was witnessed by Elizabeth Alderson.

27 – MS letter from Mrs Best in Nice dated 17 September 1817 to Francis Best.

28 – MS letter from Mrs Best in Nice dated 15 August 1817 to Francis Best.

29 – MS account book.

30 – MS letter from Mrs Best at Langton dated 31 July 1819 to Lord Lansdowne.

31 – Mary Norcliffe Best's will, dated 25 November 1836 and proved in York on April 8 1837, Borthwick Historical Institute, York.

32 – Charles William Hatfield, *Historical Notices of Doncaster*, Doncaster, 1868, pp. 357–8 and John Anthony Harrison, *Private Schools in Doncaster in the Nineteenth Century*, Doncaster, Doncaster Museum, part 2, pp. 51–3 and part 6, pp. 58–9.

33 – 'Personal Correspondence and Papers of Caroline Forth, 1816–1825', *Munby Papers*, York City Archives, Acc. 54: 183–93.

34 – *Dictionary of National Biography*.

35 – This picture is listed as 'Miss Shepherd's drawing room' in Ellen's *Album of Watercolours dedicated to Johann Anton Sarg*. It is reproduced in Tony Sarg's album with an incorrect caption.

36 – Ann Haugh, *A Few Slight Sketches of History, etc. intended as hints to future study*, Doncaster, C. and J. White, 1826, pp. 21, 28, 30. (Copy in Doncaster Public Library.)

37 – 'Personal Correspondence and Papers of Caroline Forth, 1816–1825', *Munby Papers*, York City Archives, Acc. 54: 183–93.

38 – James Roberts, *Introductory lessons with familiar examples in landscapes*, London, J. & W. Smith, 1809, p. 5 and Jane Austen, *Pride and Prejudice*, Oxford University Press, 1967, p. 164.

39 – T. P. Cooper, *The Caves of York: Topographical draughtsmen, artists, engravers and copper-plate printers*, York, City of York Art Gallery, 1934, pp. 20–31.

40 – Letter from Mrs Jane Pontey dated 18 January 1825 to Jane Munby at the Manor School, York in the 'Personal Correspondence and Papers of Caroline Forth', *Munby Papers*, York City Archives, Acc. 54: 183–93.

41 – Winifred Gérin, *Branwell Brontë*, London, Thomas Nelson, 1961, pp. 75–95.

42 – Baines, *History, Directory and Gazeteer, of the County of York*, vol. 2, pp. 117, 132.

43 – For information about George Haugh and Thomas Christopher Hofland, see the *Dictionary of National Biography* and H. L. Mallalieu, *The Dictionary of British Watercolour Artists up to 1920*, Antique Collectors Club, 1976. For Francis Nicholson's remarks see *The Practice of Drawing and Painting Landscape from Nature*, London, J. Booth, 1820, p. 83.

44 – Baines, *History, Directory and Gazeteer of the County of York*, vol. 1, p. 175.

45 – R. Robinson, *Family Chronicle*, entry for 2 January 1835, p. 48.

46 – *1841 Census*, Bromley Common, Bromley Parish, Kent, enumeration schedule p. 8.

47 – *A History of Bromley in Kent, and the surrounding neighbour-hood, together with an account of the colleges, their founders, benefactors, etc.*, Bromley, Edward Strong, 1858, pp. 126–7 and E. L. S. Horsburgh, *Bromley, Kent, From the earliest times to the present century. Compiled from materials collected from original sources by various hands*, London, Hodder and Stoughton, 1929, vol. 2, p. 286.

48 – Charles Freeman, *The History, Antiquities, Improvements, etc. of the parish of Bromley, Kent*, Bromley, William Beckley, 1832, p. 29.

49 – Letter from Käte Silber, editor of Pestalozzi's collected works and letters, Bromley Central Reference Library, MS B760 260/3/3.

50 – The first volume of Eliza Shepherd's translation was published in Geneva in 1824.

51 – *Amelia Long, Lady Farnborough 1772–1837. An exhibition of watercolours, drawings and etchings*, Dundee City Art Gallery, 1980, pp. 3–8.

52 – M. E. Best, *List of Portraits*, 1837.

53 – R. Robinson, *Family Chronicle*, passim.

2 – THE AMBITIOUS YOUNG ARTIST

1 – R. Robinson, *Family Chronicle*, and T. Robinson, *Diary*, passim.

2 – Letter from Charles H. Wake in Langor, India, dated 25 April 1830 to Charlotte Wake in York in *Book containing copies of letters from Charles H. Wake*.

3 – Gilchrist, *Life of William Etty*, vol. 1, pp. 279, 337–43.

4 – [Rosamond Best], *Views of the Parish Churches in York; with a Short Account of Each*, York, A. Barclay, 1831.

5 – R. Robinson, *Family Chronicle*, 28 August 1831, p. 5.

6 – Ibid. 19 December 1831, p. 7.

7 – Ibid. 23 November 1832, p. 17.

8 – Ibid. 3 and 10 September 1831, pp. 5–6.

9 – T. Robinson, *Diary*, 1 June 1831.

10 – Ibid. 12 June and 19 July 1831 and 12 February 1832.

11 – See, for example, Thomas Winstanley, *Observations on the Arts, with tables of the principal painters, of the various Italian, Spanish, French, Flemish, Dutch and German Schools*, Liverpool, W. Wales & Co., 1828.

12 – R. Robinson, *Family Chronicle*, 3 May 1833, p. 20.

13 – See Jones & Co., *Jones' Views of the Seats, Mansions, Castles, etc. of Noblemen and Gentlemen in England, Wales, Scotland and Ireland*, London, Jones & Co., 1829.

14 – G. F. Waagen, *Treasures of Art in Great Britain: Being an account of the chief collections of paintings, drawings, sculpture, illuminated MSS, etc.*, London, John Murray, 1854, vol. 3, pp. 334, 337.

15 – *The Visitor's Guide to Castle-Howard*, 1851, pp. 74–5.

16 – Henry Lawrance, 'Portraits at Langton Hall in the Possession of Francis Best Norcliffe, Esq.' in *Transactions of the East Riding Antiquarian Society*, vol. XII, 1904.

17 – One of the first books in translation to popularise the Rhine tourist route was Aloys Wilhelm Schreiber's *The Traveller's Guide down the Rhine*, London, S. Leigh, 1819.

18 – Stevenson, *A tour in France, Savoy, Northern Italy, Switzerland, Germany*, p. 676.

19 – Hawkins, *Germany; the spirit of her history, literature, social condition, and national economy*; pp. 465–6.

20 – Frankfurt was 'the university of servants and the table d'hote' according to Heinrich Laube, writing in the 1830s. He is quoted in Heckman und Michel, *Frankfurt mit den Augen Goethes*, p. 260.

21 – *Journal de Francfort* ed. by M. le Professeur Durand, 5 October 1834.

22 – T.B., *Journal of a tour made by a party of friends in the autumn of 1825*, p. 41.

23 – *Allgemeines Adress-buch der Freien Stadt Frankfurt 1834*, Frankfurt am Main, Georg Friedrich Krug, 1834, p. 41.

24 – M. E. Best's Frankfurt album contained a 'Triple portrait of the three Miss Eckhardts of the Rossmarkt, Frankfurt, Susanna, Margarethe Elisabeth, and Dorothea Johanna'. Her *List of Portraits* gives its date as February 1835 and the girls' nicknames as Sanchen, Lilly and Dorchen.

25 – M. E. Best's Frankfurt album contained a painting of 'A bedroom in our residence no. 9 Neue Mainzer Strasse, Frankfurt'.

26 – The history of the Marogna family in Frankfurt can be traced in the Frankfurt *Adress-buch* of 1834–44 and the 1835 *Staatskalender für Frankfurt*.

27 – T.B., *Journal of a tour made by a party of friends in the autumn of 1825*, p. 40.

28 – Stevenson, *A tour in France, Savoy, Northern Italy, Switzerland, Germany*, p. 669.

29 – For details about the Kochs see Trollope, *Belgium and Western Germany in 1833*, pp. 228, 235, 242 and Heinrich Heym, Wolfgang Klötzer, Wilhelm Treue, *Bankiers sind auch Menschen 225 Jahre Bankhaus Gebrüder Bethmann*, Frankfurt am Main, Societäts-Verlag, 1973, pp. 219–21 and Klötzer, *Clothilde Koch-Gontard an ihre Freunde*, pp. 13, 15, 25, 34, 55, 181.

30 – For details about Sir Alexander Mackenzie Downie, M.D., see his two books: *A practical treatise on the efficacy of mineral waters in the cure of chronic disease, illustrated by cases*, Frankfurt o/M, Charles Jugel, 1841 and *The Spas of Homburg considered with reference to their efficacy in the treatment of chronic disease*, London, John Churchill, 1844.

31 – For details about Louise de Panhuys see Weizsäcker und Dessof, *Kunst und Künstler in Frankfurt am Main im 19. Jahrhundert*, and *Frankfurter Zeitung*, Stadtblatt, 24.1.1937.

32 – There are actually two candidates for the 'Madame d'Adlerflycht' Mary Ellen Best knew in Frankfurt. The most likely is the artist, Susanna Maria Rebecca Elisabeth von Adlerflycht. For information about her see Weizsäcker und Dessof, *Kunst und Künstler in Frankfurt am Main im 19. Jahrhundert*, p. 1. The other possibility is Elisabeth von Adlerflycht, widow of Justinian von Adlerflycht, a distinguished lawyer and diplomat who had been lord mayor of Frankfurt in 1815. For information about her see *Blätter für Familiengeschichte*, Frankfurt am Main, 1909 and Johannes Werner, *Die Schwestern Badua*, Leipzig, 1929, pp. 136, 138, 139.

33 – This can be seen by her frequent spelling mistakes and omissions of the umlaut.

34 – *Verzeichniss der ausserordentlichen Ausstellung des Frankfurter Kunst-Vereins im Saal des goldnen Rosses, eröffnet den 16. Mai 1835*, Frankfurt am Main, Johänn David Sanerländer, 1835. (Copy in Städel Institute Library.)

35 – See, for example, Keith Kurt Andrews, *The Nazarenes. A*

Brotherhood of German Painters in Rome, Oxford, Clarendon Press, 1964, and Vaughan, *German Romantic Painting*.

36 – Geismeier, *Biedermeier*.

37 – For details of Etty's artistic training see Gilchrist, *Life of William Etty*, and Dennis Farr, *William Etty*, London, Routledge & Kegan Paul, 1958.

38 – For an account of the education provided at the Royal Academy Schools see Macdonald, *The History and Philosophy of Art Education*, pp. 28–30.

39 – Gilchrist, *Life of William Etty*, vol. 1, p. 46.

40 – Winifred Gérin, *Branwell Brontë*, London, Thomas Nelson, 1961, pp. 79, 80, 91, 101, 102, 105, 110, 139.

41 – George Knowles, *Diary*, 1 September 1837–11 July 1843, Bradford Central Library, DB37.Case 1. no. 2.

42 – Women were not admitted to the Academy Schools until 1860. There was no rule which prevented women from applying to the Schools, just tradition.

43 – *Dictionary of National Biography*.

44 – T. Robinson, *Diary*, 23, 24, 25 January 1834.

45 – *Yorkshire Gazette*, 1 May 1830. The paper also reported erroneously that Ellen had won a Silver Isis Medal 'for a portrait in watercolours'.

46 – *Transactions of the Society instituted at London for the Encouragement of Arts, Manufactures, and Commerce: with the premiums offered in the year 1828–29*, London, 1829 and *Transactions of the Society of Arts, Manufactures, and Commerce*, vol. XLVIII, London, 1831, p. xxiii.

47 – Royal Society of Arts, *Minutes of Committees 1829–1830*, pp. 89, 93.

48 – See bibliography. Also Hazlitt, Gooden & Fox, *Interiors* and Lasdun, *Victorians at Home*.

49 – Mario Praz, *Conversation Pieces. A Survey of the Informal Group Portrait in Europe and America*, London, Methuen, 1971, pp. 33, 34, 55.

50 – Hargrove, *A Description of York*, 1823, pp. 103–4.

51 – Members, gifts and donations are listed in each *Annual Report of the Yorkshire Philosophical Society* from 1826.

52 – John Ward Knowles, *York Artists*, MS in York Reference Library, vol. 1, p. 62a.

53 – Fawcett, *The Rise of English Provincial Art*, pp. 72–3.

54 – Ibid. p. 76.

55 – Thomas Agnew and Sons, *Agnews 1817–1967*, London, Bradbury Agnew Press, 1967, p. 1.

56 – See *The York Courant*, September 1836, p. 4.

57 – Gerald Reitlinger, *The Economics of Taste: The Rise and Fall of Picture Prices 1760–1960*, London, Barrie and Rockliff, 1961, pp. 90, 96, 97.

58 – Fawcett, *The Rise of English Provincial Art*, p. 22.

59 – *The York Exhibition of Paintings and other Works of Art, opened on Monday the 6th of June, 1836, in the house belonging to J. Tuite, Esq. Castlegate, York*, York, Thomas Wilson and Sons, 1836.

60 – *A Catalogue of Pictures by the Ancient Masters, and the Works of Modern British Artists, in the Gallery of the Northern Society for the Encouragement of the Fine Arts. MDCCCXXX*, Leeds, Hernaman and Perring, 1830, no. 283, p. 20.

61 – *A Catalogue of the Works of British Artists, in the Gallery of the Northern Society for the Encouragement of the Fine Arts*, Leeds, 1833, nos. 376 and 412, pp. 23, 24.

62 – T. Robinson, *Diary*, 4 August 1831.

63 – *The Northern Academy of Arts. Fourth Annual Exhibition*, Newcastle, T. and J. Hodgson, 1831, nos. 136 and 153, pp. 9 and 10.

64 – *Catalogue of the eighth exhibition of the Liverpool Academy of Arts, at the New Rooms, Post Office Place, Church Street*, Liverpool, 1831, nos. 206, 209, 247, 249, 268, 276.

3 – AN INDEPENDENT WOMAN

1 – Ann Norcliffe's will is in Humberside County Record Office.

2 – Mary Norcliffe Best's will is in the Borthwick Historical Institute, York.

3 – *The York Exhibition of Paintings and other Works of Art, opened on Monday the 6th of June, 1836, in the house belonging to J. Tuite, Esq. Castlegate, York*, York, Thomas Wilson and Sons, 1836.

4 – See bibliography.

5 – *Yorkshire Gazette*, 4 June 1836.

6 – *Yorkshire Gazette*, 11 June 1836.

7 – R. Robinson, *Family Chronicle*, 16 April and 4 November 1836, pp. 76, 89.

8 – Ibid. 12 June 1836, p. 79.

9 – Ibid. 15 February 1837, p. 97.

10 – Ibid. 11 February 1837, p. 96, 25 February 1836, p. 73, 29 August 1836, p. 84, and 7 October 1836, p. 87, 2 April 1836, p. 75, 24 November 1836, p. 89.

11 – Ibid. 24 January 1837, p. 95.

12 – T. Robinson, *Diary*, 18 March 1837.

13 – R. Robinson, *Family Chronicle*, 15 July 1837, p. 111.

14 – Ibid. 11 September 1837, pp. 115–16.

15 – Ibid. 21 September 1837, pp. 116–17.

16 – Ibid. 27 September 1837, p. 117.

17 – Ibid. 15 December 1837, p. 124.

18 – H. Ferber, *Historische Wanderung durch die alte Stadt Düsseldorf*, Düsseldorf, 1890, pt 2, pp. 6, 16–17.

19 – R. Robinson, *Family Chronicle*, 29 January 1839, p. 149.

20 – Ibid. 4 April 1839, p. 152.

21 – Ibid. 12 June 1839, p. 155.

22 – This account of Franz Xaver Sarg's life is based on his application for the protection of the city of Nuremberg dated 23 May 1807. The document is entitled 'das Schutz-Gesuch des Aufwärters Xaver Sarg aus Hünningen betreffend' and is contained in *Acta des Königlich Baierischen Unburger-Amts*, Nuremberg town archives, Niederlassungsakten nr. 1072. Other details are drawn from the Nuremberg police records, also in the town archives, which record the name, occupation and addresses of people living in the city: *Alphabet. Einwohnerregister der Polizei-Direktion, Nürnberg*, 1809–1844.

23 – Ibid. Additional information provided by Clara Luz Sarg.

24 – This account of Johann Friedrich Adalbert Sarg's career is based on letters and application forms in Frankfurt city archives to be found in *Heiratsregister 1826–1829* and *Senats-Supplement* Tom. 217 Nr 27.

25 – *Intelligentzblatt*, 8 August 1826. See also Dr L. Holthof, 'Zur Baugeschichte des ehemaligen "Russischen Hofes" in Frankfurt a. M' in *Archiv für Frankfurts Geschichte und Kunst*, Frankfurt am Main, 1896, pp. 354–7; William Freiherr von Schröder, *Das Geheimnis der Bethmännchen*

und andere Frankfurter Merkwürdigkeiten; Herausgegeben von Margaretha Koch, Frankfurt am Main, Waldemar Kramer, 1966, pp. 14–20; and Hans Pehl, *Hotels und Quartiere im alten Frankfurt. Die grossen Höfe in der Freien Reichsstadt*, Frankfurt am Main, Josef Knecht, 1979, pp. 82–6.

26 – *Allgemeines Adress-Buch der Freien Stadt Frankfurt, 1835*, Frankfurt am Main, Georg Friedrich Krug, 1835, p. 157.

27 – Oberlehrer Ph. Mané, *Zu den öffentlichen Prüfungen in der kath. höheren Tochterschule, gennant Englische-Fräulein-Schule*, Frankfurt am Main, 1869, p. 22.

28 – See Johann Anton Sarg's application to 'emigrate' from Nuremberg and transfer his household to York, dated 6 November 1839, *Auswanderung* 1839/18, Nuremberg town archives.

29 – R. Robinson, *Family Chronicle*, 29 September 1839, p. 164.

30 – Ibid. 8 October 1839, p. 164.

31 – MS letter from Thomas Taylor Worsley to Miss Lydia Worsley, 22 November 1839, Cleveland County Archives Department, Middlesbrough.

4 – MARRIAGE AND LIFE ON THE CONTINENT

1 – R. Robinson, *Family Chronicle*, 22 and 24 December, 1839, p. 168.

2 – *Yorkshire Gazette*, 18 January 1840, p. 8.

3 – R. Robinson, *Family Chronicle*, 15 January 1840, p. 169.

4 – Ibid. 10 March 1840, p. 172.

5 – Ibid. 10 February 1840, p. 171.

6 – Ibid. 6 February 1840, p. 170.

7 – *Auswanderung*, 1839/18, Nuremberg town archives.

8 – R. Robinson, *Family Chronicle*, 5 March 1840, p. 171, 10 March 1840, p. 172, 16 June 1840, pp. 177–8.

9 – For descriptions of Nuremberg see Jameson, *Sketches of Germany*, pp. 294–304 and Murray, *A Handbook for travellers in Southern Germany*, pp. 54–60.

10 – Murray, *A Handbook for travellers in Southern Germany*, pp. 54, 55.

11 – Jameson, *Sketches of Germany*, p. 294.

12 – *Alphabet. Einwohnerregister der Polizei-Direktion, Nürnberg*, Nuremberg town archives, vol. 109. The entry under *Anton Sarg, Privatier* gives the Sargs' first address in Nuremberg as 1182 Kaiserstrasse (unter den Hütern) and their second as 764 Sb Aegidienplatz. The Sargs left Nuremberg on 3 August 1841.

13 – The *Einwohnerregister* cited above describes Platner as a merchant in colonial wares and superintendent of the market. Platner's House was destroyed in World War II. The library now stands in its place at 27 Aegidienplatz.

14 – This address is given in Tony Sarg's album.

15 – *Geburten-Buch 1842*, no. 51, p. 26 and *Geburten-Register 1843*, no. 758, p. 644, Frankfurt city archives.

16 – The addresses and occupations of the Sargs' friends can be found in *Krug's Adress-Buch von Frankfurt am Main, 1844*.

17 – Hanns Engelhardt, 'Die anglikanische Gemeinde in Frankfurt vom Anfang des 19. Jahrhunderts bis zum Zweiten Weltkrieg' in *Archiv für Frankfurts Geschichte und Kunst*, Frankfurt am Main, Waldemar Kramer, vol. 53, 1973.

18 – R. Robinson, *Family Chronicle*, 7 May 1845, p. 235.

19 – Ibid. 15 May 1845, p. 235.

20 – Ibid. 4 July 1845, p. 238.

21 – See Léopold Godenne, *Malines* and G. Van Caster, *Histoire des rues de Malines* and *Malines: Guide historique*.

22 – R. Robinson, *Family Chronicle*, 23 March 1846, p. 246.

23 – Ibid. 3 March 1847, pp. 264–5.

24 – Ibid. 17 September 1847, p. 276.

25 – Ibid. 3 May 1848, p. 282.

26 – Ibid. 13 October 1848, p. 290.

27 – Ibid. 26 October 1849, p. 304.

28 – *Wormser Zeitung*, no. 84, 26 May 1864.

29 – Information from Lore Sauerwein, Worms town archives.

30 – R. Robinson, *Family Chronicle*, 3 June 1851, p. 335.

31 – Ibid. 13 June 1851, p. 338.

EPILOGUE

1 – Johann Anton Sarg wrote a letter of resignation to the Casino und Musikgesellschaft on 27 June 1866 explaining that he was changing his place of residence. (Worms town archives, Casino und Musikgesellschaft Abt.72/4.) According to the 1867 Worms *Adress Buch*, the Wollgarn-spinnerei Actiengesellschaft owned the Remaier Hof.

2 – The documents relating to Johann Anton Sarg's application to become a citizen of Worms are in the town archives (5B/X1–15a, Ratsprotokolle 23.9.1857 and 10.10.1857).

3 – MS letter from Frank dated Freiburg 23 December 1857 to Madame M. E. Sarg.

4 – Caroline Sarg and Otto Scriba's marriage certificate, dated 8 February 1865, is in Worms town archives (OO 1865, Februar 8). For information about Otto Scriba's military career and family background see Christian Scriba, *Genealogisch-biographische Übersicht der Familie Scriba*, C. Scriba's Buchhandlung in Friedberg, 1884, pp. 108–9.

5 – Major General Norcliffe Norcliffe's will, dated 13 September 1855, is at Somerset House. Mary Ellen Sarg's will, dated 8 September 1884, can be seen at Darmstadt municipal archives, Abt. G 28 Amtsgericht Da. F Nr. 2784/13.

6 – Information about Frank and Fred's career in Guatemala comes from Franz Sarg 'Alte Erinnerungen an die Alta Verapaz' in *Deutschtum in der Alta Verapaz Erinnerungen 1888–1938*, Cobán, 1938, pp. 9–44, translated by Olga Stalling Thompson; Ian Graham of the Peabody Museum of Archaeology and Ethnology, Harvard University; letters, newspaper articles and photographs supplied by Clara Luz Sarg, Juan José Sarg and Francisco Sarg Castañeda; and Tony Sarg's album.

7 – See, for example, J.W. Boddam Whetham, *Across Central America*, London, Hurst and Blackett, 1877, pp. 230–42 and Anne Cary and Alfred Percival Maudslay, *A Glimpse at Guatemala, and some notes on the ancient monuments of Central America*, London, John Murray, 1899, pp. x, 11, 99.

8 – For the Sargs' movements in Darmstadt, see the police registration records (Polizeiliche Meldebogen) in the municipal archives.

9 – *Darmstädter Tagblatt*, 12 May 1891.

References and notes
to the picture captions

2 – The letter is quoted in Tony Sarg's album.
 – MS letter dated 5 August 1816 in *Folder containing letters from Rosamond Best to her father Dr Charles Best*.

9 – For the careers of George Horton Barrett and Samuel S. W. Butler, see Phyllis Hartnoll, *The Oxford Companion to the Theatre*, Oxford University Press, 1983.

10 – Garrard Tyrwhitt-Drake, *The English circus and fairground*, Methuen, 1946, pp. 168–71.

12 – Garrard Tyrwhitt-Drake, *The English circus and fairground*, Methuen, 1946, p. p2.

14 – I am indebted to the Reverend A. S. Leak, archivist of York Minster Library, for information about changes to the South Aisle.

17 – For Rosamond's descriptions of Clifton Feast, see her *Family Chronicle*, 1 May 1833 and 1 May 1840, pp. 20, 174.

18 – For information about Henry Robinson see Charles Robinson, *Some Account of the Family of Robinson of the White House, Appleby, Westmoreland*, Westminster, Nichols and Sons, 1874.
 – MS letter dated 13 November 1828 in *Book containing copies of letters from Charles Hare Wake, 1828–1831*.

19 – This watercolour was identified by Sotheby's as being the kitchen at Elmswell Hall, which belonged to Ellen's uncle, the Reverend Francis Best, rector of South Dalton. But this attribution is not correct. the house still stands, albeit in a derelict state, and no room in it corresponds with that in the watercolour. The pencil inscription 'A Farm Kitchen at Clifton' on the *verso* of the picture corresponds with Ellen's movements in May 1834 (she was in York) and the index and page captions of the album from which it came.

22 – *The Stranger in Liverpool; or, an historical and descriptive view of the town of Liverpool and its environs*, Liverpool, T. Kaye 1829, p. 187.

26 – The identification of the people in the picture comes from a manuscript note by Florence Taylor (née Sarg). Another note of later date (probably by Mary Isabella Turpin, née Lawrance) identifies the woman in the green dress as Norcliffe Norcliffe's wife, Decima Hester Beatrix (née Foulis). But this seems less likely, given that Decima died in February 1828 and Ellen was not painting such ambitious interiors before this date. Charles Dalton was the second son of Ellen's great uncle, Colonel John Dalton of Sleningford. He married Mary Duncan in 1832. Since Ellen was abroad from July 1834 to September 1835, when Ann Norcliffe died, this interior was prob-
ably painted between 1832 and 1834.

29 – This account of Norcliffe Norcliffe's life is drawn from Rosamond's *Family Chronicle* and official nineteenth-century army lists.

31 – Rose Worsley is identified in a manuscript note by Florence Taylor (née Sarg).

33 – R. Robinson, *Family Chronicle*, 26 July 1833, p. 23. I am indebted to the Area Archives for Anglesey for this information.

34 – I am indebted to Eeyan Hartley, the archivist at Castle Howard, for finding out about the Kirby family.

36 – For information about Howsham Hall, see R. A. Alec-Smith, 'A Country House Reprieved' in *The Georgian Society for East Yorkshire*, vol 3, pt 2, 1951–52.

38 – William Chambers, *A Tour in Holland*, p. 14.

40 – See R. Robinson, *Family Chronicle*, 9 January and 17 October 1835, pp. 48, 66.
 – For Reiffenstein's impressions see Hans Lohne, *Frankfurt um 1850*, pp. 9, 12.

41 – Jacob Wohl is listed in the *Allgemeines Adress-Buch der freien Stadt Frankfurt 1837–38*, Frankfurt am Main, Georg Friedrich Krug, p. 213.

42 – I am grateful to Josef M. Grill, Zentrum für internationale Bildung und Kulturaustausch, Heimvolkshochschule, Kreuzberg for information about the vault.

43 – A picture of the promenade, island and river by Heinrich Bebi, based on a drawing made by C. Brastberger in 1840, is reproduced in 'Das Frankfurter Stadtbild', *Frankfurt Archiv 1*, Archiv-Verlag (no place or date of publication).

45 – Ellen kept the portrait reproduced here, Frederike the other.

46 – For details of the Städel Institute's organisation and collections in 1833 and 1835, see *Gemälde-Gallerie des Städelschen Kunst-Instituts nach der Aufstellung am 15. Maerz 1833* and *Verzeichniss der öffentlich ausgestellten Kunstgegenstände des Städelschen Kunst-Institutes*, Frankfurt am Main, C. Naumann, 1835.

47 – The catalogue is entitled *Verzeichniss der öffentlich ausgestellten Kunstgegenstände des Städelschen Kunst-Institutes*, Frankfurt am Main, C. Naumann, 1835.

49 – For further details about the content of the exhibition, see the catalogue, *Verzeichniss der ausserordentlichen Ausstellung des Frankfurter Kunst-Vereins im Saal des goldnen Rosses, eröffnet den 16. Mai 1835*, Frankfurt am Main, Johann David Sauerländer. The show was reviewed in *Didaskalier*, 23 and 24 May 1835.

50 – For Reiffenstein's observation, see Hans Lohne, *Frankfurt um 1850*, p. 295.

58 – For references to the Hoods see W. Hargrove, *The New Guide for Strangers and Residents in the City of York*, p. 113 and Records of York Gas Light Company, 'Deed of Settlement 26 January 1837', York City Archives.

59 – The detail about the chaise comes from a manuscript note by Florence Taylor (née Sarg).

62 – For Rosamond's comments, see her *Family Chronicle*, 31 March and 14 July 1836, pp. 75, 81.
 – The exhibition review appeared in the *Yorkshire Gazette*, 11 June 1836.

66 – The Fuller advertisement appears at the back of David

Cox, *A Treatise on Landscape Painting*, London, S. & J. Fuller 1813.

– For the anecdote about Princess Charlotte, see Lady Charlotte Bury, *The Diary of a Lady-in-Waiting by Lady Charlotte Bury being the diary illustrative of the times of George the Fourth . . .*, London, John Lane, 1908, vol 1, p. 178.

67 – This description of the Whitby herring industry is based on an article in the *Whitby Gazette* of 1946 in the archives of the Whitby Literary and Philosophical Society and additional information kindly provided by Harold Brown.

68 – See Peter C. D. Brears and S. Harrison, *The Dairy Catalogue*, Castle Museum, York, 1979.

69 – Ellen painted portraits of five Mainwaring children: Charles Woolarton and Edith in October 1837 and Harry, Ellen and Mary in 1840.

71 – Whitby Abbey House now belongs to the Countrywide Holidays Association. The interior which Ellen painted no longer exists. The house is described in: George Young, *A picture of Whitby and its environs*, Whitby, 1824, pp. 254–56; Colonel George Cholmley's two publications, *A Peep at the Borough of Whitby*, York, H. Sotheran, 1839, pp. 2, 3, 27, 35 and *An Answer to James Walker's reply to the "Peep at the Borough of Whitby"*, York, Henry Sotheran, 1839, p. 5; and Nikolaus Pevsner, *Yorkshire. The North Riding*, Penguin Books, 1966, p. 392.

– Linda Cabe thinks that the tapestry could also be eighteenth-century and French, but depicting an earlier garden.

72 – R. Robinson, *Family Chronicle*, 25 May 1838, p. 88.

75 – The quotation about Schiedam's pollution comes from John Murray and Son, *A Handbook for travellers on the Continent*, p. 22.

79 – For information about Zaandam, see Zachariah Allen, *The Practical Tourist*, vol 2, pp. 224–25.
The observation about mirrors comes from William Chambers, *A Tour in Holland*, p. 13.

80 – Robert Batty, *A Family Tour through South Holland*, p. 61.

82 – William Chambers, *A Tour in Holland*, p. 53.

– For information about steam boat travel, see Edwin J. Clapp, *The Navigable Rhine. The development of its shipping. The basis of its prosperity, of its commerce and its traffic in 1907*, London, Constable, 1911, pp. 14–26 and *The Steam-Boat Companion from Rotterdam to Mayence, describing the principal places on the banks of the Rhine*, London, Samuel Leigh, n.d., p. 22.

83 – For details about St Gereon, see David Hugh Farmer, *The Oxford Dictionary of Saints*, Oxford, The Clarendon Press, 1978, p. 168.

– I am indebted to Dr Werner Schäfke, Kölnisches Stadtmuseum, for explaining the purpose of the glass balls.

84 – Anna Mary Howitt, *An art-student in Munich*, vol 1, pp. 2–3.

85 – For further information see Christopher Hussey, 'Two Yorkshire Manor Houses: Moulton Manor and Moulton Hall' in *Country Life*, 7 March 1936, pp. 250–55.

There is a similar staircase at Astley Hall, Lancashire, which may have been carved by the same person.

86 – There are frequent references to Ellen's trips to see her great uncle and his family in Rosamond's *Family Chronicle*. Ellen made at least two copies of this particular watercolour and also painted a picture of the carved stonework in the chancel.

– For an architectural appraisal of the church, see Nikolaus Pevsner, *The Buildings of England. Yorkshire: the North Riding*, Penguin Books, 1981, p. 132. According to the church guidebook, most changes were made between 1876 and 1912.

89 – The information about the chair comes from a manuscript note by Florence Taylor (née Sarg).

90 – For some typical criticisms of German bedding see W. E. Frye, *After Waterloo*, pp. 396–97 and Charles Loving Brace, *Home Life in Germany*, London, Richard Bentley, 1853, p. 11.

91 – William Chambers, *A Tour in Holland*, p. 48.

92 – George Lewis, *A Series of Groups, illustrating the physiognomy, manners and character of the people of France and Germany*, London, John and Arthur Arch, 1823, pp. 4, 9.

95 – Henry Russell Hitchcock, *German Renaissance Architecture*, Princeton University Press, 1981, pp. 255–56.

96 – Ingelore Menzhausen, 'The Porcelain Collection' in *The Splendor of Dresden: Five Centuries of Art Collecting, An Exhibition from the State Art Collections of Dresden*, German Democratic Republic, National Gallery of Art, Washington D.C., 1978.

97 – N. Parker Willis, *Rural Letters and other records of thought and leisure written in the intervals of more hurried literary labour*, New York, Baker and Scribner, 1849, p. 296.

– Edmund Spencer, *Sketches of Germany*, p. 250.

– For details about the armoury, see Johannes Schöbel, 'The Armory' in *The Splendor of Dresden: Five Centuries of Art Collecting, An Exhibition from the State Art Collections of Dresden*, German Democratic Republic, National Gallery of Art, Washington D.C., 1978.

98 – John Russell, *A tour in Germany*, pp. 320–24.

99 – For descriptions of summer houses see Robert Batty, *A Family Tour through South Holland*, pp. 68–69 and John Murray and Son, *A Handbook for Travellers on the Continent*, pp. 15–16.

100 – The Russischer Hof started off as a private residence, but became a hotel between 1812 and 1888. It reached the height of its fame under the management of Johann Friedrich Adalbert Sarg who owned it between 1828 and 1852. It was pulled down in 1891. For the full history of the building see: the *Intelligenzblatt* of 8 August 1826; William Freiherr von Schröder, *Das Geheimnis der Bethmännchen und andere Frankfurter Merkwürdigkeiten Herausgegeben von Margaretha Koch*, Frankfurt am Main, Waldemar Kramer, 1966, pp. 14–20; Hans Pehl, *Hotels und Quartiere im alten Frankfurt. Die grossen Höfe in der Freien Reichsstadt*, Frankfurt am Main, Josef Knecht, 1979, pp. 82–86.

– The model is described in Johann Wolfgang von

Goethe, *Goethes Briefe*, Hamburg, Christian Wegner, 1964, vol 2, p. 288.

103 – In Johann Anton Sarg's application to transfer his household from Nuremberg to York following his marriage to Ellen, he gave his address as 'Clifton'. This is consistent with Rosamond noting in her *Family Chronicle* that Hugh would often drop in on his aunt for a cup of coffee on his way to school in the Minster Yard. (The Robinsons were then living at no. 44 Clifton.) Although Rosamond does not identify her sister's house on Clifton, she does mention that Mrs Charlotte Ellen Stovin (mother of Frances and Rose Worsley) took over the tenancy, following Ellen's marriage and departure to the continent. In W. White's *History, Gazeteer and Directory of the East and North Ridings of Yorkshire* (published in April 1840) Mrs Stovin's address is given as no. 1 Clifton.

104 – Ellen also painted the 'Kaisersaal' (now called the Emperor's Parlour) and another apartment with a dramatic eagle ceiling (now known as the Emperor's Living Room'). For further information about the castle, see Erich Bachman, *Imperial Castle, Nuremberg. Official Guide*, Munich, Bayerische Verwaltungen der Staatlichen Schlösser, Gärten und Seen, 1982.
 – The quotation comes from Anna Brownwell Jameson, *Sketches of Germany*, p. 298.

105 – For a picture of sixteenth-century York bakers at work see Peter C. D. Brears, *The Gentlewoman's Kitchen. Great Food in Yorkshire 1650–1750*, Wakefield Historical Publications, 1984, p. 62. For further information about the history of table settings, see Louise Conway Belden *The Festive Tradition*, New York, W. H. Norton, 1983.

107 – William Howitt, *The rural and domestic life of Germany*, p. 226.

110 – Marie Pauline Rose (Stewart), *Baronne* Blaze de Bury, *Germania; its courts, camps, and people*, London, Henry Colburn, 1850, pp. 186–87.

112 – For further details see: Anton Horne, *Die wichtigsten öffentlichen Denmäler von Frankfurt a/M*, Frankfurt a/M, 1904, pp. 6–7; Seth William Stevenson, *A tour in France*, pp. 673–74; Edmund Spencer, *Sketches of Germany*, p. 13; and John Ross Browne, *An American Family in Germany*, p. 114.

122 – For the history of the Altpörtel, see Joseph Behles, *Das Altpörtel zu Speyer*, Baden-Baden/Strasbourg, Verlag Heitz GMBH/Editions P.H. Heitz, 1959, pp. 48–49.

124 – William Howitt, *The rural and domestic life of Germany*, pp. 78, 81.

125 – The main sources of information about Dr Wolff are his own prolific writings, the *Dictionary of National Biography*, H. P. Palmer, *Joseph Wolff. His romantic life and travels*, London, Heath Cranton, 1935.

130 – For the Ecole St Joseph's history see Léopold Godenne, *Malines jadis & aujourd'hui*, pp. 233–34 and G. Van Caster, *Malines: Guide historique et description des monuments*, pp. 81–82. The orphanage was housed in Rue de la Coupe when Ellen painted it.

133 – The attribution of this painting is Tony Sarg's.

135 – R. Robinson, *Family Chronicle*, 26 October 1849, pp. 304–5.

List of illustrations

The following list of Mary Ellen Best's paintings is in thematic and chronological order.
Dimensions where known are in centimetres, height before width. The full title and date are given in the caption. Unless otherwise stated, all paintings are in private collections. Owners are given at the end of this list.

A LIST OF OWNERS

Caroline Davidson, Jeanne Dominick, Ruth Dubrow, James Estey, Shirley Farber, George Garwood, Rosamond Gorringe, Jane Gray, Rose Harms, Richard Howard-Vyse, Hugh Lawrance, Jeremy Lawrance, Joan Lawrance, Peter Lawrance, Thomas Lawrance, Timothy Lawrance, Wray Menzies, Philippa Moyle, Howard Rutkowski, Francis Sarg, Juan José Sarg, Rosamond Selsey, Francis Taylor, Timothy Turpin, Victoria and Albert Museum, Rosamund Wilcox, York City Art Gallery.

Index